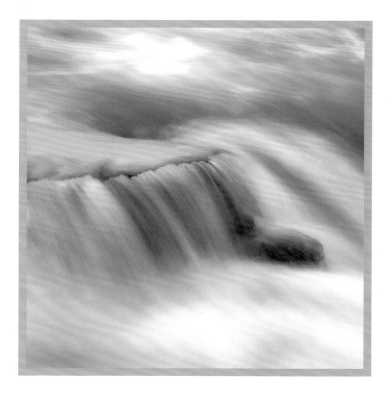

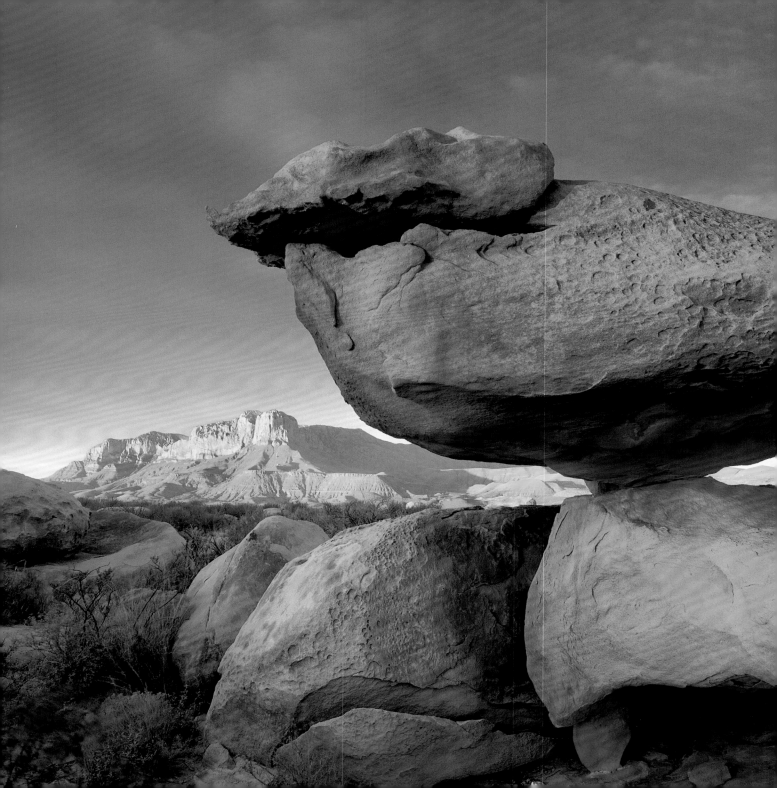

National Park Photography

Tim Fitzharris

AAA Publishing
1000 AAA Drive
Heathrow, Florida 32746

Published by AAA Publishing
1000 AAA Drive, Heathrow, FL 32746.

President & CEO: Robert Darbelnet
Executive Vice President, Publishing & Administration: Rick Rinner
Managing Director, Travel Information: Bob Hopkins

Director, Product Development: Bill Wood
Director, Sales & Marketing: John Coerper
Director, Purchasing & Corporate Services: Becky Barrett
Director, Business Development: Gary Sisco
Director, Tourism Information Development: Michael Petrone
Director, Travel Information: Jeff Zimmerman
Director, Publishing Operations: Susan Sears
Director, GIS/Cartography: Jan Coyne
Director, Publishing/GIS Systems & Development: Ramin Kalhor

Product Manager: Nancy Jones, CTC
Managing Editor, Product Development: Margaret Cavanaugh

AAA Travel Store & e-store Manager: Sharon Edwards
Manager, Marketing: Bart Peluso
Manager, Product Support: Linda Indolfi
Manager, Electronic Media Design: Mike McCrary
Manager, Pre-Press & Quality Services: Tim Johnson

Book design and production by Tim Fitzharris and Joy Fitzharris. Cartography by Joy Fitzharris.

The author wishes to express his thanks to National Park staff who assisted with advice on photography in the field, a valuable service which is freely extended to all. He is grateful to the many staff members who verified information presented in the text. Any errors which may remain are the fault of the author.

ISBN 1-56251-549-7 Stock No. 141602

Cataloging-in-Publication Data is on file with the Library of Congress.

Photo Captions
Opening Page: Paradise Creek, Mount Rainier National Park, Washington.
Title Page: El Capitan, Guadalupe Mountains National Park, Texas.

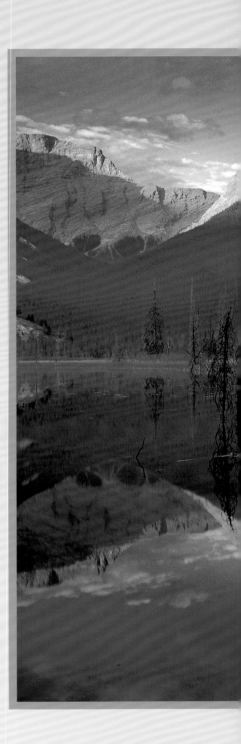

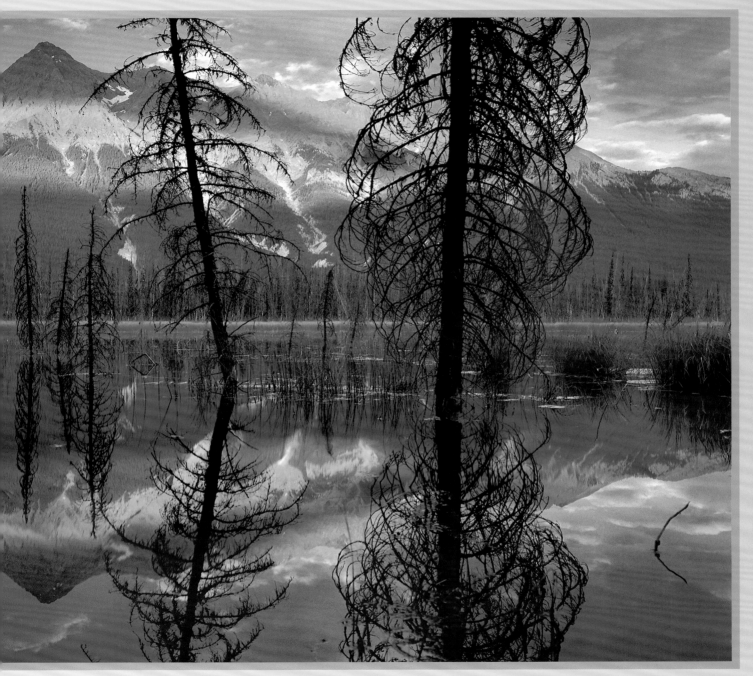

Ottertail Range, Yoho National Park, British Columbia

CONTENTS

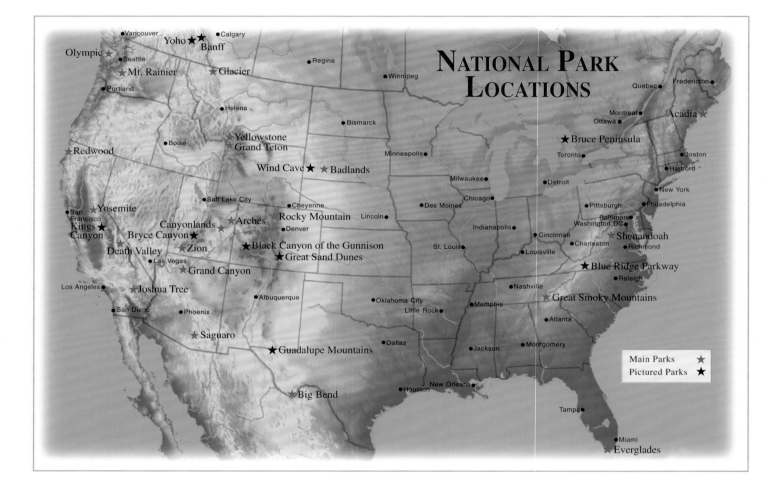

NATIONAL PARK LOCATIONS

Vancouver • Calgary •
Yoho ★★ Banff
Olympic ★ • Seattle Regina •
Mt. Rainier ★ ★ Glacier Winnipeg •
• Portland
• Helena Quebec • Fredericton •
Montreal • Acadia ★
Yellowstone Ottawa •
• Boise Grand Teton Bismarck • ★ Bruce Peninsula Boston •
Redwood ★ Minneapolis • Toronto • Hartford •
Wind Cave ★ ★ Badlands New York •
San ★ Yosemite • Salt Lake City Milwaukee • Detroit • Pittsburgh • Philadelphia •
Francisco Chicago • Baltimore
Kings ★ Canyonlands ★ Cheyenne • Rocky Mountain Lincoln Des Moines • Washington DC •
Canyon Bryce Canyon ★ ★ Arches • Denver Indianapolis • Cincinnati • Shenandoah
Death Valley ★ Zion ★ Black Canyon of the Gunnison St. Louis • Louisville • Charleston • Richmond •
• Las Vegas ★ Great Sand Dunes ★ Blue Ridge Parkway
Los Angeles • ★ Grand Canyon Nashville • Raleigh •
Joshua Tree Albuquerque • Great Smoky Mountains ★
San Diego • • Phoenix Oklahoma City • Memphis • Atlanta •
★ Saguaro Little Rock •
Dallas • Jackson • Montgomery •
★ Guadalupe Mountains Main Parks ★
Pictured Parks ★
★ Big Bend
New Orleans •
Houston •
Tampa •
Miami •
★ Everglades

FOREWORD

PHOTOGRAPHY ESSENTIALS

APPENDIX

THE PARKS

FOREWORD

Tunnel View, Yosemite National Park, California (above). **This great park is crowded with excited photographers during summer. You will have few problems with crowds and you will make better photos if you shoot at sunrise and sunset. Convenient access to classic vistas is common in national parks.**

Bison Bull (right). **With patience, animal portraits are easily taken in many national parks, especially those in the Rocky Mountain region. Canon EOS 3, Canon 500mm f/4 IS lens, 1/500 second at f/5.6, Fujichrome Provia 100F.**

THIS BOOK OFFERS PRACTICAL advice on shooting the most exciting attractions in 21 of America's most popular wilderness parks. The text details where and when you can record beautiful landscape, wildlife, wildflower, and other natural views. It presents specific camera-handling techniques and approaches to composition appropriate to each situation. Photographers of all skill levels should find this book valuable.

Although I have spent most of my career taking photographs in national parks, I do not consider myself an expert on even one of them—most are too large and diverse and I have spread myself too thin to be able to make such a claim. I am expert in the techniques of nature photography, and in this book I try to pass on my best recommendations, based on field experience, to finding and effectively capturing on film the most photogenic attributes of each park.

THE NATIONAL PARKS

North America's national parks are the most exciting locations for nature photography in the world.

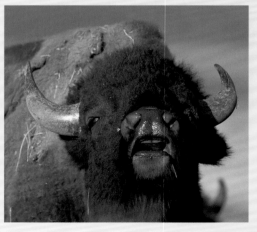

Nowhere else can you find such dramatic combinations of abundant wildlife and breathtaking scenery. Not only is the potential for taking beautiful pictures unmatched elsewhere, but an infrastructure of roadways, lodges, campgrounds, and stores makes access and logistics a relatively simple matter. The parks are patrolled by rangers who safeguard both park resources and the visiting public. They also can provide expert guidance to attractions, trails, and natural history.

HELP FROM THE VISITOR CENTER

In order to make the most of the information in this book, your first stop should be at one of the park's visitor centers. Your main purpose there is to pick up an official park map (if you didn't get one at the park entrance) which will guide you to all of the main attractions and facilities. These detailed, large-format maps show geologic features as well as main roads and most side roads. They should be used in concert with the Hot Spot maps in this book.

While you are at the visitor center, take the opportunity to orient yourself to the park environment. You

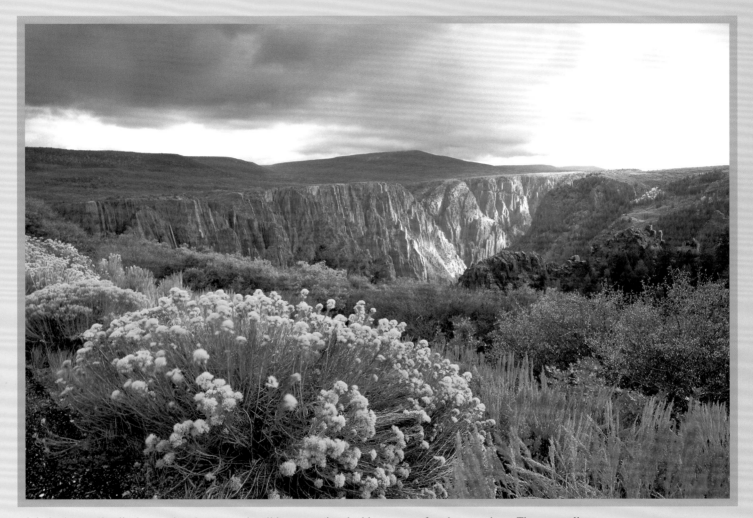

might look over the displays and perhaps attend a slide show or video program. Browse the retail book shop for literature that may be of special relevance to your visit. Look over the wide selection of photos in books, calendars, postcards, and posters to get a feeling for the photographic potential of the area. Staff at the visitor center have intimate knowledge of the park and are an invaluable resource for photographers. They can tell you where wildflowers are blooming, elk are rutting, and waterfalls are surging; provide an up-to-the-minute weather forecast and the exact time of sunrise; or enlighten you on such prosaic issues as campsite availability and road closures.

You can usually talk to national park staff simply

Black Canyon of the Gunnison National Park, Colorado (above). **To find beautiful fall colors and wildflowers in bloom, ask a park ranger or the staff at the visitor center for the latest information.**

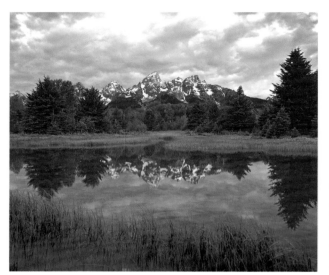

Grand Tetons from Schwabacher Landing, Grand Teton National Park, Wyoming (above). **This book provides information on finding the most photogenic vistas in each national park. (For information on this classic view, see p. 102.)**

Prickly Pear Cactus and Red Paintbrush (right). **Tune in to the details of the park environment. This floral study (shot from a low tripod) was captured with a zoom lens. A close-up filter was screwed onto the front of the lens for extra magnification. A white reflector was used to bounce light into shadow areas for better detail.**

by calling the park's main telephone number found at the head of each park section in this book. Dial ahead to inquire about facilities or what clothes to bring. Cell-phone-toting photographers can often get on-the-spot information while in the field—"I'm calling to find out if that grizzly is still in the Dunraven Pass area. Have the trail closures been lifted?" Another source of excellent information is national park websites. Individual web addresses are found at the head of each park section.

PARK REGULATIONS

It's your responsibility to know and follow the regulations of the park. These rules are intended to protect fragile wilderness habitat and wildlife as well as ensure a safe and enjoyable stay for visitors. Regulations (which vary from park to park) are posted on signs in relevant locations and usually appear in both the official map and the free seasonal visitor guides available at entrance stations. Most

regulations will have no effect on your activities as a photographer but a few require special attention.

PHOTOGRAPHING SCENERY

Driving off-road is prohibited so be prepared to hike to many scenic locations. In some areas (especially alpine, subalpine, and desert environments) you must stay on established trails to avoid damaging vegetation which can lead to erosion and general habitat deterioration. Don't remove or otherwise alter any vegetation or natural artifacts in the course of shooting. Take only pictures and, if possible, don't even leave your footprints!

PHOTOGRAPHING WILDLIFE

Feeding or baiting animals is strictly prohibited for many reasons. Perhaps most significant is the danger that animals habituated to feeding pose to park visitors (especially children), even those who have no intention of offering a tidbit. Aside from painful bites and scratches from animals as seemingly harmless as chipmunks and squirrels, some species carry serious infectious diseases.

Fortunately for photographers, the protection given park wildlife has reduced its fear of humans, making close-range shooting of many species routine. Always keep in mind that your photographic activities should not affect the behavior

of the subject. If an animal moves away from you, even at a slow pace, you have likely approached too closely and should retreat. It's best to be patient, quiet, and still and allow animals to come closer to you (which they often do). Special precautions are required with aggressive species like elk, bison, and bear. If possible, shoot such species from the safety of your vehicle. If working on foot, maintain a safe distance and stay alert not only to the behavior of the animal you are shooting but to others which may be in the vicinity. Park visitor guides provide specific advice on how to avoid negative wildlife encounters.

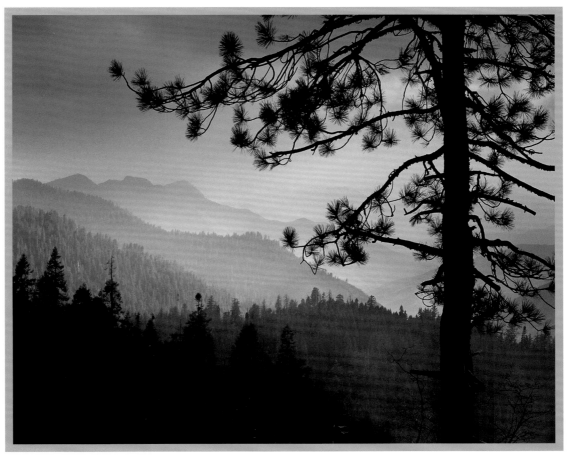

King's Canyon National Park, California (above). **Mist and fog are dramatic atmospheric elements that frequently grace the pictures of early-rising photographers. Remember to set your alarm and pack your tripod!**

PHOTO ETIQUETTE

You will encounter many other photographers at popular scenic locations and where there is wildlife close to the road. How one shares the park's opportunities with other photographers is mainly a matter of simple courtesy and common sense. I do my best to stay out of the line of fire of anyone else with a camera. I avoid setting up my tripod near other photographers in order not to disrupt their concentration. If I like a spot that is already occupied, I wait until it is vacated. I normally don't approach wildlife that someone else is shooting in case my arrival frightens the animal. If my presence seems unlikely to cause a disturbance, I get into position quietly and go no closer to the subject than other photographers. For my own peace of mind, I only shoot from a vehicle in areas where there is little, if any, traffic and I pull well over onto the shoulder of the road for my own safety.

USING THIS BOOK

An understanding of photographic principles is necessary to fully appreciate this book. The information here is presented in several forms, most important being the photographs themselves. If you are a novice, use the pictures as models for your own work. For more advanced photographers, including professionals, the photographs provide the best idea of what you can

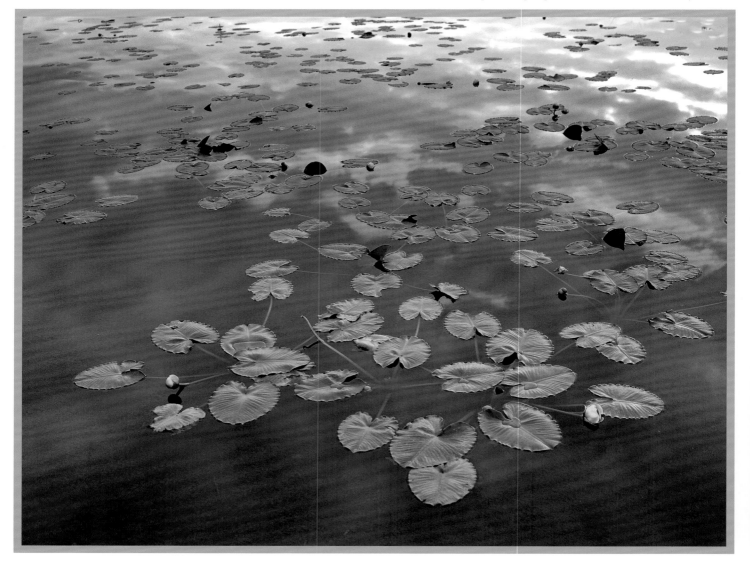

expect to shoot and how you might personally deal with the subject. The selection of images represents situations that can be readily addressed by photographers during an initial visit of one to two weeks. I've limited the Hot Spots photo sites to those which are within an hour's hike of vehicle access. You can walk to most of the locations in a few minutes.

The introductory text briefly describes equipment you will need as well as a few of my favorite shooting tips for landscapes and wildlife. The information that follows on individual parks is the core of the book. You will find general recommendations about when, where, and how to shoot each park's unique attractions. These general comments give way to specific treatments of photo hot spots. Many of these locations are the origin of magnificent calendar and postcard shots you may have long admired but were never able to shoot. Others are less known favorites of mine and other professionals. Access information and shooting tips are provided for each hot spot where necessary. Each picture is accompanied by a description of photographic technique, approaches to composition, and/or field considerations. Advice on excursions to exceptional nearby locations outside the park is provided. These side trips often can be as productive as shooting within park boundaries.

CLASSIC PHOTOGRAPHS

Many of the views cited in the text have been photographed countless times before. Don't let this dim your enthusiasm. You not only will enjoy shooting these beautiful subjects, but you will likely come away with variations on classic photographs that show something new and valuable. To date I've photographed the Grand Tetons from Schwabacher Landing on eight occasions (see photo p. 10), sometimes in company of a dozen other shooters. Even so, I look forward to my next visit. The Tetons will have the same majestic profile, but they may be dusted with snow, ablaze with autumn color, wreathed in fog, backed by a crimson-tinted sky, or, if I'm lucky, all of the above.

Recording grand and familiar landscapes is one of the most enjoyable aspects of national park photography. But searching for untapped scenes is an elixir that can be equally intoxicating. Get off the beaten path once in a while to search for your own classic views. Who knows, other photographers could someday make pilgrimages to one of your discoveries.

Low Shooting Angle for Wildflowers (above). **Whether recorded as a simple portrait or a foreground for a wider view, wildflowers are best recorded from a low camera position that captures intriguing detail.**

Mount Moran from String Lake, Grand Teton National Park, Wyoming (left). **I discovered this classic-looking vista by scouting for views off the beaten path. You can find out about this site and others in the park section on Grand Teton.**

Pond Lilies at Sunrise (far left). **Most bodies of water have great potential for an outstanding picture. In the national parks, explore these micro habitats for colorful close-ups as well as reflections of the surrounding terrain.**

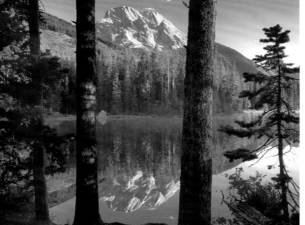

PHOTOGRAPHY ESSENTIALS

LEARNING TO PHOTOGRAPH nature is a lifelong process. The technical requirements can be learned quickly but applying them in the uncertain conditions of the wild calls for an intimate knowledge of the subject (whether it be wildlife or landscape) and artistic judgment. The development of these skills is an enjoyable, if slower, process directly linked to your experience in the field. To assist your progress, you will find in the appendix a list of guide books on shooting and traveling in the national parks as well as "how to" books on nature photography.

BASIC EQUIPMENT

Serious nature photographers, both professional and amateur, use 35mm single-lens-reflex (SLR) cameras. The versatility of this camera, primarily due to its through-the-lens viewing system and facility to accept a variety of lenses, makes it suitable for recording a wide range of subjects from erupting volcanoes to hovering hummingbirds to bugling elk. Less expensive point-and-shoot cameras also make beautiful photographs, but they are limited by their built-in lenses to subjects that do not require much magnification or close focusing, such as landscapes or wildlife depicted as part of a larger scene. Such themes account for many of the photographic opportunities in national parks, making point-and-shoot cameras fit for a wide range of attractions. These cameras are not so suitable for shooting during sunrise and sunset when direct control of the camera's lens opening and shutter speed is beneficial. For consistent professional results, you also need to see the actual effect of filters that are placed in front of the lens. This is only possible with SLR cameras. You should find this book's advice on composition and shooting locations valuable regardless of the type of equipment you use.

POINT-AND-SHOOT CAMERAS

A point-and-shoot camera for working in the national parks should have the following features.
- A tripod socket for steadying the camera during long exposures that is sturdy enough to allow film reloading without removing the camera from the tripod (a socket located in the center of the camera base is best).
- Self-timer (two-second delay is best for rapid shooting) or infra-red remote release so that you can trip the shutter without shaking the camera.
- Zoom lens in the 28–80mm (or greater) range for precise framing of scenic compositions.
- Continuous focusing into macro range or easy-to-use

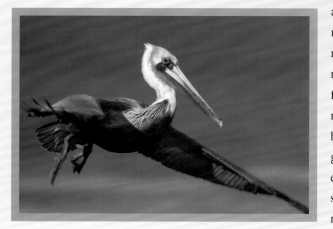

Brown Pelican on the Wing (below). **Because they are protected from hunters, wildlife in most national parks are unafraid of people and you can get much closer to most species than you ever could outside the park. Nevertheless, telephoto lenses and sturdy tripods are needed to make high-quality, frame-filling portraits. This huge, pouched aviator can be easily photographed at several south Florida locations described in the Everglades section.**

Log Dump Beach, Bruce Peninsula National Park, Ontario (left). **Knowing where and when to shoot this arresting scene was as important as using proper technique. An afternoon scouting expedition cued me to this boulder-strewn setting which was then shot just after sundown. The through-the-lens (TTL) viewing of the 35mm SLR made it easy to target the exaggerated perspective of the interchangeable 20mm wide-angle lens that I attached to the camera.**

Shooting in Badlands National Park, South Dakota (below). **This photo illustrates several important shooting suggestions: use a tripod whenever possible, carry your equipment in a vest, shoot in the warm soft light of sundown (or sunrise), trip the shutter with a cable-release to avoid camera-shake, include clouds in your compositions if possible.**

macro modes for wildflowers and other small subjects.

• Exposure/focusing programs that include *focus lock* for focusing on off-center subjects and *bulb* (or shutter speeds in the 10-second range) for twilight scenics.

35MM SINGLE-LENS-REFLEX CAMERAS

What features and accessories are most valuable on a 35mm SLR? Most essentials (e.g., lens interchange and through-the-lens exposure metering) are integral to all models. However, two not-so-standard features are necessary to take professional quality pictures: depth-of-field preview and motor-driven film advance. Depth-of-field preview is important for judging picture composition at shooting aperture prior to exposure; it is often missing on newer model SLRs. Motor-driven film transport gives you the best chance of capturing wildlife in action; it is usually missing on older,

Colin Range, Jasper National Park, Alberta (above). **A split neutral density filter reduced the contrast range in this scene (dark portion was placed over the sky) allowing the reflection to be recorded with more detail and color.**

sharp images if shooting with telephoto lenses or close-up equipment which greatly magnify the subject. The most suitable tripods are tall enough to bring the camera to eye level with the center post seated, have legs that spread independently for easy setup on uneven terrain, and are fitted with clip-lock levers for controlling the extension of leg sections. I like tripods that are light and quick to erect rather than those that are heavy and stable. Ball heads (rather than pan/tilt heads with levers) make the best links between tripod and camera. They are compact, don't get snagged on vegetation, and allow you to lock the camera in any position quickly by tightening a single control. Once you have a camera and tripod, you are ready for a wide range of shooting situations. Later you can expand your system at leisure according to your personal interests and budget.

EQUIPMENT FOR WILDLIFE

Frame-filling photos of most wild animals (including birds) are not possible without using a telephoto lens, the most expensive piece of equipment in a nature photographer's bag. I prefer small, light telephotos—a

mechanical single-lens-reflex camera models.

A tripod is the second most important piece of equipment after the camera and a basic lens. This three-legged field companion is necessary for shooting most subjects in the dramatic (but weak) light of dawn and dusk when exposure times are too long for you to hold the camera steady. It is also essential for attaining

300mm for large creatures in motion and a 500mm for small and/or wary subjects. Professional quality telephotos have low-dispersion or apochromatic lens elements for sharp color reproduction (usually designated by APO, LD, UD, or ED) and image stabilization (designated by IS or VR), which reduces camera-shake and mirror vibration during exposure.

Ideally, your wildlife gadget bag will be rounded out with a 1.4X teleconverter (increases focal length of the prime lens by 1.4) and an extension tube of around 25mm (allows close focusing for chickadees, pikas, chipmunks, dragonflies, and other small critters).

EQUIPMENT FOR LANDSCAPES

Short focal length zoom lenses are preferred for landscape work because they allow you to precisely magnify the scene for the best composition. (In this respect most point-and-shoot cameras are ideal.) You will want to span all focal lengths between about 24mm and 200mm with one or two zooms (e.g., a

24–80mm and an 80–200mm). For landscape shooters, internal-focusing (IF) lenses eliminate the need to readjust polarizing and neutral density filters when you change focus.

You will need a screw-on polarizing filter to darken blue skies, modify reflections from water, and eliminate reflections from foliage (for increased color saturation). To keep the contrast range of the landscape within the contrast range of the film, split neutral density filters are required. These filters allow you to achieve good detail and color in both the lightest and darkest parts of the image simultaneously. Split neutral density filters are square and fit into adjustable holders that screw onto the front of the lens (see photo at right). Two filters (a one-stop density and a two-stop density) are sufficient for most situations you will encounter.

EQUIPMENT FOR CLOSE-UPS

Don't overlook nature's miniature world—dew drops, wildflowers, butterflies, spiders, and frogs.

Split Neutral Density Filter (above). **These two-tone, square, plastic filters are positioned in front of the lens with a slotted, screw-on holder. You can slide the filter up and down to control the brightness range of the scene. Usually the dark part of the filter is placed over the sky to tone it down. You can preview the results easily in the viewfinder while you make adjustments. A floppy hat shades the viewfinder from stray light and makes viewing easier.**

White Ibis, Everglades National Park, Florida (left). **To capture this elegant wading bird, I approached to within 20 feet, a frame-filling range for my 500mm lens. For correct exposure of this white subject, I took a spot-reading from a nearby patch of dark sand, an average subject better suited to the camera's programmed settings.**

When Shooting Wildlife...

Use a large aperture (f/2.8, f/4, f/5.6) to blur the background.

Keep the center of interest (usually the head) away from the central area of the frame.

Try to catch the ears fanned toward the camera (not laid back).

Focus on the animal's eyes.

The background usually should be darker than the subject.

Try to record highlights in the eyes.

Shoot with a telephoto lens from a safe distance so that the animal does not become alarmed by your presence. Use enough magnification to show detail in the eyes.

For portraits, the animal should be facing the camera or looking toward the center of the picture area.

Use a brief shutter speed to freeze the animal's movements and reduce blur due to camera shake.

Position the camera level with the subject's head.

Schedule shooting session for early morning or late afternoon or during midday when skies are overcast.

Use a saturated, medium-speed film for recording strong color and accessing action-stopping shutter speeds.

Steady the camera with tripod for maximum sharpness and detail.

Include in-focus features of the animal's habitat.

Check peripheral areas of the frame for distracting branches, twigs, and grass.

Black-tailed Deer, Vancouver Island, British Columbia

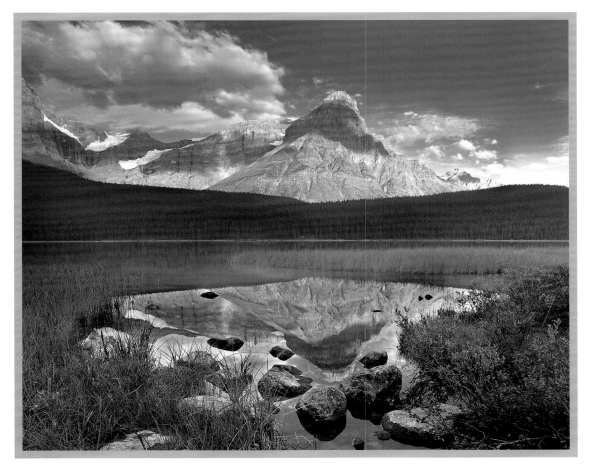

Mount Chephren from Waterfowl Lakes, Banff National Park, Alberta (left). **Although restricted by shoreline obstacles, I was able to obtain satisfactory framing, thanks to a zoom lens which allowed varied magnification of the scene from a single position. A one-stop split neutral density filter placed over the sky and sunlit mountains reduced scene contrast to produce good detail and color in both highlight and shadow areas. Pentax 645 SLR, Pentax 45-85mm f/4.5 lens, one second at f/22, Fujichrome Velvia.**

Amphibious Foot Gear (below). **Whenever you think you might be shooting near water, be prepared to get your feet wet to reach the ideal tripod position. I carry a circular, fold-up reflector on my back and all my gear in vest pockets.**

Frame-filling photos of these subjects are not possible with standard lenses. You either need special close-up adapters to extend the focal range of your existing lenses (least expensive) or macro lenses which are specially designed for this work (more convenient). Either approach yields excellent results.

Close-up accessories include screw-on supplementary lenses—simple magnifying meniscus lenses. These accessories cost little more that a few rolls of film and give you access to the greatest variety of nature subjects for the least amount of money. Extension tubes provide another relatively inexpensive way to get close. These hollow tubes, available in a variety of stackable sizes, are inserted between the prime lens and camera body. They generally yield better quality images and a greater range of magnification than supplementary lenses. They work best when used with prime lenses of normal to telephoto length.

Fixed-focal-length macro lenses focus from infinity to a close-up range that provides enough magnification to take a frame-filling picture of a bumblebee. No need to fiddle with accessories; shoot a landscape on one frame and a butterfly on the next without taking your eye from the viewfinder. Zoom or telephoto lenses *with macro capability* do not yield this much magnification, usually being suitable for portraits of animals the size of chipmunks and larger. For creatures smaller than a bee, even more specialized techniques and equipment, including electronic flash, are necessary.

Another valuable piece of close-up gear is a reflector to modify lighting effects. A portable, fold-up reflector with one side silver for maximum reflection and the other side white for a more subtle effect is inexpensive, easy to carry and simple to use and produces professional results. Reflectors made by Flexfill are popular and widely available.

These equipment recommendations should keep you on track until you get a better feeling for the subject matter, how you wish to work, and the style of imagery you want to produce.

FAVORITE SHOOTING TIPS

Studying the photographs and accompanying captions in this book (and others) is one of the best ways to develop your technical and artistic skills. If you are new to photography, begin by trying to replicate the pictures you see here. As your experience and ability grow, you will develop personal approaches to subjects and situations. For starters, here are some of my favorite tips for making great photos.

GENERAL FIELD TIPS

• Save your energy for the magical shooting periods of dawn and dusk. Rest during midday.

• Transport your camera (with your most useful lens attached) on a tripod over your shoulder. Keep extra equipment and film in well-organized, padded pockets of a vest especially designed for photography.

• Carry adequate equipment for shooting landscapes or wildlife or close-up subjects—but not all three.

• Dress in layers so that you can sustain a comfortable body temperature under changing weather conditions.

• Prevent eyestrain by wearing a floppy hat or one with a bill to shield the viewfinder from stray light.

• Keep a supply of extra batteries in your vest.

• Carry a cell phone in case you need to call for information or help.

• Pack energy bars in your vest for emergencies.

WILDLIFE SHOOTING TIPS

• Do not approach the subject closely. Use a telephoto lens of 300mm or

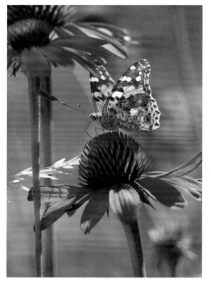

Wildflower Patches (above). **You can enjoy hours of photography by working a patch of wildflowers with a telphoto lens in the 400mm range equipped with an extension tube of about 50mm for close focusing. Place the camera on a tripod at bloom level and sweep back and forth through the flowers while you focus in and out to create new compositions. Use colorful blurs to frame in-focus blooms and insects.**

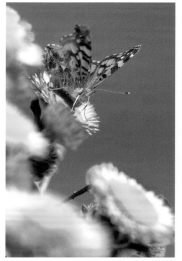

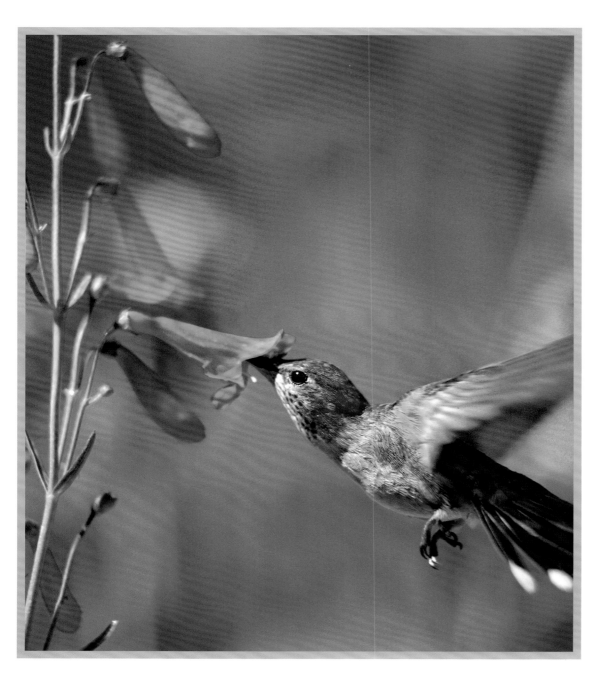

Broad-tailed Hummingbird (left). Generally not wary of humans, these thumb-sized fliers follow a feeding routine, returning to the same patch of flowers at regular intervals. This habit allows the patient photographer to prepare in advance and wait at a strategic location for the subject's appearance. You will see lots of humming-birds during the summer in the subalpine wildflower meadows of western moun-tain parks. A fast shutter speed (1/500 second) was used to arrest this bird's motion and a large aper-ture (f/5.6) yielded shallow depth-of-field which re-sulted in an attractively blurred background.

Painted Lady on Daisy (far left). This butterfly was photographed with a 300mm lens and 50mm ex-tension tube attached between the camera body and lens. The tube enabled the lens to focus closer than normal, providing the mag-nification needed to show the details of this tiny subject. These flowers, complete with butterflies in summer, grow along ocean cliffs in Redwood National Park, California.

When Shooting Landscapes . . .

Use a polarizing filter to increase color saturation and darken the sky.

Keep the center of interest away from the central area of the frame.

Use a small aperture (f/22 or f/32) for sharpness (depth-of-field) that spans the entire picture field.

Try to include clouds in the composition.

Wait for best light on the center of interest.

Position the camera for side-lighting of the main subject if possible.

Attach a split neutral density filter to reduce contrast and improve detail in shadows and highlights

Try to include a view of the distant horizon for scale and deep perspective

Include well-defined midground features to lead the viewer's eye through the picture

Make sure the camera is level.

Use a saturated film for vibrant color.

Try to include atmospheric affects like fog and mist.

Shoot early or late in the day for dramatic light.

Steady the camera with a tripod for maximum sharpness and detail.

Include a strong foreground feature for scale.

Frame the subject tightly using a zoom lens.

Mount Moran from String Lake, Grand Teton National Park, Wyoming

longer for close-up portrait views.

* Shoot from a tripod.
* Select a camera position that is likely to record the animal looking toward the sun.
* Do not place the subject in the middle of the frame except in tight portrait shots.
* Capture the animal when it is engaged in interesting behavior—feeding, running, etc.
* Learn the habits of your subject by field observation and study of published literature.
* Shoot in the early morning when many species are active (evening is the second most active period) and lighting is most beautiful.
* Shoot at a fast shutter speed to freeze action and limit the blurring effects that result from camera movement during exposure.
* Shoot with a medium speed (ISO 100–200) film. I prefer Fujichrome Provia 100F.

LANDSCAPE TIPS

* Shoot during the most attractive light of the day at sunrise and sunset when the sun is within a few degrees of the horizon (both above and below).
* Use a tripod. This will help you organize the composition systematically and will yield sharp pictures by keeping the camera rock-steady during exposure. Trip the shutter with a cable release.
* When using transparency film, take extra shots over and under the exposure indicated by the camera's light meter. (This procedure is called bracketing.)
* For vibrant color, use a fine-grained, saturated transparency film. I prefer Fujichrome Velvia.

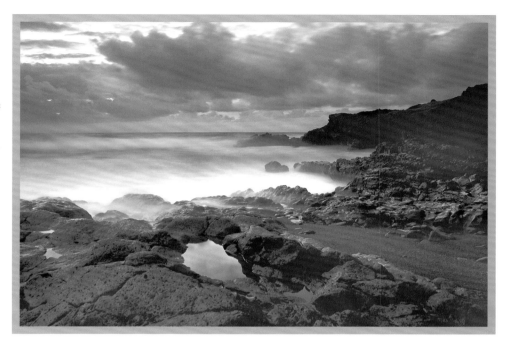

* Add a polarizing filter to the lens to increase color saturation of foliage and intensify the color of the sky.
* Shoot at a small aperture to maximize depth-of-field (the part of the scene in sharp focus).
* Use split neutral density filters to reduce contrast between light and dark areas of the scene (see p. 17).
* Include clouds in the composition.
* Schedule your shoot to capture the view when its main features are lit from the front or side.
* Scout locations to establish tripod positions and to determine when the light is most suited to your subject.

That's all for the preliminaries. Now on to the parks. Happy travels and great shooting!

Beach at Seven Sacred Pools, Haleakala National Park, Maui, Hawaii (above). A predawn arrival allowed me to capture the momentary pinkish tints in the sky while a split neutral density filter placed over the sky prevented overexposure of this part of the picture. The horizon is placed 1/3 from the top of the frame, a position which usually results in a pleasing spacial relationship between earth and sky.

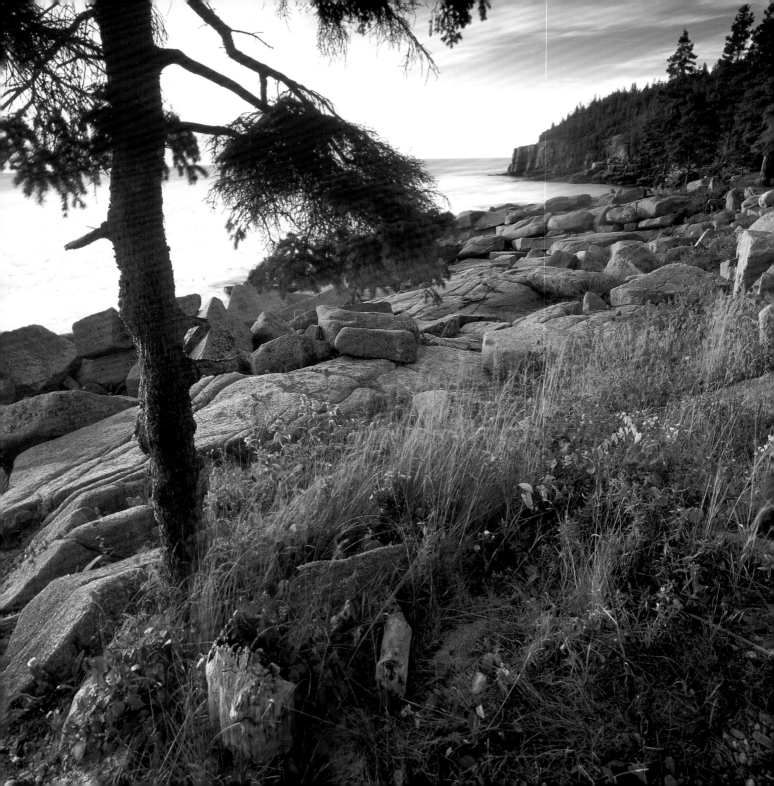

ACADIA

Maine • Spring/Summer/Fall • 760-440-2331 • www.nps.gov/acad/index.htm

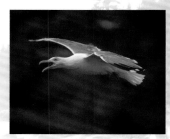

Herring Gull (above). **Close-up flight shots can be made of this species at Sea Wall on Mount Desert Island and the picnic area on Schoodic Peninsula. Shoot the birds with a handheld camera and lens in the 300mm range.**

ACADIA NATIONAL PARK is the fifth smallest national park (47,633 acres) but it ranks in the top 10 in popularity with more than 3,000,000 visitors annually. The park consists of three disconnected parts. In the south is remote Isle au Haut, a small offshore island accessible only by boat. To the east is rugged Schoodic Peninsula, another diminutive, lightly visited parcel featuring a loop road which skirts a granite shoreline. Anchoring these two outposts is Mount Desert Island, a patchwork of park land, private property, and seaside villages that fills up with tourists during summer. The largest, most popular segment of the park with the most exciting photography, Mount Desert Island serves up a compact collection of natural attractions which includes sand beaches, precipitous headlands, rock and boulder shorelines, mountains both forested and naked, wide valleys, small lakes, marshes, and a blend of two major forest types— northern coniferous and eastern deciduous. Wildlife is present but most species are difficult to see and even more difficult to photograph. Photo attractions with the most potential include seascapes, landscapes, and still-life studies of forests and wildflowers.

Fall is the best time for an expedition. The crowds of summer have diminished and fall foliage, which usually reaches its peak of color in mid-October, decorates the rugged topography with bronze to sapphire accents. Mid-May to mid-June is another prime photography time free of crowds which provides

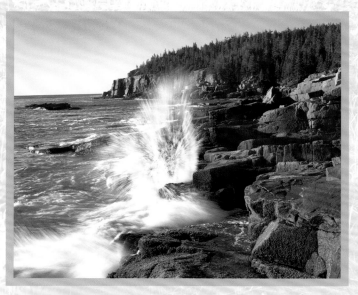

Otter Point Sunrise (far left). **The first light of sunrise sets aglow this autumn view toward Otter Point on the east side of Mount Desert Island. Park Loop Road parallels the park's most outstanding lineup of seascape views. You can park on the side of the road a few steps from great tripod positions.**

Big Splash (left). **Breaking surf offers numerous photo possibilities and produces often surprising results. You can blur waves with a slow shutter speed (see photo p. 31) or, as seen here, freeze splashes with a fast shutter speed. This impression was recorded at 1/125 second.**

wildflowers and budding trees to embellish the park's splendid scenic attractions. Most of the roads are

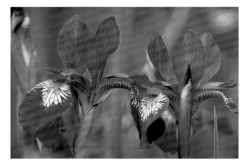

Blue Flag (above). **These large, shapely irises are found along park roads, ditches, and freshwater shorelines during early June. Here I used a telephoto lens and large aperture to set the flowers against a soft background of similar color.**

Maple Leaves and Birch Trunk (right). **With the change of leaf color in autumn (peak time is mid-October), Acadia explodes with photo opportunities. Overcast days are ideal for exploring quiet woodland trails. In this study, soft light evenly illuminates details to maximize color saturation in both highlight and shadow areas. Pentax 645, Pentax 80–160mm f/4.5 lens, 1/8 second at f/11, Fujichrome Velvia.**

closed from December through April due to snow and ice. Be prepared for changeable weather at any time of year. In spring and fall, daily high temperatures are 50–60°F and rain and fog are common occurrences.

The park has two campgrounds with limited capacity. Open all year, Blackwoods is well situated for photography and is available by reservation (800-365-2267) between May 1 and October 15. Seawall is filled on a first-come/first-served basis with waiting lines forming early in the morning in July and August. It is too far from the best photo attractions on the island's east side and you are better off staying at a private campground in Bar Harbor if Blackwoods is full. Lodging, camping, restaurants, and supplies can be found in nearby villages, especially Bar Harbor, Mount Desert Island's commercial center.

You will need an assortment of nature photography equipment including close-up accessories and

lenses from 20mm up to about 200mm. Most of your shooting will focus on rugged landscapes and seascapes and the patterns, rich color, and details of the forests and lakes. A small reflector will be useful for close-up work. Saturated, fine-grained, low-speed (ISO 50–100) color transparency film will render the

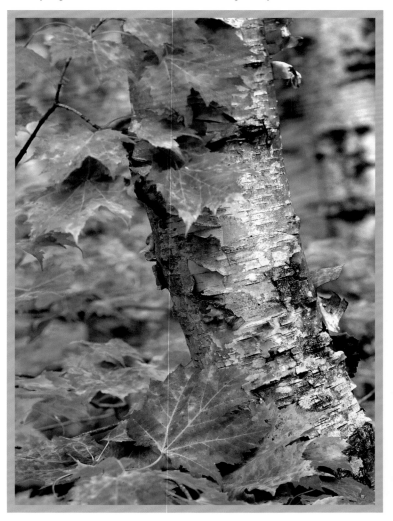

best quality images of these subjects. An umbrella, plastic bags, and cotton cloths for wiping off your equipment will come in handy on rainy days. River sandals and quick-drying shorts are great for getting the perfect angle on reflections and midstream close-ups of leaves and rushing water.

GENERAL STRATEGIES

From either Bar Harbor or Blackwoods Campground you will be able to easily reach all of the best sunrise tripod spots along the 27-mile Park Loop Road without sacrificing a good night's sleep. Set out for your early-morning destination about an hour before dawn

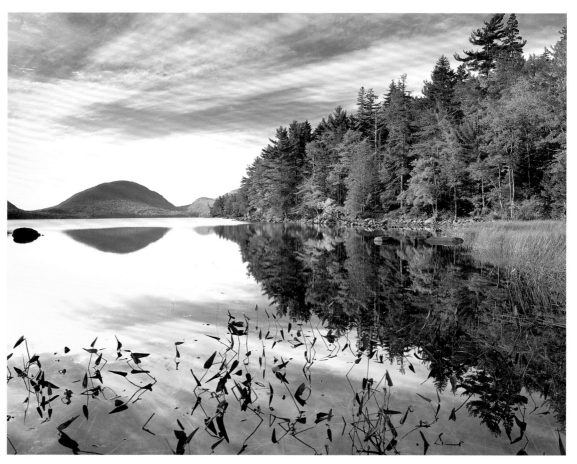

(check at the visitor center for the time of sunrise). This should allow you to start shooting about 20 minutes before the sun's appearance, a time when the sky often presents its best display of color. Generally you will want to spend early and late-day periods shooting rugged coastal landscapes along the eastern shore of Mount Desert Island, panoramic views from the top of Cadillac Mountain, and reflections and other shoreline compositions of small lakes, ponds, and streams. At other times of the day, especially if it is overcast, you can explore the park's trails for still-life compositions of the forests, meadows, and marshes. The park's most beautiful sections are readily reached from the Park Loop Road which skirts the eastern coastline and then weaves through interior valleys and mountains. A maze of other roads threads through Mount Desert Island's rumpled topography, skirting mountain ridges, lakes, and ocean inlets to shepherd visitors to less

Eagle Lake (above). **Along the north shore of Eagle Lake near the boat launch are varied foreground components (small pools, rocks, aquatic vegetation) which can be incorporated into panoramic views (Hot Spot 3). Arrive before sunrise for perfect reflections and soft, warm light .**

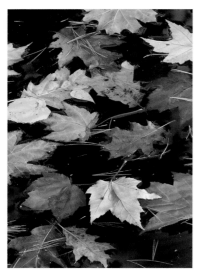

Autumn Leaves (above). **These leaves at Eagle Lake were shot with a tripod-mounted camera and a telephoto zoom lens for easy, precise framing. A polarizing filter eliminated reflections from the water, resulting in a simple, black background.**

View from Cadillac Mountain (far right). **This big hill is Acadia's top landscape attraction (Hot Spot 2). In this photo, telescoping rock patterns draw the eye into the picture. Pentax 645, Pentax 35mm f/3.5 lens, polarizing filter + split neutral density filter, 1 second at f/22, Fujichrome Velvia.**

photogenic but more peaceful swatches of the park in the central and western part of the island. In addition to 120 miles of hiking trails, the park also has 57 miles of carriage roads, winding gravel byways originally constructed to provide an alternative to exploring the park by noisy automobile. You can follow these quiet winding routes by carriage tour or bicycle or on foot. Witch Hole Carriage Road (3.5 miles of easy hiking) leads you through beautiful stands of maple, oak, aspen, and birch which ignite with volcanic color in autumn. The road starts at the parking area just off route 233 north of Eagle Lake. Hadlock is another nice carriage road that features a waterfall. Its southern end can be picked up at the parking lot off Route 3/198 across the road from Lower Hadlock Pond.

PHOTO HOT SPOTS

❶ THUNDER HOLE. The eastern shore of Mount Desert Island is the most scenic part of the park. In the Thunder Hole area are numerous access points

leading to the water's edge where sunset and sunrise sky tints can be loaded into compositions with strong foregrounds (pine trees, wildflowers, boulders, tide pools, crashing surf) and views to dramatic terrain both offshore and along the shoreline to the south where the cliffs of Otter Point offer up classic coastal scenery (see photos p. 24, 25, 30, 31).

❷ CADILLAC MOUNTAIN. Of Acadia's numerous peaks, this one is the most grand. The summit is the highest point (1,530 feet) on the U.S. East Coast and is easily reached by car via a winding 3.5-mile paved road with several overlooks. Topside it provides 360-degree views of the park and surrounding waters. The open terrain is furnished with photogenic collections of shrubs and impressive lichen-decorated slabs of pink granite lying in rhythmic arrangements. There are trails branching away from the summit parking lot which lead to varied overlooks with countless composition possibilities. Present yourself here for sunrise (especially) or sunset and you will have an excellent chance of combining colorful cloud formations with rugged landscapes and distant stretches of shining seas.

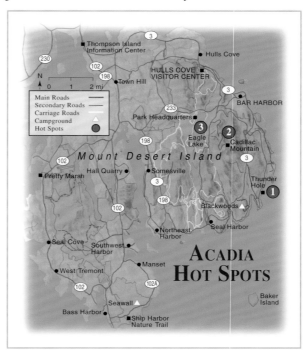

ACADIA HOT SPOTS

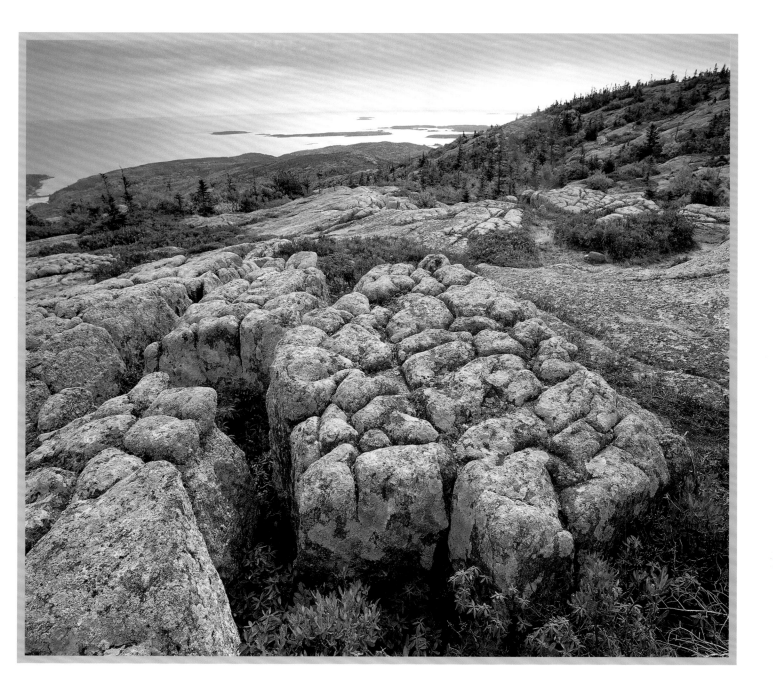

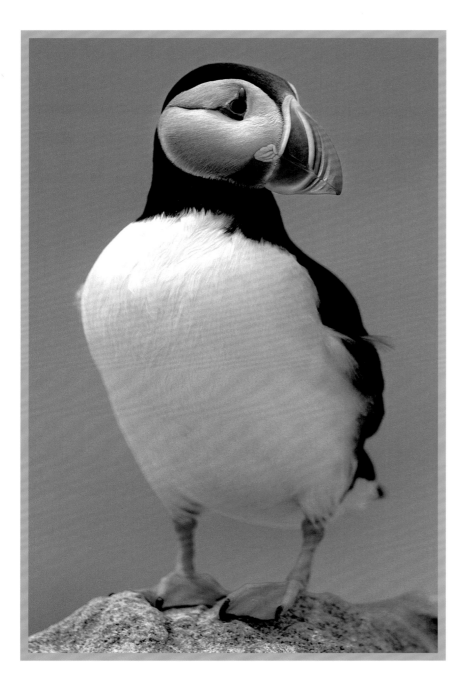

③ EAGLE LAKE. This is the largest body of fresh water in the park. The shoreline is crenulated with inlets, small coves, and swooping bays. In some places it is marshy with emergent vegetation such as cattail and bulrush. In others the water's edge is framed with huge boulders and tipping shelves of granite which disappear into the clear depths. Beginning in early October, you can create images of adjacent mountains and hills aflame with autumn color reflected in the quiet waters of the lake. The best time for mirrorlike reflections is at sunrise (see photo p. 27). Scout for locations where the water's surface is shielded from the wind by rocks or a fallen log. A small protected pool works as well as the entire lake for capturing panoramic reflections.

EXCURSIONS

There are numerous photo destinations outside the park. Maine is known for its lighthouses, quaint fishing villages, rugged coastline, and forested lake-spattered interior. Unfortunately you will not find too many places free of human settlement. The most unique excursion for nature photographers is Machias Seal Island accessed by charter boat from Cutler, a coastal town about two hours by car northeast of Acadia. Machias Seal Island, lying 10 miles off the coast, is a boulder-strewn

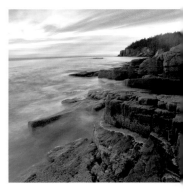

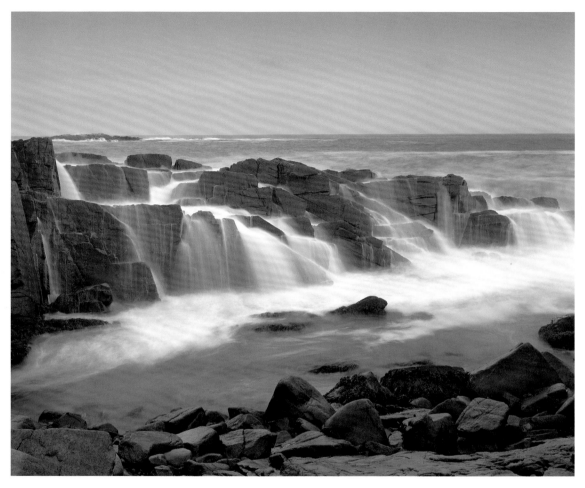

Atlantic Puffin (far left). **Machias Seal Island is the most convenient place in the United States to photograph this seabird engaged in nesting activities (see Excursions). Soft light is necessary to record detail in both the black and white areas of this bird's high-contrast plumage. If possible, schedule your trip for a cloudy day. Bring your tripod, your longest lens, and plenty of film.**

Evening Surf (middle). **The seascapes around Thunder Hole on Mount Desert Island's eastern shore are the most attractive in the park (Hot Spot 1). This simple view was recorded about 10 minutes after sundown. As waves washed over the rocks, I recorded the ephemeral cascades at a shutter speed of four seconds which resulted in the blurred impression.**

Otter Point Dawn (far left). **At sunrise the stretch of shoreline north of Thunder Hole offers good shooting toward Otter Point to the south. Pentax 645, Pentax 45–85mm f/4.5 lens, polarizing filter + split neutral density filter, two seconds at f/22, Fujichrome Velvia.**

nesting refuge for seabirds, most notably Atlantic Puffins, razorbills, and arctic terns. Wooden blinds are erected near the puffin burrows and you can photograph these clownish penguin look-alikes coming to the nest with beaks stuffed full of fish for their hungry young. Normally you will have about three hours on shore but only about 30 minutes in one of the blinds. This is usually plenty of time to get some great photos.

Frame-filling pictures are possible with lenses in the 300–500mm range. Peak shooting season is from the end of June to the middle of July. Try to schedule your trip for an overcast or foggy day which provides the soft light needed for recording these largely black and white subjects. For more information contact Bold Coast Charter Company at 207-258-4484 or check their website at info@boldcoast.com. Have a great shoot!

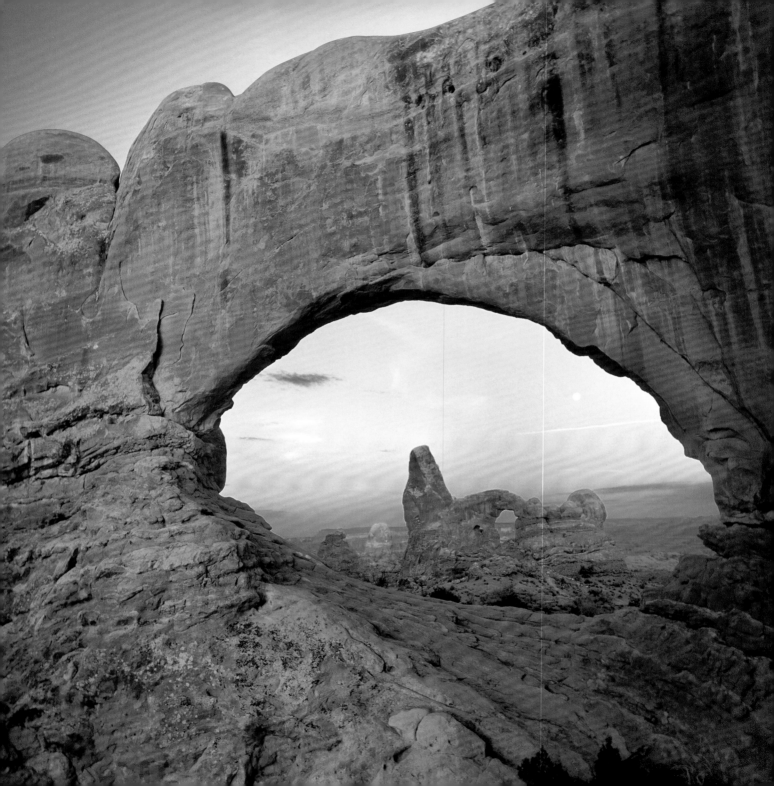

ARCHES

Utah • Winter/Spring/Summer/Fall • 760-440-2331 • www.nps.gov/arch/index/htm

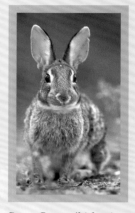

CREATED BY 100 MILLION YEARS of erosion, the unique geology of Arches National Park seems to have been especially created with the interest of photographers in mind. The park area boasts the largest concentration of natural stone arches (mostly red sandstone) in the world (more than 2,000) with spans ranging from three feet to over 300 feet. These formations not only make good subjects in themselves but also are useful as foreground and framing elements for views of the greater landscape filled as it is with redrock canyons, pinnacles, domes, and snow-capped mountains. Although big game specialists will not have much to keep them busy (a few coyotes), close-up enthusiasts will be greeted with

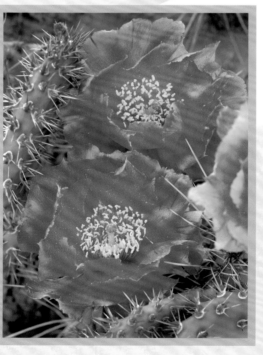

good assortments of desert subjects—wildflowers (in spring and summer), cacti, insects, lizards, birds, and small mammals.

Perched high above the Colorado River, the park's 75,519 acres receives about 1,000,000 visitors each year. The park's only campground is small (52 sites) and operated on a first come/first-served basis. It usually fills by mid-morning from mid-March through October. There are no lodgings within the park. The charming town of Moab, located only five miles south, has several campgrounds, numerous motels and restaurants, and most services. The park's climate is dry with summer temperatures often surpassing 100°F and winter temperatures dropping below freezing with light snow not uncommon. Although photography is excellent here

Desert Cottontail (above). **These common subjects must be approached cautiously and photographed with lenses in the 500mm range. Here a ground-level perspective throws the background attractively out-of-focus.**

Grizzly Bear Cactus (left). **These beautiful subjects bloom in late May and early June (Hot Spot 1). This bouquet was photographed in the shade of an umbrella at midday.**

Turret Arch through North Window (far left). **This line-up of arches and moon was taken with a zoom lens. A polarizing filter darkened the sky and reduced overall contrast for better detail in both highlight and shadow areas (Hot Spot 4).**

Courthouse Wash (above).
**In appropriate seasons,
low areas along Court-
house Wash west of the
main park road provide
opportunities to shoot
wildflowers, cacti, and var-
ied sandstone formations
reflected in quiet pools and
stream eddies . Both sun-
rise and sunset provide
attractive light on major
landforms (Hot Spot 5).**

all year, the best shoot-
ing season is probably
spring when tempera-
tures are cooler and the
landscape is decorated
with wildflowers (annu-
als in April and May,
cacti in May and June).
In summer, cloud
buildup late in the day
creates conditions for
dramatic, fiery skies at
sunset. The willows and
cottonwoods along
Courthouse Wash show
their best fall colors in
late October and early
November. Winter of-
fers freedom from crowds and the opportunity to
capture terrain dusted with snow.

GENERAL STRATEGIES

As is usual with most landscape work, you will want to
restrict shooting sessions to periods around sunrise and
sunset when the light is warm and soft. The more
clouds there are above the subject the longer you can
keep shooting. Don't neglect twilight periods when the
sun is below the horizon. Obviously a tripod will be
necessary to steady the camera during the long expo-
sures such conditions require. Early morning is the best
time to concentrate on photographing small animals

such as desert cottontails and pinyon jays which are
common around campground and picnic sites. During
midday, you can target macro subjects such as cacti
and, if it is not windy, wildflowers. Tactics here require
you to shade the subject from direct sunlight to reduce
contrast and bounce in auxiliary accent light with a
white reflector (see photo p. 33).

The park is roughly bisected by a paved 18-mile
road which provides relatively easy access (via foot
trails and short side roads) to the most photogenic
arches and other unique rock formations. Trailheads for
all major geologic attractions can be reached by car in
less than an hour from either the park campground or
the town of Moab. A pleasant and productive routine is
to plan on shooting a single major attraction (one of
the arches, for example) at each sunrise and sunset pe-
riod. Schedule your shoot so that the main landscape

Twilight Sunflowers (left). Clumps of sunflowers bloom in the Courthouse Wash area in late spring (Hot Spot 5). Soft, rosy light floods the area after sunset and before sunrise, normally periods of stillness when long exposures can be used to record motionless flowers in sharp detail. Pentax 645, Pentax 35mm lens, polarizing filter + split neutral density filter, eight seconds at f/16, Fujichrome Velvia.

Lupines and Dunes (far left). These red sand dunes are found alongside the northeast side of the main park road below the Fiery Furnace. In spring the dunes are dotted with wildflowers (mostly lupines), colorful foreground subjects that establish scale and anchor the composition. Sunset is the best time to shoot here.

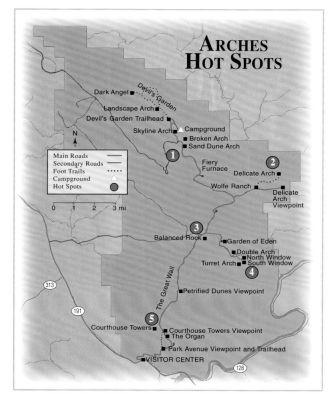

ARCHES HOT SPOTS

Dark Angel ■
Devil's Garden
Landscape Arch ■
Devil's Garden Trailhead ■
Skyline Arch ■ ▲ Campground
■ Broken Arch
■ Sand Dune Arch
N
① Fiery Furnace
Delicate Arch ■
Wolfe Ranch ■
Delicate Arch Viewpoint
②

Main Roads	
Secondary Roads	
Foot Trails
Campground	●
Hot Spots	●

0 1 2 3 mi

③ Balanced Rock ■
■ Garden of Eden
■ Double Arch
North Window
Turret Arch ■ ■ South Window
④
The Great Wall
313
191
■ Petrified Dunes Viewpoint
⑤ Courthouse Towers ■
■ Courthouse Towers Viewpoint
■ The Organ
■ Park Avenue Viewpoint and Trailhead
▲ VISITOR CENTER
128

close-up studies and a backpack for carrying your equipment on longer hikes, particularly the challenging uphill trek to Delicate Arch, the park's signature landscape feature and a not-to-be-missed photo opportunity.

PHOTO HOT SPOTS

The selection of hot spots described below are well-known favorites, but there are many other arches and unique rock formations in this park to photograph. Your success with landscapes will depend primarily on timing your shoot for the best light. Both luck and persistence determine whether your photos are blessed with skies filled with clouds, valuable picture elements which add interest to the composition as well as soften light for better highlight and shadow detail.

① **CACTUS PATCH**. Although you will find cacti scattered everywhere in the park, this convenient spot has thick growths of grizzly bear and prickly pear, as well as other species. It stretches for several hundred yards along the west side of the main park road north of the Salt Valley Road turnoff. This flat sloping bench is screened from the noise and wind of passing vehicles by an embankment. The cacti here normally bloom in late

The Organ (far left). This distinctive sandstone tower is flanked by various wildflower species in spring. These paintbrushes were brightened by light reflected from a white, handheld reflector.

Prickly Pear Cactus (below). A zoom lens permitted tight framing of this trio of lush blooms (Hot Spot 1). The even lighting results from shading the scene with an umbrella and reflecting light onto the flowers with a white reflector.

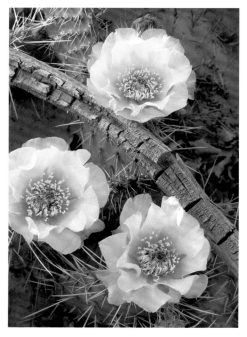

feature is illuminated from the front or side. (A compass is often valuable in determining such lighting angles.) Spend the middle part of the day exploring potential sites, establishing upcoming tripod positions, and working on close-up subjects.

At Arches you will be able to make good use of most of the equipment in your bag. Although wide-angle lenses will likely do most of the landscape chores, longer focal lengths up to super telephoto will come in handy for everything from isolating a distant arch on the horizon to making portraits of butterflies and lizards. Don't forget to bring a reflector for

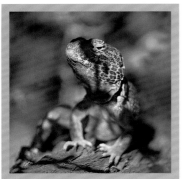

Collared Lizard (above).
Look for lizards sunning themselves on rock piles and outcrops throughout the park. These speedy, wary reptiles should be approached straight-on in slow, cautious stages. Use your longest lens equipped with an extension tube for close focusing.

Balanced Rock (right). **On sunny days with no clouds, try to be in position so that you can shoot just as the rising sun is bisected by the horizon. As shown here, the light at this time is warm, soft and yields good shadow detail. Unfortunately, the effect lasts only a few seconds. Compelling impressions of classic park monuments can be taken from afar as key elements of compositions based on interesting foreground features (Hot Spot 3).**

May and early June (see photos p. 33, 37).

❷ **DELICATE ARCH**. The signature landform of the park, this most elegant of all the arches is perched precariously on the edge of a sandstone basin. Delicate Arch Viewpoint provides a long range (0.5 mile) view of the landmark. For closer views you have to hike the 1.5-mile trail which begins at the Wolfe Ranch parking lot. The trail is steep but relatively smooth and takes about 45 minutes to climb. The arch is best photographed at sunset and you should give yourself a two-hour head start so that you have time to rest from the hike and orient yourself to the picture possibilities. As you reach the top, the view opens suddenly to reveal for the first time the arch standing on a smooth, sloping rock shelf. The La Sal Mountains, snow-capped for much of the year, decorate the eastern horizon. Five miles to the south, the rock features of the Windows area lineup in miniature along the canyon rim. You can use the arch to frame either of these distinctive land-

scapes. Be careful when working near the arch itself as the rock table drops off several hundred feet. Be sure to take your tripod, a polarizing filter, and lenses from ultra wide-angle to 200mm (see photo p. 39).

❸ **BALANCED ROCK**. The park road winds right past this obvious landmark. A foot trail circles the attraction but it is too close and low to show the teetering slab in context of its beautiful setting. The best camera angles are directly across the road to the northwest about 100 yards from the main parking area on an expanse of slickrock studded with junipers (see photo below).

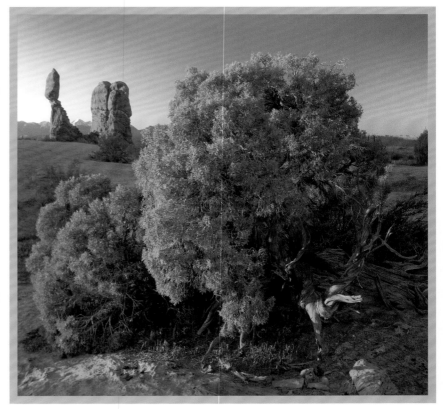

❹ THE WINDOWS. In this section of the park there are photo opportunities both early and late in the day accessible from numerous trails. The best tripod spots are at the very end of the paved access road where four major arches are grouped within a small area. Here you will find the classic view of Turret Arch through North Window (another arch). To orient yourself to the scene, first hike up and stand inside the North Window (the largest arch easily seen from the parking area). Here you will see the camera position you want—about 20 yards to the north across a small chasm, a dangerous scramble that is now closed. To get across, you must hike around North Window in a counterclockwise direction (takes about 15 minutes) and come up to the position from below. Be careful, as a bit of climbing is still necessary and a serious fall is possible. This is a sunrise shoot best recorded with wide-angle to normal focal lengths (see photo p. 32). For precise framing, a zoom lens is needed due to the restricted shooting area which you will find on top of a large boulder.

❺ COURTHOUSE WASH. There are numerous attractions in this tree-lined arroyo. In spring, you can shoot the Organ, a towering red sandstone projection, with foregrounds of sunflower or red paintbrush (see photo p. 36). Spring (April/May) and monsoon season (August/September) are good times to shoot reflections of rock formations in the trickling streams and pools of the wash (see photo p. 34). Be prepared for deer flies when it is wet. In fall, cottonwoods and willows fringing the stream display bronze and gold tints.

Arches National Park is next door to Canyonlands National Park and Deadhorse Point State Park, two grand photo locations described in the Canyonlands section that you should not miss. Have a great shoot and watch out for the cactus!

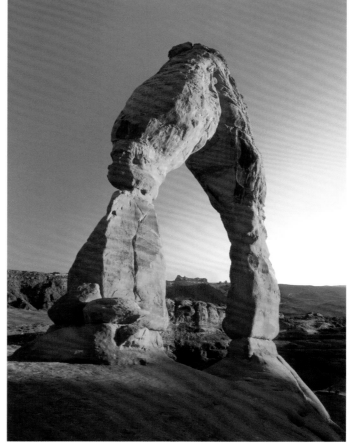

Delicate Arch (left). **This graceful vault of Entrada sandstone (over four stories high) is the most popular photography site in the park (Hot Spot 2). You can walk up to, and even inside, the arch for a variety of camera angles. Try to schedule your shoot for an evening when partially cloudy conditions are forecast. If you are lucky, the setting sun will paint the clouds above the arch in rosy tints. (This may not happen until several minutes after sunset.) Be sure to take a flashlight to find your way back down the trail in the dim twilight. This rendition was taken a minute or two before sunset with a wide-angle zoom lens which allowed precise framing of the arch and distant landforms.**

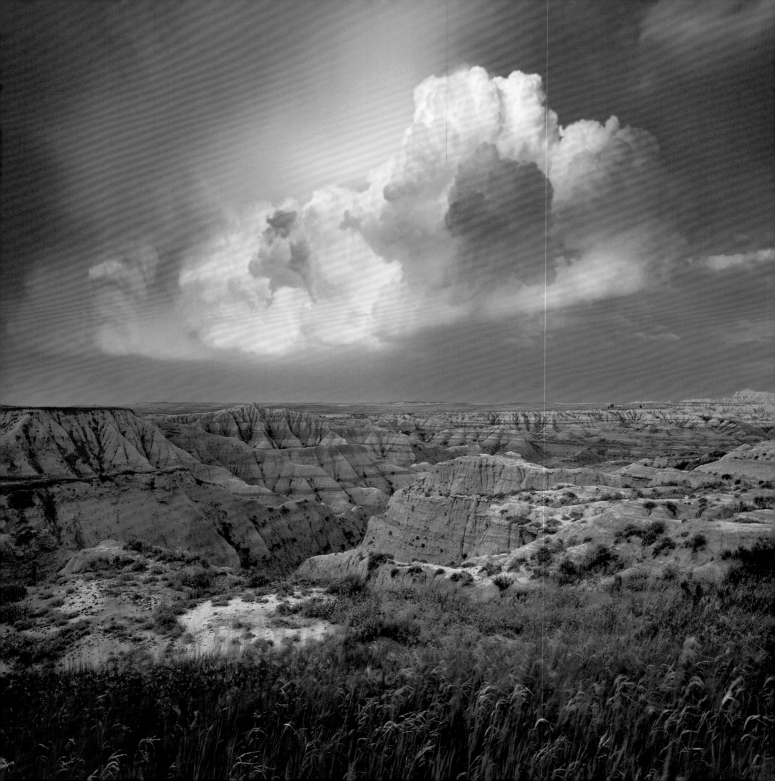

BADLANDS

South Dakota • Spring/Summer/Fall • 760-440-2331 • www.nps.gov/badl/index.htm

BADLANDS NATIONAL PARK encompasses 244,000 acres of wilderness prairie—undulating expanses of green gouged by a mysterious, tinted architecture of jumbled gullies, valleys, buttes, pinnacles, and spires. The exotic landforms, rich colors, and changing skies beckon the landscape photographer above all others. The park also offers opportunities to record the natural history of the largest protected mixed-grass prairie ecosystem in the United States. Wildflowers, cacti, native grasses, and prairie dogs are reliable close-up subjects.

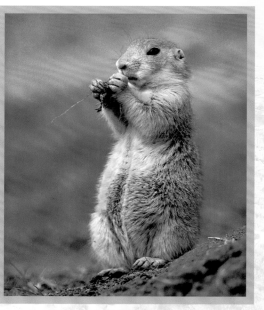

Although there are small numbers of pronghorn and bison in this park, wildlife shooters will find far better hunting in two equally beautiful adjoining parks in the Black Hills less than an hour's drive to the west. Wind Cave National Park and Custer State Park are strongholds for prairie mega fauna—bison, pronghorn, mule and white-tailed deer, and coyote, not to mention a plethora of prairie dogs. Except for the pronghorn, these animals are conditioned to people, especially those in vehicles, and can be photographed readily if caution is exercised. Unlike Badlands, these parks boast no exotic landforms. Their scenic beauty resides chiefly in a dynamic interplay of expansive prairies and dramatic skies. Although the Black Hills are impressive geologic structures, their photogenic assets are subdued by a cloak of dark coniferous forest. However, thunder storms and fiery summer sunsets add the accents necessary for prize-winning pictures, especially in more open terrain.

There are handy stores, gas stations, restaurants, and lodgings in the small towns adjacent to these parks, as

Black-eyed Susans (above). Midday sunlight can be used effectively for wild-flower portraits provided you position the camera for backlight. Subjects will appear spotlit by framing them against a shaded background. This species blooms in June and July near the visitor center.

Prairie Dog (left). For the best results when shooting this Badlands specialty, position your camera at ground level and shoot with your longest lens set at maximum aperture for out-of-focus backgrounds that will emphasize the main subject.

Sunset Cloud Show (far left). In summer storm clouds often form over Badlands terrain in late afternoon. This is a typical view from Badlands Loop Road recorded just as the sun was setting.

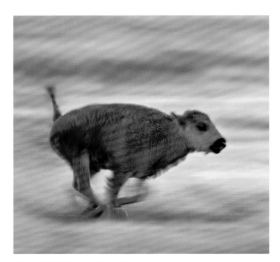

Bison Calf (above). **In early summer, sturdy bison calves sprint through the herds to strengthen their legs. It's easy to snap blurred motion shots of the action using slow shutter speeds (1/15 or 1/30 second) and panning. This exuberant youngster was recorded in Wind Cave National Park.**

Bison Bull (far right). **During the summer rut, these bad-tempered behemoths strike a variety of photogenic poses.**

Wind Cave Grassland (right). **Early summer brings dramatic cloud formations to Badlands. Cue your landscape efforts to these features.**

well as campgrounds convenient to top shooting spots within the parks themselves (available on first-come/first-served basis at Badlands and Wind Cave). Badlands and Custer have lodges. Crowds are rarely a problem. June into early July is the best time to visit, although fall is also wonderful. In early summer you have a trio of attractions: lush prairies dotted with wildflowers, the frisking of bison, pronghorn, and prairie dog newborns, and thunder storms which dramatize the sky with rolling towers of cloud and intensify the rainbow tints of the Badlands with torrential downpours. July marks the beginning of the bison rut when gigantic bulls bellow, plow up the prairie with horns and hooves, and battle one another in dust-raising head-to-head battles. September offers the most pleasant shooting conditions with fair skies and temperatures much moderated from the sweltering levels of August.

Badlands and its

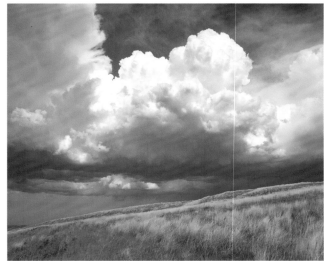

two neighboring parks provide diverse subjects requiring a full selection of equipment from extreme close-up accessories to long-range telephoto lenses (500–600mm). Be sure to bring a bean bag support or window mount to steady telephoto lenses when shooting wildlife from your vehicle. You will find a small, white reflector useful on sunny days for brightening the shadows of frame-filling flower shots.

GENERAL STRATEGIES

If you are arriving by air, Rapid City is the most convenient staging location. For visits of 10 days or longer, make your first destination the Black Hills region. Spend a few days exploring and photographing wildlife in Wind Cave and Custer parks. Then move camp to Badlands National Park for a few days of landscape and wildflower shooting. Finish your trip off back at Custer and Wind Cave to catch all the great shots you missed on your first attempt. If you can stay only a week or less, cover the three parks in a circular route in either direction.

In Badlands National Park, you will find by far the best and most easily accessed landscape views in the Sage Creek and

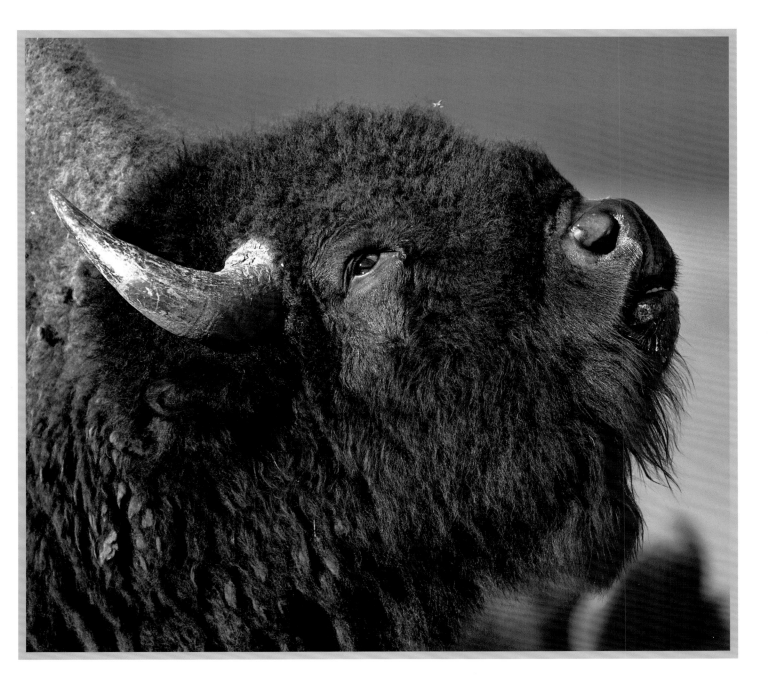

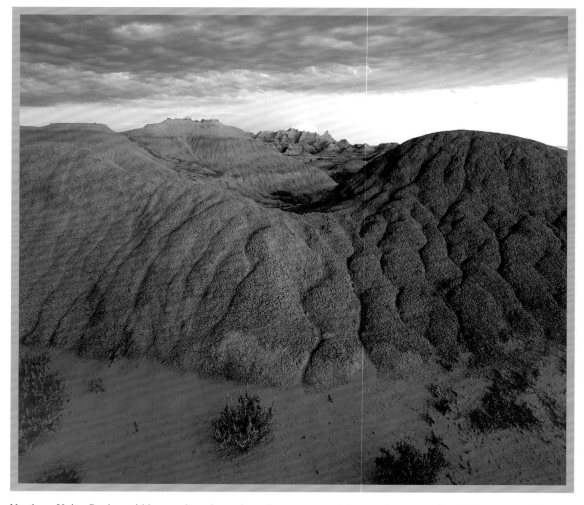

Castle View (right). **This intriguing foreground terrain is found about 1.5 miles east of the Journey Overlook picnic area on both sides of the road (Hot Spot 2). Sidelighting is usually ideal for landscape scenes. It models major geologic features and accentuates textures of foreground elements. The effect of a polarizing filter is also maximized, resulting in denser color in the sky. Pentax 645, Pentax 45–85mm f/4.5 lens, polarizing filter + split neutral density filter, 1/2 second at f/22. Fujichrome Velvia.**

Northern Units. During midday, explore the park road north of Cedar Pass, the Badlands Loop Road (both paved), and the Sage Creek Rim Road (gravel) for tripod locations appropriate for sunrise and sunset. Then be on location in plenty of time to capture the best light. When not preoccupied with recording dawn and dusk theatrics, you can work on wildflower and grass compositions and prospect for landscape possibilities.

PHOTO HOT SPOTS

There are many exciting Badland roadside views (mostly toward the south) from the northeast entrance all the way to the Sage Creek area. Hike around both designated and non-designated overlooks to discover

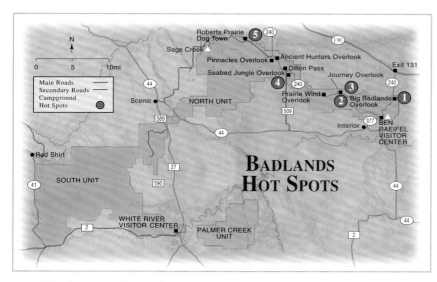

BADLANDS HOT SPOTS

look best from this vantage point in late afternoon until past sunset (see photo p. 44).

❸ GRASSY MOSAICS. Subtle patchwork patterns of mixed-grass prairie can be photographed from the east edge of Journey Overlook picnic area. Windless, twilight periods before sunrise and after sunset provide the best opportunities for recording these variations of green with an occasional wildflower accent.

compelling line-ups of interesting foreground, midground, and distant features, including clouds.

❶ BIG BADLANDS OVERLOOK. The first overlook you will encounter upon entering from the northeast off Interstate 90, this vantage point provides a sweeping view of typical Badland formations. It is a good sunset location although sunrise may also be rewarding depending on cloud conditions. Climb down over the edge of the slope to target foreground elements.

❷ CASTLE VIEWS. Interesting terrain about 1.5 miles east of the Journey Overlook picnic area off Badlands Loop Road provides framing features for views of the Castle, a distinctive geologic formation in the park. Sculpted humps serrated by cracked mud patterns are found within 100 yards of the road along both sides. The Castle (and nearby ridges and pinnacles)

Gaillardia Patch (above). These showy flowers are found in foothills habitat during summer. This portrait was made with a telephoto zoom lens at its closest focusing distance. For more color saturation, a white reflector was used to bounce light into the face of the closest bloom.

Badland Terrain from Badlands Loop Road (below). Numerous unmarked locations along both the Sage Creek Road and Badlands Loop Road offer compelling scenic views. This grassy projection is 0.25 miles east of Changing Scenes Overlook. An elevated camera position (the top of my motor home) allowed me to bring the grassy point and Badland terrain together in the composition.

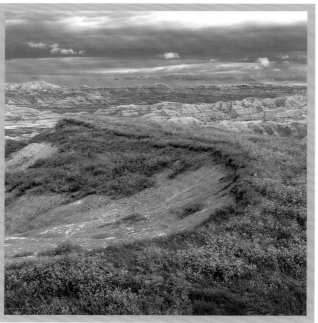

Wind Cave National Park Prairie (below). **This scene drew my attention only because of the clouds which I knew would light up with rosy color for a few minutes after sundown. The moon was shifted into this twilight landscape from another part of the sky by double exposure.**

④ **SEABED JUNGLE OVERLOOK**. This roadside stop confronts a concentration of red, yellow, and copper colored hills and hummocks (yellow mound paleosols) offering abstract design possibilities. Best times are around sunrise and sunset and on an overcast day after a shower when the colors become especially vibrant.

⑤ **ROBERTS PRAIRIE DOG TOWN**. A good spot to shoot people-habituated prairie dogs is on Sage Creek Rim Road about five miles west of the paved Loop Road. Arrive at the dog town before sunrise and set up a tripod with your longest lens and extension tube combination near a burrow. Choose a spot away from passing cars on the periphery of the colony (avoid walking among the burrows) that will provide front lighting. Keep the tripod low (this will isolate the prairie dog against a soft background) but stay high enough to shoot over foreground vegetation (see photo p. 41). Try to include some wildflower color in the frame. Keep still and patiently await the appearance of these personable rodents a little after sunrise.

EXCURSIONS

Excursions to these two nearby parks are convenient, pleasant, and as photographically rewarding, especially for wildlife enthusiasts, as Badlands National Park.

WIND CAVE NATIONAL PARK

You might want to try shooting the subterranean attractions at Wind Cave. No tripods are allowed below ground so all photography of the dim interior must be done with flash. For me, the real attraction here is topside where the park's

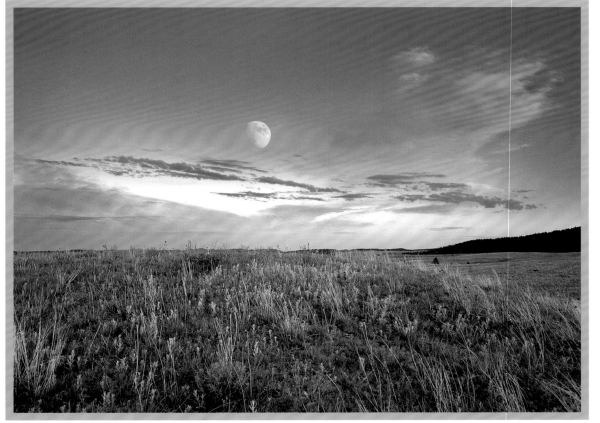

28,000 acres of beautiful mixed-grass prairie provide a realiable environ to photograph bison, prairie dog, and pronghorn. One of the best of the numerous prairie dog towns is at the junction of Highways 385 and 87. There are often bison around the towns and sometimes they roll about on the bare turf created by the digging rodents, stirring up clouds of dust that look especially dramatic when back-lit early and late in the day. Park Service Roads 5 and 6 (dirt) are great areas for shooting deer, bison, and especially elusive pronghorn, weather permitting.

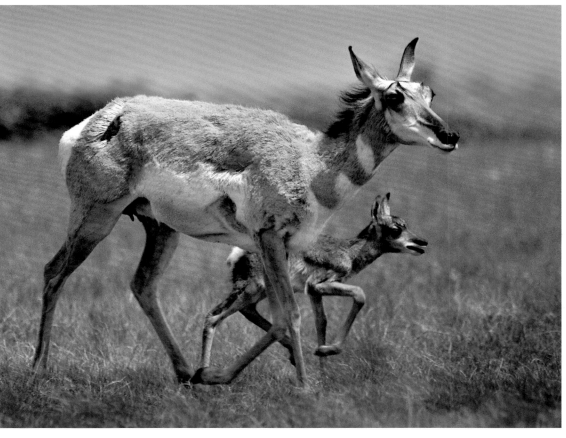

CUSTER STATE PARK

The highlight of Custer State Park (even larger than Wind Cave) is the 18-mile Wildlife Loop Road, a quiet byway which winds through rolling park lands, conifer-clad uplands, and open prairies. Here you will have opportunities to shoot large herbivores either from your car or on foot (both methods are effective). Exercise caution when working near bison, especially females. Drive the loop each day both at sunrise and sunset to capture these roving bands in dramatic light and appealing settings. For individual subjects, work for endearing portraits or interesting behavior. Check out the overlooks along the winding roads within the Black Hills for scenic potential, especially when skies are enlivened with clouds. You may catch a glimpse of some of the 500 elk that find refuge in these coniferous forests. Huge boulders at the northern end of Sylvan Lake can be recorded in the warm light of dawn in mirror-like reflection before the waters are disturbed by visitors to this popular camping and recreation location. Have a great trip!

Pronghorns (above). **These wary subjects are best photographed from a vehicle with a long telephoto lens steadied by a bean bag or window-mount support. I happened on this mother and young fawn while cruising Wildlife Drive in Custer State Park in the late afternoon.**

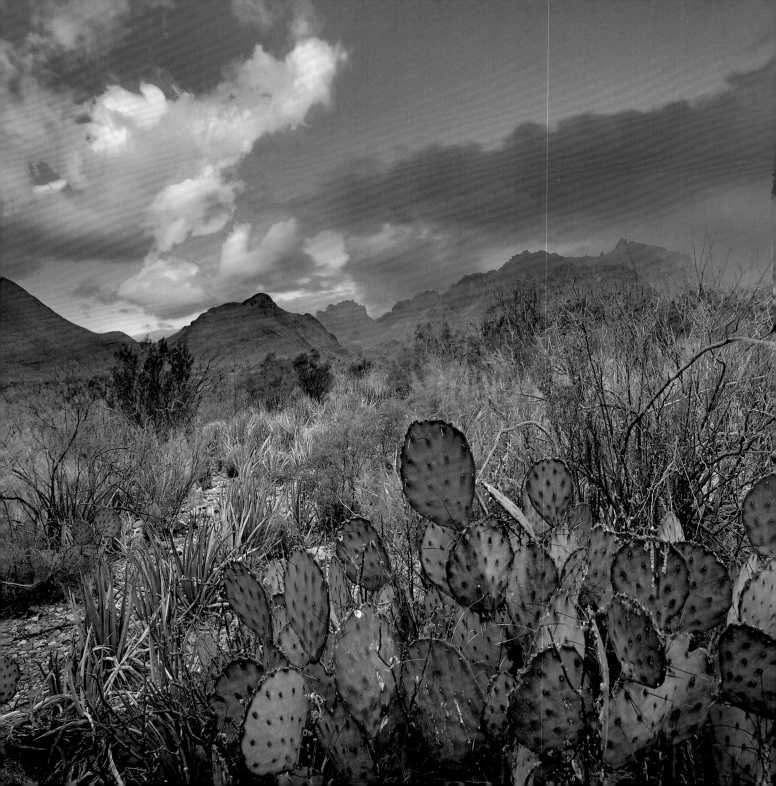

BIG BEND

Texas • Fall/Winter/Spring/Summer • 760-440-2331 • www.nps.gov/bibe/index.htm

Near Rio Grande Village (above). **Dramatic vistas are found throughout the park. Set them up with interesting foreground features like this clump of prickly pear.**

BIG BEND RANKS near the top of national park photography sites. It offers stunning scenery, gorgeous flora in all seasons, several easily-approached wildlife species, pleasant weather, and no crowds except during holidays. It is neglected by photographers only because of its isolated location in southern Texas.

At over 800,000 acres, Big Bend is the eighth largest park in the lower 48 states. Its varied terrain includes the rugged Chisos Mountains soaring to 8,000 feet, expanses of cactus and creosote-studded Chihuahua desert spread over tilting planes, and dark echoing canyons of the Rio Grande. Its dramatic southern horizons are dominated by the rugged, silent prominences of Mexico's mountains and plateaus. This remote park is nestled in the great south-dipping curve of the Rio Grande River, here a shallow flow that forms the border between Texas and Mexico.

There are numerous attractions for photographers during much of the year. First on the list is the park's diverse topography. It is anchored by the Chisos Moun-

tains, a pocket of bare rock sculptures lying completely within park boundaries. Convenient paved roads penetrate the Chisos Mountains for intimate takes on individual peaks and wander through peripheral foothills to provide distant profile and silhouetted views. Packed with impressive spires, the range is compact—a

Chisos Mountains East of Panther Junction (far left). **A 20mm wide-angle lens set at f/22 and placed close to the prickly pear cactus imparted depth to this scene (Hot Spot 2).**

Chisos Mountains from Desert Mountain Overlook (left). **This pre-sunrise view from the west side of the Chisos (Hot Spot 6) was shot with a tripod-mounted 500mm lens. I tripped the shutter with a cable release to avoid camera-shake during the two-second exposure at f/16.**

Yucca in Bloom (above).
These beautiful succulents begin to bloom in February, a great time to schedule your visit.

Desert Marigold (right).
Low and close is the formula for successful wildflower portraits. Out-of-focus backgrounds are the key to emphasizing the main subject.

View from Green Gulch Road (far right). **This is an excellent early morning location (Hot Spot 4) with dramatic light, impressive mountain profiles, and Havard agave foregrounds.**

beautiful one-hour drive separates the sunrise shoot on the east side from sunset shoot on the west side. The Chisos are surrounded by a collection of photogenic topographies—canyons, desert plains, and the Rio Grande Valley.

Big Bend's terrain supports a surprising variety of animals and plants—1,200 species of flora and more species of birds (about 350) than any other national park. Cooler temperatures and greater rainfall in the mountains support northern tree species such as trembling aspen and bigtooth maples which add fiery color in autumn to the green palette of their southern relatives—pinyon pine, juniper, and oak. The river floodplain, crowded with cottonwoods and willows, winds like a green ribbon through the surrounding desert. This oasis is frequented by diverse bird species both resident and migratory—vermillion flycatchers, summer tanagers, painted buntings, cardinals, sandpipers, killdeer and other varieties you would not expect to find in this arid country. Away from the mountains and river, verdency gives way to tawny desert, much of it sprinkled with lush collections of grasses, cacti, yuccas, and shrubs. In years of adequate

rainfall, wildflowers spring from the gravel expanses, washing the broad landscape with lupine blue and mustard yellow.

Although Big Bend offers good photo opportunities all year long, late winter and early spring are usually the best times to visit. Temperatures are pleasantly warm (highs in the 60's) yet there is chance for an attractive dusting of snow. Skies are often rumpled with cloud. Although predictions are difficult, annual wildflowers usually bloom through February and March when there is ample rain. In April most of the cacti are in bloom, punctuating vistas with their saturated petals. Spring is also the best season for bird photography; migrants are moving through the park and resident species are in peak plumage and singing on territory. Late summer is a time of afternoon thunderstorms accompanied by dramatic atmospheric effects. In autumn, mountain areas and bottomlands are enlivened with the changing color of deciduous species.

The park has all necessary facilities for visitors. Campgrounds are operated on a first-come/first-served basis only and may be full during Thanksgiving, Christmas, and spring-break periods. Weather changes quickly. Be prepared for both cold/hot and wet/dry conditions. Call park headquarters or check their website for help planning your trip.

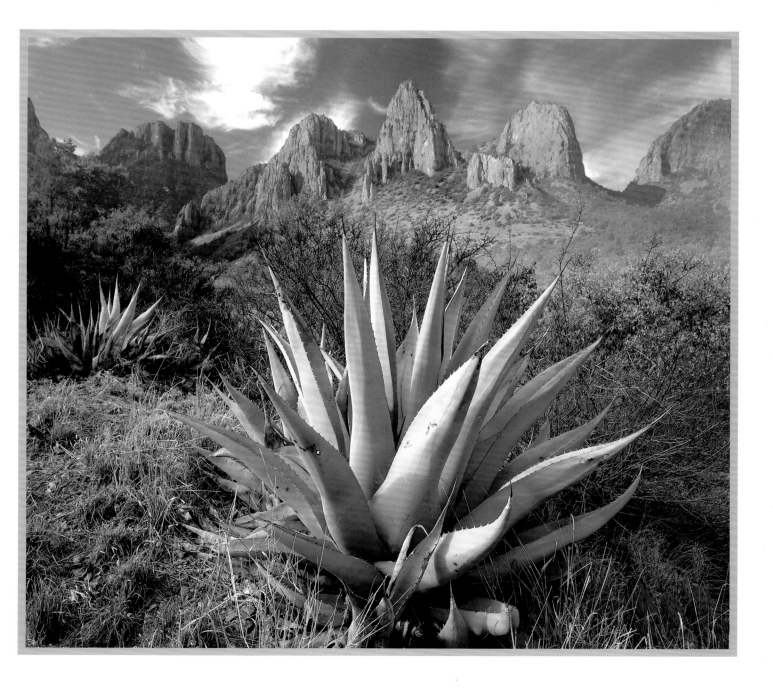

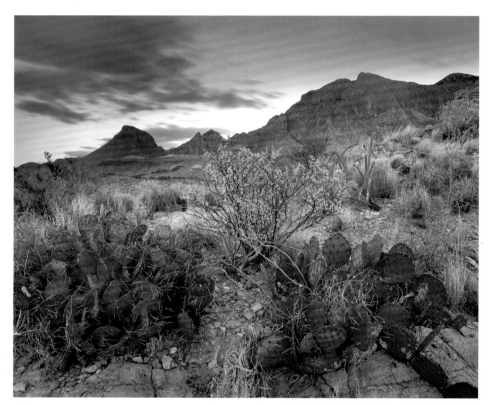

Chisos Mountains from Ross Maxwell Scenic Drive (above). **Colorful vegetation abounds in Big Bend even outside the flowering seasons. This soft, warm light resulted from shooting just as the sun was dropping over the horizon in the evening. The density of the sky was held with a one-stop split neutral density filter (Hot Spot 5).**

bases. The most popular area is the Chisos Basin where there is also a lodge. Here you can photograph numerous attractions, particularly the Chisos Mountains and their associated flora, as well as other geologic formations scattered over the desert foothills nearby. The other two sectors are centered on the Rio Grande at the terminus of park roads. To the west is the settlement of Castolon, flanked by two imposing rock monuments—Cerro Castellan and the twin peaks of the Mule Ears. Castolon is also the gateway to the Santa Elena Canyon, a famous landmark that is not photogenic due to its deep, dark interior and northern exposure. The campground at Castolon is a good place for shooting birds attracted to irrigated meadows and riverine habitats. On the park's eastern side is Rio Grande Village, a haven for wildlife with a skyline punctuated by the Sierra del Carmen of Mexico and nearby Boquillas Canyon, another well-known landform that is shrouded in high-contrast light much of the time.

GENERAL STRATEGIES

As in most desert parks, you will want to shoot early and late in the day when the light is soft enough to hold detail in both shadow and highlight portions of the scene. During midday I investigate locations to determine precisely where I will set up the tripod. This reconnaissance is especially important for dawn sessions when it is too dark for effective exploration prior to the curtain-call of sunrise.

This large park can be divided into three shooting sectors, all with campgrounds that you can use as

PHOTO HOT SPOTS

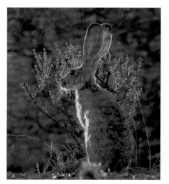

Following are descriptions of my favorite photo locations listed from east to west. Aside from these great sites there is a multitude of

other possibilities to discover on your own.

❶ RIO GRAND VILLAGE CAMPGROUND. This is an excellent place to shoot roadrunners, javelinas, and jackrabbits which wander confidently among the camp-sites. Telephoto lenses of 300mm and over provide adequate magnification. During nesting season in spring you can set up near a roadrunner's nest (a dinner plate-sized compaction of twigs less than 10 feet from the ground in a shrub or cactus). Use a long lens and stay back so as not to disturb the bird.

❷ EAST OF PANTHER JUNCTION. There are great sunrise views of the Chisos Mountains along the Rio

Mule Ears from near Mule Ears Viewpoint (left). To reach this high vantage point (Hot Spot 6) requires a cautious walk through clumps of spiky lechuguilla. I used a three-stop split neutral density filter to equalize the brightness be-tween the spot-lit peaks and the cactus which was grow-ing in deep shade. Precise framing was afforded by a zoom lens. When exposure times are long (in this case four seconds) cacti, tree trunks, rocks, and other objects unaffected by the wind are the best choices for creating detailed fore-grounds.

Jackrabbit (far left). The long, translucent ears of the jackrabbit make it an ideal subject for back-lighting. For correct exposure, take a close-up or spot reading from an average shaded area of the scene. Shoot an extra frame at 1/2 stop under your base setting. Canon T90, Canon 500mm f/4.5 lens, 1/125 second at f/4.5, Fujichrome 50.

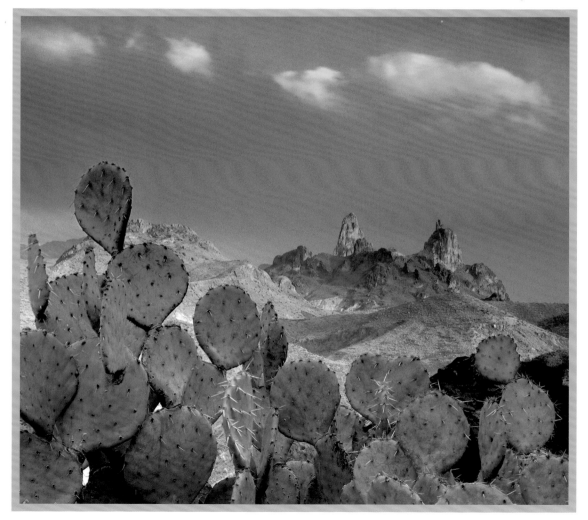

Grande Village Road from this junction eastward for five or six miles. Set up the scene with an interesting foreground element such as a cactus, rock outcrop, or clump of wildflowers and keep your fingers crossed for an attractive buildup of cloud (see photo p. 48).

③ BALANCED ROCK AT GRAPEVINE HILLS. This geologic balancing act is best recorded in early morning both before and after sunrise. Take the Grapevine Hills road (bumpy but OK for cautious two-wheel driving in dry weather) for about six miles until you come to the small parking lot on the northeast side of the road. Take

before dawn, especially on your first visit. There isn't much maneuvering room in front of the window so camera angles are limited. On clear days the ideal position picks up Nugent Peak in the center of the window— you can't miss it in clear weather (see photo p. 54).

④ CHISOS BASIN. Nestled in the heart of the Chisos Mountains and accessed by a winding, narrow paved road, this alpine enclave is the focal point of much park activity and offers an array of photographic opportunities from both roadside and trailside. This is a good area to record landscapes using beautiful Havard agaves as foreground features for the panorama of ridges and peaks. You will find dramatic side-lit views of the Chisos (with agave foregrounds) in early morning from the basin road as it begins climbing out of Green Gulch (see photo p. 51). Carmen Mountain white-tailed deer wander through the village and campground area and make easy targets for telephoto lenses.

⑤ THE DIKES. Ridges of reddish sedimentary rocks (dikes) project from the foothills east of Ross Maxwell Scenic Drive. These formations make excellent

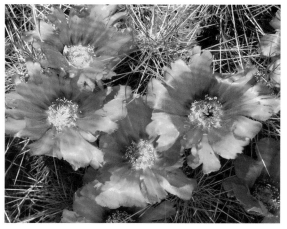

Strawberry Hedgehog Cactus (above). **Big Bend's many cactus species are excellent floral subjects because they remain still in the wind. A small white reflector will brighten shadow areas naturally for better color.**

Window Rock at Grapevine Hills (far left). **This view usually picks up distant Nugent Peak through the rock frame, but when I took this photograph the peak was hidden in fog. I shot with a zoom lens from atop a boulder about 20 feet from the window (Hot Spot 3). Pentax 645, Pentax 45–85mm f/4.5 lens, polarizing filter + color enhancing filter, one second at f/22, Fujichrome Velvia.**

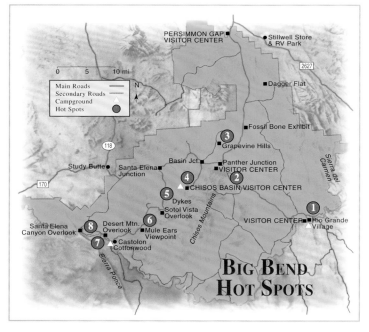

PERSIMMON GAP VISITOR CENTER

Stillwell Store & RV Park

2627

Dagger Flat

0 5 10 mi

Main Roads
Secondary Roads
Campground
Hot Spots

N

118

③ Grapevine Hills

Fossil Bone Exhibit

Study Butte

Basin Jct.

② Panther Junction VISITOR CENTER

Santa Elena Junction

④ CHISOS BASIN VISITOR CENTER

170

⑤ Dykes
Sotol Vista Overlook

Chisos Mountains

Sierra del Carmen

VISITOR CENTER ① Rio Grande Village

Santa Elena Canyon Overlook

⑧ Desert Mtn. Overlook

⑥ Mule Ears Viewpoint

⑦ Castolon Cottonwood

Sierra Ponce

BIG BEND HOT SPOTS

the braided trail to the end of the canyon. Then be sure to follow the signed, winding trail up the wall to the window which is only recognizable from one vantage point. This hike takes about 30 minutes so leave well

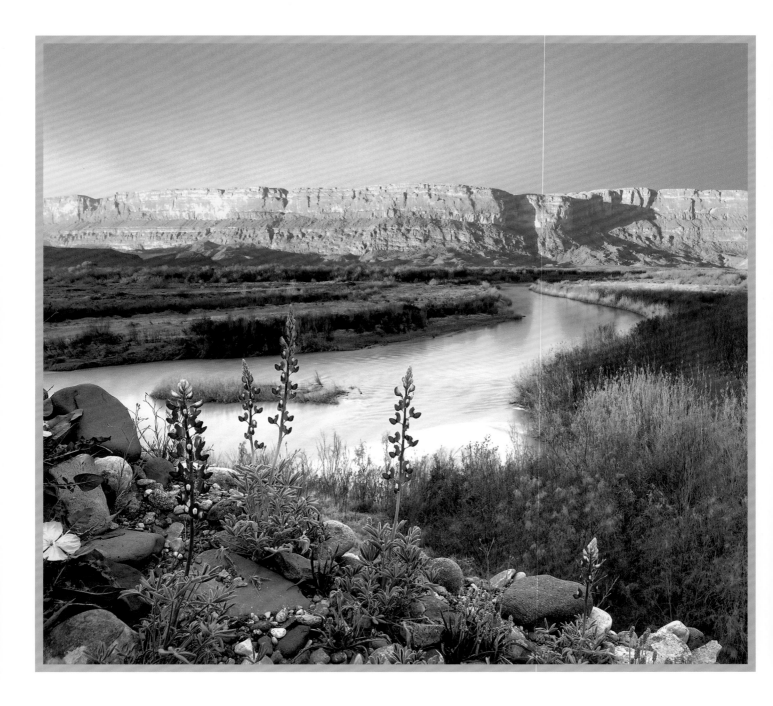

counterpoints to the western face of the Chisos late in the day. Park at the Fins of Fire Exhibit and allow at least 30 minutes to make your way across the creosote flats, through the arroyos, and up the steep slope to the top of the dikes (see photo p. 52).

⑥ MULE EARS VIEWPOINT. Late afternoon throws the best light on these awesome rock spires. The most accessible camera position is found a few hundred yards along the trail that begins at the northeast corner of the parking lot heading east. Follow the trail until it climbs to the top of a gentle rise which opens the view to the Mule Ears. Better foregrounds are to be found a few hundred yards southeast of the parking lot near the top of a massive boulder butte whose walls are decorated with cacti and wildflowers in spring. Although it seems close, schedule an hour to climb into position (much of the route is plagued with skin-piercing lechuguillas) and find a foreground frame (see photo p. 53).

⑦ DESERT MOUNTAIN OVERLOOK. This signed roadside overlook a few miles west of Castolon offers interesting perspectives on the Chisos Mountains in early morning when mists separate the range into stacked ridges. Be there for sunrise and isolate the rock patterns with a telephoto (see photo p. 49).

⑧ RIO GRANDE AND SIERRA PONCE. There are several locations along the road between Santa Elena Canyon Overlook and Desert Mountain Overlook to shoot the river against the backdrop of Mexico's Sierra Ponce. The imposing ramparts are side-lit attractively in early morning. Spring sets out wildflowers (mostly lupines) for foreground interest and autumn offers the bronze of mid-ground cottonwoods and willows (see photo p. 56).

This short list of hot spots only hints at the photographic opportunities to be found in this magnificent park. Happy exploring and good shooting!

Rio Grande and Sierra Ponce (far left). A polarizing filter darkened the sky and removed reflections from vegetation in this scene (Hot Spot 7) for better color saturation. Lighting effects change quickly as the sun rises and sets, especially on rugged terrain. To capture the "decisive moments" you have to be prepared to work quickly. Filters, film, and extra lenses should be handy and ready for instant use. In this respect, a vest works better than a bag.

Roadrunner (left). When shooting wildlife, remember to position the camera at the subject's eye level. Once you have taken a record shot or two, adjust for the best background. For this roadrunner, I repositioned the 500mm lens with 1.4X teleconverter to include the prickly pear cactus, symbol of the bird's desert habitat (Hot Spot 1).

CANYONLANDS

Utah • Fall/Winter/Spring/Summer • 435-719-2313 • www.nps.gov/cany/index.htm

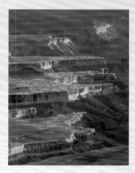

Green River Canyon (above). **This abstract view taken from the Green River Overlook (Hot Spot 5) was cropped tightly with a tele-photo zoom lens to include the most uniform features of the pattern of protruding sandstone bluffs.**

Red Paintbrushes (left). **This saturated bouquet was recorded adjacent to the Shafer Trail Overlook in late May. The blooms were shaded from direct sunlight to achieve a soft, low con-trast lighting effect. Accent light was bounced into the scene with a white reflector.**

Mesa Arch (far left). **Canyonlands most famous photo stop (Hot Spot 3), this sunrise version pre-sents tight framing of the elegant vault and the classic formations which it frames.**

PROTECTING A HUGE AREA (337,598 acres) of re-mote wilderness, Canyonlands National Park offers photographers the most diverse collection of landscape motifs of any of the Southwestern parks. A far-flung re-gion of deep canyons, sheer-drop mesas, staircase benchlands, and soaring sandstone spires all dabbed in varying tints of white through rust to black, its precipitous vistas rival the Grand Canyon and its exotic geology is first cousin to that of nearby Arches. Vegetation is sparse over most of this desert habitat. Uplands are clothed in pinyon pine and juniper and river banks are fringed with willow and cottonwood. Photographers will be at-tracted to the assortment of wildflowers and cacti which are sprinkled over the landscape. Although

the park is home to desert bighorn sheep and mountain lion, you are not likely to see these species. But your long-range equipment will be useful for targeting liz-ards, butterflies, chipmunks, pinyon jays, cottontails, and other diminutive members of the close-up world, as well as landscape vistas depicted in compressed, layered patterns.

The park is composed of three sections whose boundaries are carved out of the rocky landscape by the Colorado and Green Rivers. Isolated from one another, each section is accessed by a separate, dead-end road which snakes inward from the park periphery. On the southeast side of the Colo-rado River is The Needles section (about 90 minutes from Moab—the commer-cial center for visitors to Canyonlands). This is the

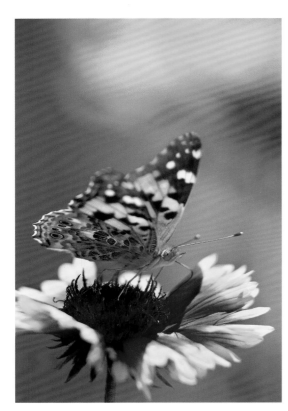

Painted Lady Butterfly on Gaillardia (above). **This hungry specimen was shot alongside the main park road at The Needles with a 100–400mm zoom lens and +2 diopter close-up lens. For improved detail, a white reflector bounced light into the shaded underside of the insect. A low camera angle and large aperture generated attractive blurs of harmonious foreground color.**

most developed part of the park with a visitor center and campground hosting 26 sites available on a first-come/first-served basis (fills in the morning March to October). Less than two miles from the visitor center and just outside the park boundary is Needles Outpost with a small store (limited supplies), café (very limited menu), and campground. The Needles is known for its maze of canyons, arches, spires, and buttes. Unfortunately, the most appealing attractions can be reached only by four-wheel-drive vehicles or hikes of several miles. If neither of these options suits you, there are worthwhile photo opportunities within a few minutes of the main road to keep you busy for several days.

Sandwiched between the Green and Colorado Rivers and looming over the northern reaches of the park, Island in the Sky is a grand, flat-topped, tree-studded mesa offering the park's most accessible and dramatic shooting opportunities. About 45 minutes from Moab, it is bisected by a paved road which meanders past numerous overlooks, each offering a heart-stopping view of hundreds of

square miles of unearthly, river-carved terrain thousands of feet below. About one mile north of the visitor center, the Shafer Trail Road (high-clearance, two-wheel-drive vehicles) leaves the mesa's rim and drops 1000 feet in a series of tight, jaw-clenching switchbacks to the White Rim, a massive bench of rock which encircles Island in the Sky. Here the road branches, the south fork circling the mesa atop the bench and the north fork dropping another 1,000 feet to the Colorado River. Facilities at Island in the Sky include a visitor center and small campground (12 sites available on a

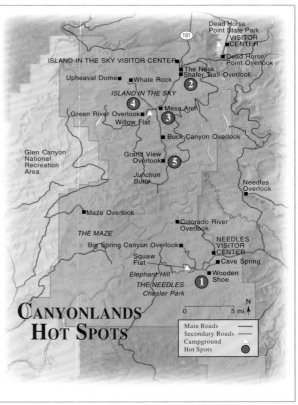

CANYONLANDS
HOT SPOTS

first-come/first served basis, no water). There is another campground nearby at Deadhorse Point State Park with 21 campsites (reservations 435-259-2614). Both campgrounds fill early in the day during spring and fall. Open camping on Bureau of Land Management property is available nearby.

On the west side of the Green and Colorado Rivers is The Maze district, Canyonlands' most remote and least visited sector. This labyrinth of multi-hued rock canyons is accessible only by four-wheel-drive vehicle and/or extensive hiking, much of it over unmarked trails. Thorough preparation is necessary before mounting an expedition into this area. Those interested in photographing some of the finest Indian pictographs in

View from Shafer Canyon Overlook (below). **The sky in this predawn landscape composition was reduced in brightness with a two-stop, split neutral density filter to reduce contrast and increase color saturation and shadow detail (Hot Spot 2).**

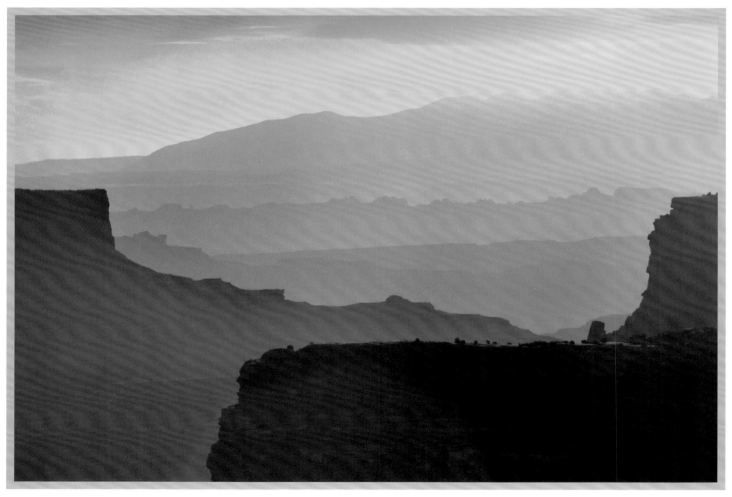

Sego Lilies (above). **These sculpted blooms, photographed near the Shafer Trail Road, are one of many beautiful species in Canyonlands which usually appear in April and May. Diagonal arrangements of blossoms result in strong compositions. The area of sharpest focus should usually be placed on the pistils and stamens.**

shapes and colors, and magnificent sunsets. Rainwater accumulates in pothole basins, providing opportunities for shooting reflections. Discomforts aside, August probably offers a greater potential for prize-winning photos than any other time of the year. Fall color makes its appearance along rivers and streams during October, although skies tend to be laser clear and lacking distinction. Any of the winter months may see an attractive dusting of snow over this rust and tawny tinted wilderness.

You will be wise to take a full selection of equipment to Canyonlands, including a reflector for close-up work. Fine-grained, saturated films, such as Fujichrome Velvia will produce the highest quality results of this panoramic offering of primarily still-life subjects.

North America may want to visit Horseshoe Canyon, a separate unit of the park, also on the west side.

Every season offers something unique. Spring, with its pleasant weather, light crowds, and burst of wildflower color is the favorite shooting period. May and early June provide a combination of both flowering cacti and herbs. Summertime brings a lot more people, sweltering weather, and biting insects. On the positive side, high temperatures also stir up thunderstorms which energize landscape photos with spotlighting effects, rainbows, warm shafts of sunlight, clouds of all

GENERAL STRATEGIES

On your first visit to Canyonlands, plan on shooting at The Needles section about 20 percent of the time, saving the bulk of your visit for Island in the Sky. If you wish to photograph The Needles more extensively, a four-wheel-drive vehicle is necessary (available for

rent at Needles Outpost). Thus equipped, you will want to explore the Salt Creek Road which twists for 13 miles past wildflowers and cottonwoods before reaching the 1/2-mile hiking trail to Angel Arch, one of the most beautiful stone formations in the park.

Your shooting at Canyonlands will no doubt be mixed with photography at Arches National Park, which is situated between The Needles and Island in the Sky. An efficient itinerary is to begin your shoot at The Needles, then move north for your work at Arches, finishing up at Island in the Sky. If at all possible, stay in campgrounds rather than commuting long distances from a motel in Moab (for Island in the Sky) or Monticello (for The Needles). Plan on shooting one

major landscape attraction each morning and evening, spending the middle part of the day checking out precise tripod positions for your upcoming shoot and photographing close-up subjects. Good areas for working with spring wildflowers are alongside any of the paved byways, the Shafer Trail Road at Island in the Sky, and the gravel road

leading up to Elephant Hill in The Needles. When making predeterminations for landscape sessions, be sure that the starring geologic feature(s) will be lit from the front or side (a compass is helpful in checking angles). Back-light is best reserved for silhouetted motifs set off against fiery backdrops of sunrise or sunset. Look for interesting foreground elements and strong midground forms, if this area is not already occupied by your center of interest.

PHOTO HOT SPOTS

Canyonlands is an immense park whose photographic attractions are yet being discovered. In addition to the sites described here, be sure to conduct your own searches for new and exciting subjects.

❶ WOODEN SHOE ARCH. One of the most distinctive landmarks in The Needles, Wooden Shoe Arch is an excellent sunset destination (see photo this page). A good vantage point with many foreground design components

Wooden Shoe Arch (above). **Unique landscape features can be emphasized by leading the eye to them using other elements of the composition, in this case, the overhanging rock. Such natural design factors are commonplace once you become aware of their utility. Small rocks or trees often work just as well as large ones. To attain this view (Hot Spot 1), it was necessary to lower the camera to near ground level.**

North Six Shooter Peak (left). **This tripod location is off the beaten track atop a small rock bluff near Wooden Shoe Overlook in The Needles. The shot was made a few minutes after sundown, a time when clouds become painted with warm pastel hues.**

Green River Overlook (below). **This naked juniper projects from the mesa's edge about 50 yards west of the main viewing area (Hot Spot 4). It makes an arresting foreground subject to frame landscape features in the distance. To insure that all parts of the scene are sharp, shoot at minimum aperture (f/22 or smaller) and adjust focus to a point slightly beyond the most significant foreground element.**

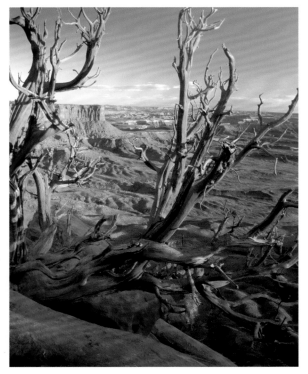

—overhanging sandstone ledges, tiered pillars, and patterns of strewn boulders—lies about 1/2 mile off Salt Creek Road. This elevated rock terrace can be reached with a short hike up a dry wash lined with cottonwoods and willows and an easy scramble across a jumbled slickrock incline. The unmarked access point is on the south side of Salt Creek Road 1/4 mile before it rejoins the main park road at its southern terminus.

❷ **SHAFER CANYON OVERLOOK.** This lofty roadside viewpoint 1/2 mile past the visitor center at Island in the Sky awards the early rising photographer with misty, overlapping ridges and mesas of the Colorado River Canyon hugging the looming contours of the La Sal Mountains. A telephoto zoom lens isolates the patterns created by this interplay of atmosphere and solid rock. The best shooting period begins about 15 minutes before sunrise (see photo p. 61).

❸ **MESA ARCH.** Canyonlands' signature photograph depicts this graceful sweep of Entrada sandstone, a scene conspicuous on numerous postcards, calendars, and posters (see photo p. 58). The well-marked 1/2 mile trail to the arch begins about six miles south of the visitor just off the main park road. You can walk right up to the arch which hangs a little higher than eye level on the sheer cliffs of Island in the Sky. Various spires, towers, and even an arch are visible through this beckoning, rust-tinged frame of gnarled rock. In winter, when the La Sal Mountains are snow-covered, they also become one of the arch's featured attractions and are best portrayed in the soft, front-light of late afternoon. By-and-large, however, this shooting adventure should be conducted at sunrise when the first shafts of light transform the belly of the arch into a vault of glowing neon. Numerous designs are suggested by the interplay of arch, distant landforms, and light and you will want to shoot from different camera positions with a variety of focal lengths. The shooting site is restricted and you will likely have to share territory with other photographers. Don't fret; the glow lasts 10 minutes or more and you should have ample time to record your best ideas. The exposure conditions are tricky with back-light, high-contrast subjects, and perhaps even sun shining directly into the lens. Choose a full-screen average or evaluative metering pattern and then bracket one stop over and under the automatic exposure setting in half-stop intervals.

❹ **GREEN RIVER OVERLOOK.** This viewpoint, adjacent to the Willow Flat campground, offers grand vistas of the great canyons carved by the Green River. It is suitable for shooting both at sunrise and sunset. You can't control the weather, but do your best to be on site when low clouds and thunderstorms are hanging

over the canyons. This spot offers a selection of intriguing pinyons, both dead and alive, just west of the main viewing platform that can be used to frame the view (see photo p. 64).

⑤ GRANDVIEW POINT OVERLOOK. This location presents unmatched panoramic views of both the Green and Colorado River canyons. A beautiful two-mile hiking trail skirts the mesa's precipitous rim, winding through clumps of fragrant pinyon and juniper, past patches of wildflowers and around jumbles of boulders and slickrock, all of which can be incorporated into photographs of the wider landscape. This site has much to offer both late and early in the day.

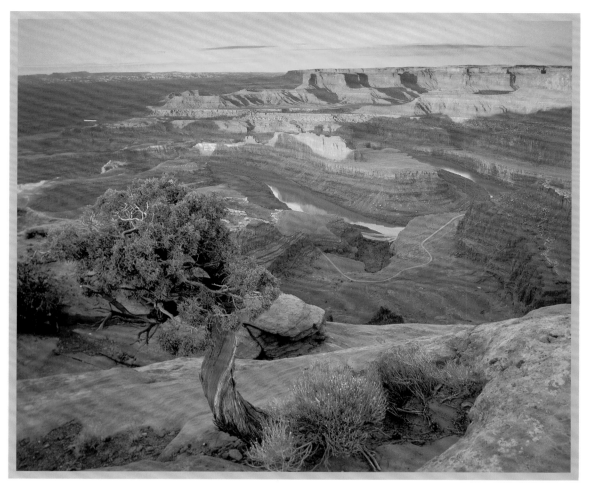

EXCURSIONS

This corner of Utah has a surfeit of photographic attractions in addition to the national parks. One of the best is Dead Horse Point State Park, situated on Canyonlands' doorstep. The main viewpoint looks over the twisted goosenecks of the Colorado River 2,000 feet below. Hike along the cliff to discover a variety of framing elements for this singular scene, attractive at both sunset and sunrise. You will encounter numerous vantage points along the edge of the mesa westward from the main viewing deck. Traversing this jumble of trees, shrubs, boulders, and ledges involves some scrambling so give yourself plenty of time to get into position (see photo above). Have a great shoot!

Colorado River from Dead Horse Point (above).
A polarizing filter will reduce contrast, darken skies, and bring out details of the shaded canyon bottom at this premier shooting site (see Excursions).

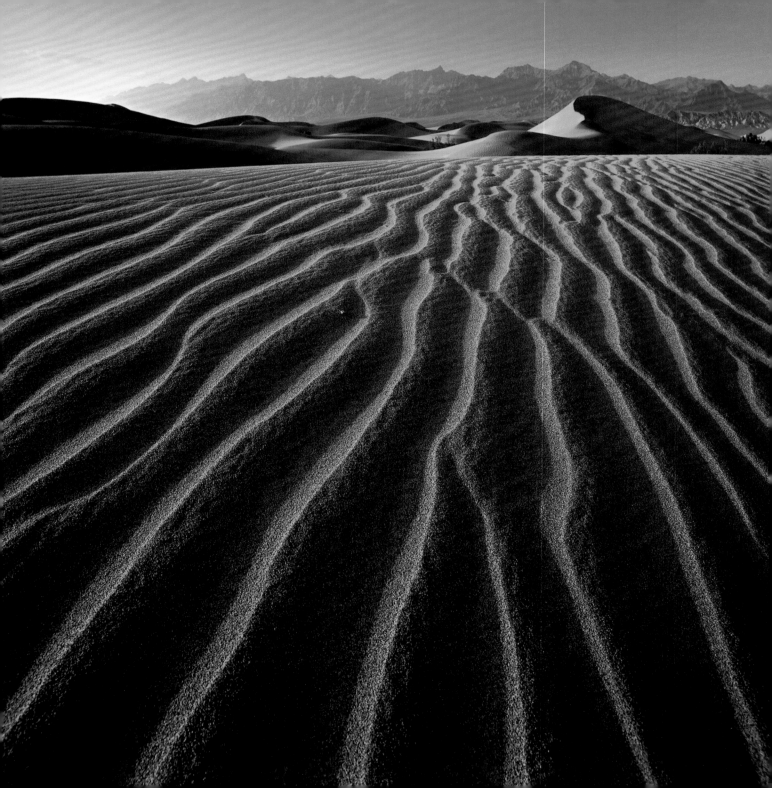

DEATH VALLEY

California • Fall/Winter/Spring • 760-786-2331 • www.nps.gov/deva/index.htm

A LANDSCAPE PHOTOGRAPHER'S dream, Death Valley is the largest national park in the lower 48 states—3,300,000 acres of airy wilderness furnished with tinted mudstone hills, wind-sculpted dunes, twisting canyons, snow-clad peaks, green oases, and table-flat stretches of sand and gravel. This park is not well known for wildflowers, but when conditions are right, the bloom can be outstanding. Although Death Valley is both the hottest (summer temperatures sometimes soar to 130°F) and driest (less than two inches of rainfall per year) spot on the continent, shooting here is pleasant from November through March with warm, blue-sky days and cool, starry nights. Death Valley receives more than 1,300,000 visitors per year but you will rarely feel crowded here.

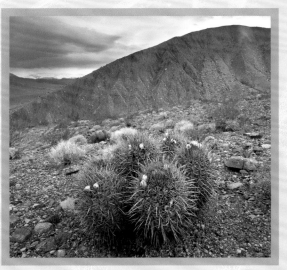

If you intend to stay at one of the lodges, make reservations well in advance—six months if your visit coincides with a holiday weekend. If you intend on camping and need full hookups, you should call ahead for reservations. Otherwise, camping space is ample. If you have any other concerns about what is needed to make your trip successful, check the park's website or give headquarters a call.

The park's beautiful landscapes will draw most of your attention. Wide-angle and zoom lenses and plenty of saturated, fine-grained color film are items you should be sure to pack as well as close-up accessories for flora. Although 350 bird species have been spotted in Death Valley, there are other places where you can photograph them more easily. You won't see much wildlife aside from the odd coyote. If luggage space is limited, you might want to leave your big telephoto lens at home.

The photographic highlight of Death Valley is the stretch of sand dunes near Stovepipe Wells. There is a good chance that your shoot at the dunes will be accompanied by winds and blowing sand, factors which benefit photography but pose a serious hazard to

Coyote (above). **Coyotes are about the only large species you will have a good chance of photographing. This specimen was recorded sniffing about the parking lot at Scotty's Castle. Campgrounds are another hangout for these wily carnivores.**

Mesquite Flat Sand Dunes (far left). **These easily accessible dunes (Hot Spot 5) are the photographic highlight of Death Valley. Endless designs are possible, from close-ups to panoramas. In this photo, a 20mm wide-angle lens placed low and close to these cross-lit ripples created a pattern leading the eye to midground dunes and then on to the distant mountains.**

Cactus Patch (left). **This roadside site (Hot Spot 3) offers numerous cotton-top cactus clumps that turn scarlet during wet weather.**

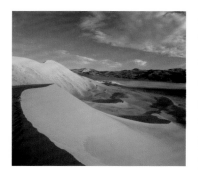

Eureka Dunes (above). **These remote, massive dunes can be most effectively photographed at sunset (Hot Spot 1).**

Desert Sunflowers (right). **I came upon this surprising bloom of annuals along the road to Ubehebe Crater in mid-May. This photo was taken ten minutes before sunrise with an exposure of eight seconds.**

Manly Beacon from Zabriskie Point (far right). **This sunrise photo (Hot Spot 6) was made with a one-stop split neutral density filter + polarizing filter to reduce the brightness of the sky and bring up the detail and color of the shaded foreground. This vantage point is reached by taking the trail at the north side of the Zabriskie Point parking lot which climbs a ridge running out toward the west.**

equipment. Sand will almost surely get into your bag if you rest it on the dunes while shooting, especially if there is wind. A single grain is enough to put a camera or lens out of commission. You shouldn't have any trouble if you work from a camera vest rather than a shoulder bag or backpack. (I use the Lowepro Street and Field system.)

In addition to photographing Death Valley's beautiful landscapes, you will be interested in wildflowers. The peak months vary with elevation and are difficult to predict. Generally, February and March are good bets, but it's best to check with park headquarters periodically to 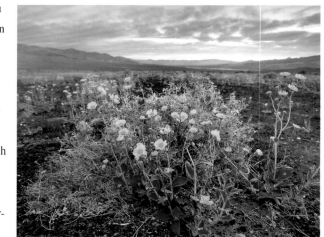 find out how the floral season is progressing. There will be small but beautiful clumps of paintbrushes, mallows, daisies, and other species growing along the roads skirting the valley walls. In rare years of appropriately synchronized rain, warmth, and no wind, flowering annuals spread over large areas.

GENERAL STRATEGIES

Due to habitually clear skies over Death Valley, shooting times are best restricted to brief periods (normally about 30 minutes) at sunrise and again at sunset. Such times offer warm light, soft shadows, and, if there are clouds over the subject, the possibility of a warm show of color as the sun approaches the horizon. Unless it is overcast, lighting conditions are too harsh at other times to expect pleasing results.

The middle part of the day is essential for scouting new locations to determine where your tripod should be positioned to take full advantage of twilight shooting sessions. Plan on shooting but one site each dawn and another each dusk. Some attractions (such as the Mesquite Flat sand dunes) are good subjects at either sunrise or sunset, but most landscapes are suited to one period only—generally those on the west side of the valley should be photographed at dawn and those on the east side at dusk. Schedule your shooting so that the most important feature in your composition is illuminated from the front or side. Driving distances are great here and there is no route that allows the main sites to be covered in convenient sequence. On occasion expect to return to your lodge or campsite well after dark and to set out in the morning when the sky is full of stars. As a general guide, plan to work the park in three sections, scheduling two days or more for each locale—the northern sector

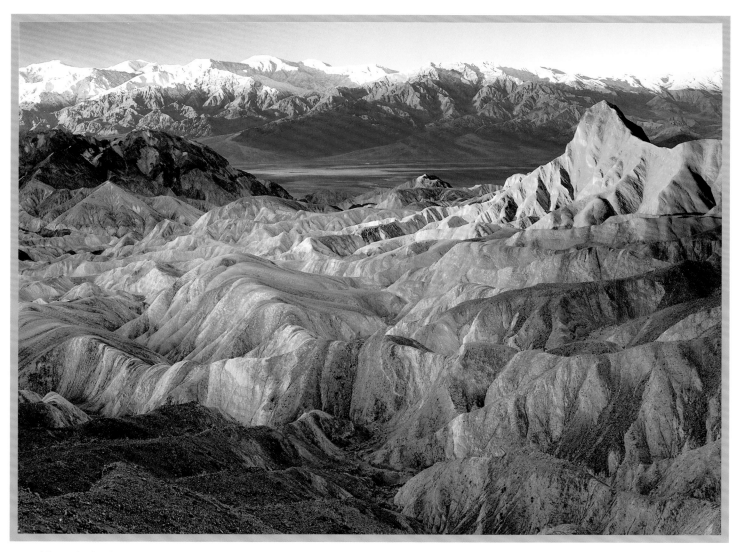

around Scotty's Castle, the central area at Stovepipe Wells, and the southern region near Furnace Creek.

PHOTO HOT SPOTS

These top sites are ordered according to location, north to south. Keep in mind that they represent only a sampling of my favorite highlights that this huge, varied park has to offer. As usual your success will be to a degree dependant on weather.

❶ EUREKA DUNES. These high dunes are about 45

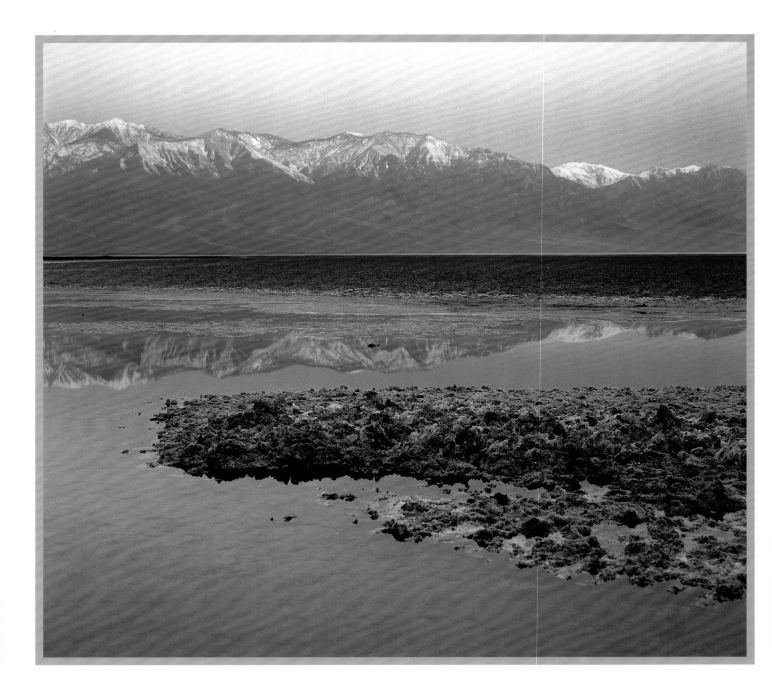

miles from Scotty's Castle—the last 10 miles are over a dirt road. Although sunrise will produce beautiful images, these dunes are best photographed at sunset when the Last Chance Mountains to the east can be included in the background under front-light. A late-day shoot also gives you a chance to scout the area in the afternoon for good camera angles (see photo p. 68).

❷ UBEHEBE CRATER. This distinctive volcanic depression only a few minutes by paved road from Scotty's Castle offers its best face late in the day when the mountains in the eastern background catch the last glow of sunset. Use a two-stop split neutral density filter to equalize the brightness of the sky and the bottom of the crater (see photo p. 72).

❸ CACTUS PATCH. You can find cacti all over the park but the area along Route 267 6.2 miles south of the Mesquite Spring turnoff supports an abundant crop of cotton-top cactus that turn crimson when it rains (see photo p. 67). If it sprinkles, this is your destination.

❹ THE RACETRACK. This dry lake bed lies about 30 miles from Scotty's Castle by washboard dirt road. The route winds through stands of Joshua trees and passes Tea Kettle Junction, a crossroads where travelers leave their worn-out kettles. The lake bed's notoriety springs from rocks which slide about on the mud during high winds, leaving tracks. There is also a rock formation (the Grandstand) in the middle of the valley that resembles bleachers in profile. The moving rocks are found at the south end about 10 minutes by foot from the parking area. The low light of sunrise or sunset is needed to create shadow relief on the rock trails.

❺ MESQUITE FLAT SAND DUNES. These dramatic dunes spread over 14 square miles. People love to climb over the dunes and it takes

Badwater (above and far left). This is an excellent sunrise shooting destination (Hot Spot 7) within easy driving distance of accommodations at Furnace Creek. The main scenic elements to feature are the Panamint Range to the west and its often mirror-like reflection in the shallow pools. Scattered rocks and shoreline shrubs make interesting foreground elements. Move around the shore to access different shaped pools (you'll sink into the muddy bottom if you step in the water). Keep your fingers crossed for clouds over the western horizon the morning of your shoot. The attractive rosy tones of these photos result from shooting during the presunrise twilight period.

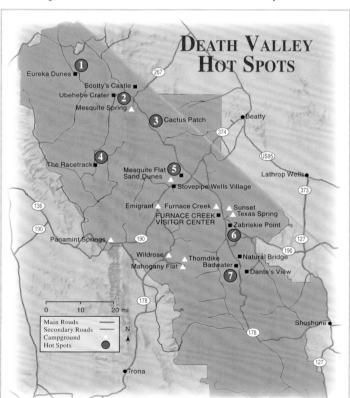

DEATH VALLEY HOT SPOTS

Eureka Dunes ■ ❶
Scotty's Castle ■
Ubehebe Crater ■ ❷
Mesquite Spring ▲
267
❸ Cactus Patch
■ Beatty
374
The Racetrack ▲ ❹
Mesquite Flat Sand Dunes ▲ ❺
■ Stovepipe Wells Village
US95
Lathrop Wells ■
373
136
Emigrant ▲ Furnace Creek ■
FURNACE CREEK ■
VISITOR CENTER
▲ Sunset
Texas Spring ▲
190
Panamint Springs ▲
190
■ Zabriskie Point
127
Wildrose ▲
Thorndike ▲
Mahogany Flat ▲
■ Natural Bridge
190
Badwater ■
■ Dante's View
❻
❼
178
Shoshone ■
178
127
● Trona

0 10 20 mi

Main Roads ———
Secondary Roads ———
Campground ▲
Hot Spots ●
N

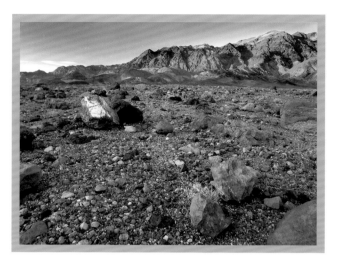

Rock Field and Funeral Mountains (above). **With good light, proper technique, and sound composition, compelling photos are possible in countless locations not described under the Hot Spot section. This location is near Furnace Creek.**

Ubehebe Crater (right). **This attraction (Hot Spot 2) is a difficult subject because of the deep crater's dark interior. I held back the sky's brightness with a two-stop, hard-edge neutral density filter. Pentax 645, Pentax 45–85mm f/4.5 lens, color enhancing filter + split neutral density filter, eight seconds at f/16, Fujichrome Velvia.**

a bit of work to find a stretch that is devoid of foot prints. The dunes are photogenic at both sunset and sunrise. Early morning after a windy evening is especially good for capturing these sandy wastes in pristine condition and decorated with the tracks of nocturnal animals. The best access is from Route 190 on the south side. Crossing the dried mud flats to the heart of the formation takes about 15 minutes. The walking is easy and the caked mud provides interesting foreground patterns for distant dunes. The best light occurs when the sun is just above the horizon and only lasts a few minutes. I like to use curving sand ridges as the main design feature of a composition and to establish foregrounds with side-lit ripple patterns (see photo p. 66).

6 ZABRISKIE POINT. After Mesquite Flat sand dunes, this overlook is the most popular destination for photographers. It is best shot in the morning when the rising sun puts a spotlight on Manly Beacon, a dogtooth projection of tawny rock surrounded by stacked ridges tinted in pastel hues. Behind this smorgasbord of shape and color rests the snow-capped Panamint Range. Great shots are possible from behind the guard rail above the parking lot but I prefer to take the narrow trail north from the lot which steadily climbs westward up a ridge providing a more southerly angle on Manly Beacon. From here picture-taking benefits from stronger polarization of the sky and better cross-light modeling of the terrain (see photo p. 69).

7 BADWATER. This below-sea-level site is one of the few places in the park where you will find permanent standing water. In early morning, the pools cast beautiful reflections of the Panamint Range to the west. It's best to arrive well before sunrise so that you have time to set up to catch the distant peaks as they receive the first rays of the rising sun. I generally use a one-stop split neutral density filter to reduce contrast between the sky and shaded foreground (see photos p. 70, 71).

EXCURSIONS

An easily accessible photo excursion from Death Valley is the Alabama Hills, lying just west of the town of Lone Pine about 80 miles west of Stovepipe Wells. Sprawled beneath the Sierra Nevada range and Mount

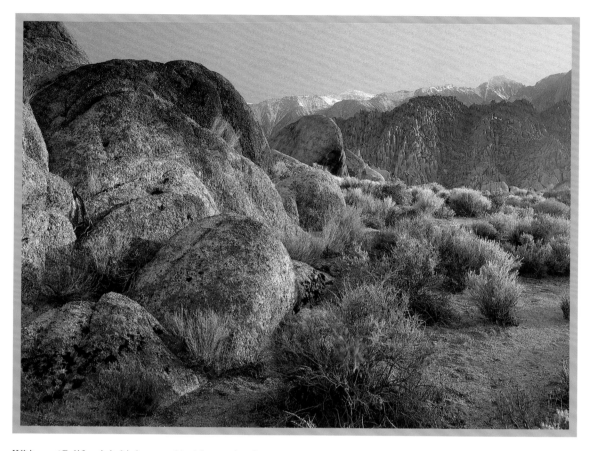

Alabama Hills (left). **You could shoot in this excursion location for days and never exhaust the photographic possibilities. When working on landscapes, I try to set up the scene in four planes—foreground, midground, background, and sky—to give the composition a strong projection of three dimensions. Each plane should exhibit interesting detail to draw the eye further into the scene. Shooting at right angles to the sun (as in this photo) allows a polarizing filter to darken the sky without resorting to the use of split neutral density filters which are not suitable for scenes with an irregular horizon.**

Whitney (California's highest peak), this area has been the setting for over 200 western movies. The terrain is a loose collection of giant boulder piles made accessible by a network of informal dirt roads most of which are suitable for two-wheel-drive vehicles. There are lots of cacti and wildflowers in spring which make interesting macro studies or colorful foregrounds for the spectacular landscape views. Scenics are best shot in early morning when mountain faces are illuminated by the rising sun. Try to arrive in the early afternoon so you can spend an hour or two exploring this area for good shooting locations for both the evening and next-morning shoots. To reach the Alabama Hills, drive west from the center of Lone Pine on Whitney Portal Road for about three miles to Movie Set Road (unpaved) which heads off into the boulder fields to the north and west. There are several National Forest campgrounds in the foothills nearby and motels and restaurants in Lone Pine. Stay cool, have good light, and a great trip!

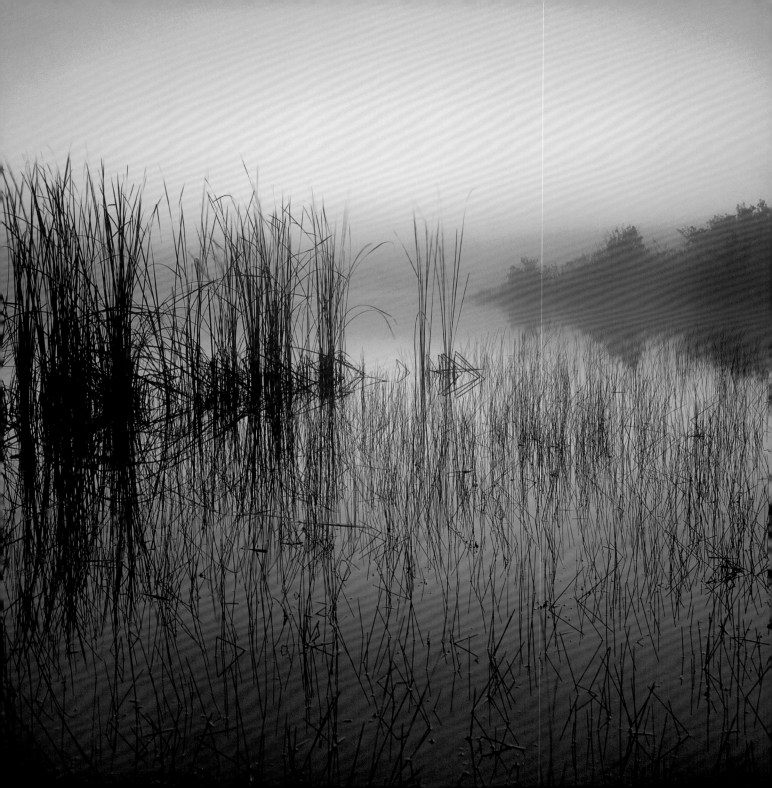

EVERGLADES

Florida • Fall/Winter/Spring • 305-242-7700 • www.nps.gov/ever/index.htm

AMERICA'S THIRD LARGEST national park (1,508,570 acres), Everglades occupies the southern tip of Florida, a region of unrestrained commercial enterprise and gentle nature in retreat. This area was once a paradise of empty white-sand beaches fringed with palms and mangroves. Inland were unbroken forests harboring panthers, black bears, ivory-billed woodpeckers, bald eagles, alligators, and more. Today all of this is gone, save for a few scattered remnants, by far the most extensive being Everglades National Park. Despite protection, the park's natural resources have declined significantly in the last century due to interruptions in the flow of water across its grassy expanses. Nevertheless you will find excellent photography here of both wildlife and landscapes. Pocket preserves north of the park, discussed in the Excursions section, also provide exciting photography. You can commonly shoot a host of creatures—alligators, ospreys, or even endangered wood storks, often without even leaving the road.

This region is foremost a bird-shooter's paradise, offering more than a dozen species of colorful, long-legged wading birds (roseate spoonbill, tri-colored heron, wood stork, etc.) as easy, big-lens targets. Although south Florida is pancake flat, there is much to appeal to landscape enthusiasts: placid lakes, moss-draped forests, cypress swamps, textured dunes, and white-sand beaches sparkling under blue skies. During winter, inland motifs are distinguished by morning mists which shroud features alluringly and funnel the sun's energy into golden shafts.

The best shooting is during the dry season which runs from December through May. March and April are ideal for bird photography when colonial species are performing courtship displays. This is also the height of the dry season when wading birds are drawn to the Everglades to feed on fish that gather in shrinking pools. In this part of Florida, the weather is reliably warm and sunny during winter. The ocean

Roseate Spoonbill (above). **These colorful waders are wary and usually must be photographed with lenses of 500mm and longer in preserves where they are accustomed to people, such as Ding Darling National Wildlife Refuge on Sanibel Island (see Excursions).**

Spider Webs (left). **You can find these delicate hangings in meadows around Sweet Bay Pond during the winter (Hot Spot 2). This image was made with the sun behind the subject and framed so that the background was in shade.**

Sweet Bay Pond (far left). **This seldom visited attraction is best photographed at sunrise when the water is most likely to be perfectly calm and reflective of the colorful eastern horizon (Hot Spot 2).**

Nine Mile Pond (right). **For most early-morning land-scape attempts, I am ready to begin shooting at least 15 minutes before sunrise when some of the most colorful cloud and lighting effects occur. In this location (Hot Spot 3), the most dramatic view, complete with a silhouetted alligator, was displayed a little after sunrise. A one-stop split neutral density filter was used to more closely balance the brightness of the reflection with the sky and produce richer color.**

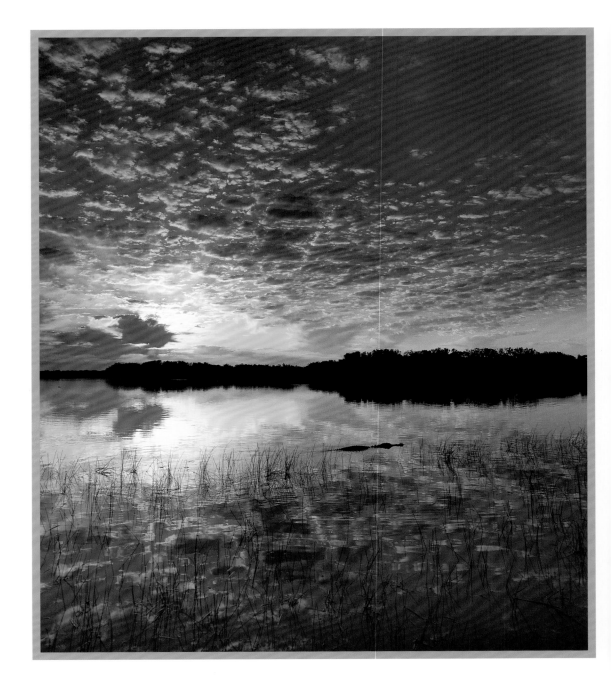

beaches are pleasant and close to prime shooting areas.

Winter is also tourist season so you need to arrange for overnight accommodation, whether it be a campsite or room, early in the day if you are staying outside the park. Inside the park, you should make campground reservations in advance to be sure of getting a site, especially at Flamingo (800-365-2267). In Flamingo you will find a lodge, restaurant, marina, and small store. Call the park or check the website for information.

For birds bring telephoto lenses, teleconverters, a sturdy tripod, and plenty of medium-speed film. You will want extension tubes for your long lenses to shoot frame-filling images of the small, wary alligators and songbirds you will encounter. Be sure to include all of your equipment for scenic photography as well.

GENERAL STRATEGIES

At first glance this park looks like a huge, undistinguished prairie dotted here and there with small bunches of trees (hammocks). Wildlife numbers don't seem to live up to reputation. (Bird populations are down 90 percent from pre-colonial days.) Nevertheless you will soon begin to appreciate the unique and subtle beauty of this sub-tropical ecosystem and discover plenty of subjects to photograph.

I often shoot for a brief time at sunrise at a pre-scouted landscape location and then hastily make my way to a nearby wildlife site where the best shooting begins a little later when the light has strengthened enough to allow action-stopping shutter speeds of 1/125 second or faster with ISO 100–200 films.

It's convenient to photograph the park in three segments. If you are like most visitors and arrive at the park from Miami, your first stop will be the Anhinga Trail at Royal Palm Hammock near the main entrance on the east side of the park. Schedule at least one early-morning and late-afternoon session at Anhinga trail. (Campers will find it convenient to stay at Long Pine Campground.) Move south to Flamingo on Florida Bay for the next not-to-be-missed segment. Here there is good bird shooting at several ponds as well as interesting scenic possibilites on Flamingo Bay. For the third segment, you must

Alligator (above). **This mini-gator was photographed at the edge of Nine Mile Pond (Hot Spot 3). Although accustomed to humans (this area is a regular canoe-launching site), these reptiles must still be approached with caution lest they head for deeper water out of camera range. Canon EOS 3, Canon 500mm f/4 IS lens, 1/500 second at f/4, Fujichrome Provia 100F.**

Wood Stork (left). **I shot this endangered giant just after sunrise on Anhinga Trail (Hot Spot 1) at the southeastern terminus of the boardwalk trail. Pentax 645, Pentax 80–160 f/4.5 lens, split neutral density filter, 1/8 second at f/5.6, Fujichrome Velvia.**

*Preening Roseate Spoon-
bills (right).* **Photographed
at Ding Darling NWR (see
Excursions) along Indigo
Trail, this pink flock
preened calmly while I
photographed from a dis-
tance of about 40 yards
with a tripod-mounted
500mm lens. The long ex-
posure (30 seconds) was
taken about 10 minutes af-
ter sundown.**

*American Oystercatcher
(below).* **For intimate, low-
level views of shorebirds, I
rest the lens on its tripod
collar directly on hard-
packed sand or mud. This
alert specimen was photo-
graphed at Little Estero
Lagoon, a reliable site for
many water-loving species
(see Excursions).**

leave the park and enter through its northern
entrance at Shark Valley. This area is adja-
cent to Big Cypress National Preserve,
another photo attraction with camping facili-
ties convenient to the park. At this point you
are poised to proceed northward to a handful
of wildlife refuges where the shooting is just
as good as that encountered in the park

PHOTO HOT SPOTS

You may encounter wildlife anywhere
along the main park road, especially in late
winter and early spring when birds gather to
feed on marine life concentrated in shrinking
pools. In addition to the hot spots cited, other
areas may be productive depending on season, time of
day, and movement of wildlife.

❶ ANHINGA TRAIL. The most reliable concentration
of wildlife is found along Anhinga Trail near the Royal
Palm Visitor Center. This paved trail and boardwalk
wind through a series of pools teeming
with alligators, turtles, and bird life—
common and purple gallinules, great
blue herons, green herons, snowy and
common egrets, white ibises, wood
storks, and anhingas. The birds are
conditioned to people and surrender
frame-filling views to lenses of
300mm. You will get the best results
with optics in the 500mm range with a
1.4X converter option. Don't become

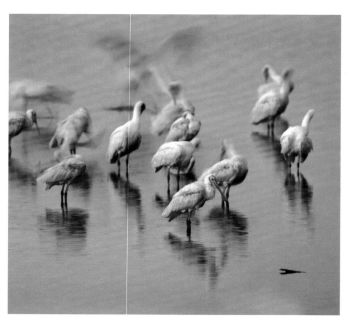

jaded by the easy targets and the assembly of like-
minded photographers. Take your time and work for
interesting angles, pleasing backgrounds, unique poses
and behavior, and dramatic lighting. The best shooting
is at sunrise and on a cloudy day (see photo p. 77).

❷ SWEET BAY POND. This is a sunrise landscape
destination rarely visited by either tourists or photogra-
phers. The shoreline is fringed with rushes that look
beautiful in reflection (see photo p. 74) and the lake
swirls with mist on winter mornings. At times, the sur-
rounding wet meadows are densely hung with large,
dew-laden spider webs and make compelling close-up
subjects once you have finished your landscape shoot-
ing (see photo p. 75). Expect to get your feet wet going
down the muddy trail to the lake and when exploring
along the shore for good shooting angles.

❸ NINE MILE POND.
This large pond offers a thin assembly of the usual wading birds, including spoonbills, although they are not as easy to approach as elsewhere. More important, Nine Mile Pond is a dependable spot to shoot small alligators resting in shallow water near shore just opposite the parking lot. With a cautious approach you can make frame-filling portraits with a 500mm lens plus extension tube combination. These gators also make interesting foreground features for scenes of the lake reflecting fiery sunrise colors (see photos p. 76, 77).

❹ MRAZEK POND. This tiny pool beside the main park road becomes packed with hundreds of birds of a dozen species (wading birds, white pelicans, black skimmers, moor-hens, and ducks) feeding on the pool's marine life for a week or two each winter. The main congregation takes place in early morning. Timing of the phenomenon is difficult to predict but March is your best bet. You can check

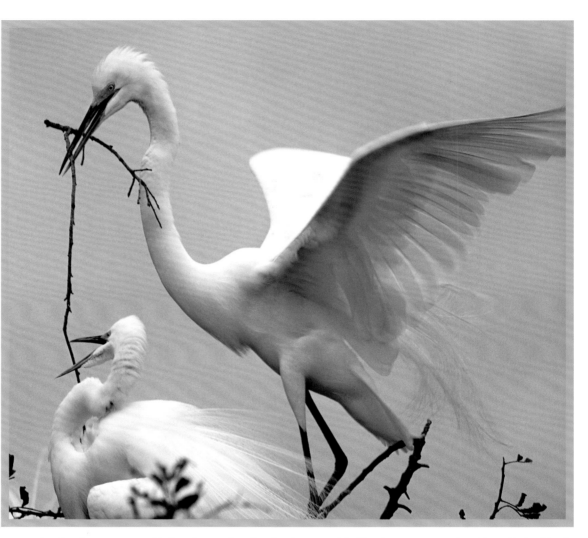

this location easily when headquartered in Flamingo seven miles to the south.

❺ ECO POND. This beautiful marsh at Flamingo is a dependably great spot for birds. A trail circles the pool which has a small central island where egrets and ibises roost each night. Unafraid of people, birds from

Great Egret Nesting Ritual (above). **Soft, overcast light is ideal for white birds like this breeding pair photographed at the Venice Rookery with a 500mm lens and 2X teleconverter.**

Anne's Beach, Florida Keys (above). **There are many photogenic beaches within easy driving distance of the Everglades that you will want to explore. This pristine view, couched amidst rampant commercial development, was photographed at sunrise.**

short distance into the park in order to be on location for first light. Herons, egrets, and purple gallinules are all likely subjects that are accustomed to humans at close range. The best time is during March when the canal dries into a series of small pools where aquatic life and its avian and reptilian predators become concentrated. Carry your tripod and longest lens.

EXCURSIONS

From Shark Valley on the north side of the park, you are set to visit a string of small preserves northward to Fort Meyers. Although this area does not offer the tranquil wilderness experience of the park, you will be surprised to find that both wildlife and scenic photography are equally, if not more, productive once you know where to look.

SANIBEL ISLAND

There are three main attractions on this small, laidback, picturesque island near Fort Myers. Ding Darling National Wildlife Refuge features a one-way drive through tidal marshes, brackish ponds, and alligator

red-shouldered hawks to snowy egrets to mockingbirds are easy to shoot here. You will need your longest lens to capture many of the marsh subjects due to a guardrail that keeps visitors away from the water.

6 SHARK VALLEY. This northern section of the park features an elevated trail that meanders alongside a small canal through the sawgrass expanses. Accessible by bicycle or tram, you will get the best photos on foot. The parking lot doesn't open until 8:30 A.M. but you can leave your car outside the gate and walk the

holes. There are plenty of tourist-habituated birds (often in immense flocks) including white pelicans and roseate spoonbills (see photo p. 78). The refuge doesn't open until 7:30 A.M. but you can leave your car at the gate and hike earlier for a private shooting session featuring the rising sun and dancing birds. On Sanibel's northwest shore, Bowman's Beach is considered one of the most beautiful in Florida (see photo at right). It's spread with white sand, decorated with masses of shells, and fringed with sea grape and sea oats. Best shooting time is sunrise before the hordes of sun-bathers and boogie boarders arrive. The fishing pier at the eastern tip of the island off Periwinkle Way is a great place to shoot brown pelicans mooching from fishermen off-loading their catch. Arrive late on a windy day to catch these big, pouched aviators hanging in mid-air.

VENICE ROOKERY

At 500mm+ telephoto range, this natural history nugget serves up dramatic breeding and nesting behavior of egrets, herons, and anhingas (see photo p. 79). It's located behind the Florida Highway Patrol station off Route 41, a short block north of Jacaranda Boulevard. Be prepared to join the line up of carbon fiber tripods and long lenses as wildlife papparazi from all parts of the globe celebrate the decisive avian moment. Take a lawn chair, a cooler of your favorite beverage, and plenty of stories for swapping. This is nature photography at its most social.

LITTLE ESTERO LAGOON

This secluded lagoon offers not only abundant birds (reddish egrets, great blue herons, American oystercatchers) but these protected backwaters provide good landscape opportunities at sunrise and sunset (see photo p. 78). It lies beside the Gulf of Mexico on Estero Island about five miles southeast of downtown Fort Myers Beach. Park opposite the Holiday Inn on San Carlos Boulevard and head toward the Gulf. The lagoon extends for a mile to the southeast. Have a great shoot and don't forget the mosquito repellant and your swimming suit!

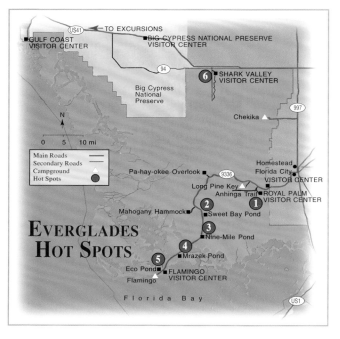

Bowman's Beach, Sanibel Island (above). **One of the most beautiful shell beaches on Florida's Gulf Coast (see Excursions), this site becomes crowded with sun-worshippers early in the day. Arrive before sunrise and you may have this stretch of white sand to yourself. This scene was shot back from the water's edge to pick up a colorful patch of sea grape in the foreground. Pentax 645, Pentax 35mm f/3.5 lens, two-stop split neutral density filter + polarizing filter, two seconds at f/22, Fujichrome Velvia.**

GLACIER

Montana • Summer/Fall • 406-888-7800 • www.nps.gov/glac/index.htm

GLACIER NATIONAL PARK OCCUPIES 1,013,572 acres of mountain wilderness in the northwestern corner of Montana. Its snow-crowned precipices, carved and chiseled by glaciers, spring abruptly from surrounding prairies. Dominating the horizon in nearly every direction, the alpine architecture is punctuated with dozens of glaciers, glistening waterfalls, white-water rivers locked in twisting gorges, and more than 600 lakes. The varied topography is home for an equal assortment of wildlife. In the appropriate season and habitat, you will have opportunity to photograph numerous large species including elk, moose, deer, mountain sheep, mountain goat, and possibly even black and grizzly bear (at long range). To this list of photo possibilities can be added smaller mammals—chipmunks, golden-mantled ground squirrel, hoary marmot, and pika. Gray jay, Clark's nutcracker, spruce grouse, and white-tailed ptarmigan are bird species that also can be readily

photographed with super telephoto lenses and patience.

The photographic fun doesn't end with pristine landscapes and obliging wildlife. The display of spring wildflowers is likewise generous. In the sagebrush-studded ponderosa parklands you will find sunflowers and lupines, in the montane forests at higher elevations beargrass and paintbrush, and on the tundras ringing the highest peaks above timberline glacier lilies and monkey flowers, to mention only a few species. Added to this rainbow of blooms is a diversity of uniquely

McDonald Creek (above). I reached this quiet backwater of McDonald Creek wearing chest waders as defense against the chilly waters (Hot Spot 1).

Mountain Goat (left). This species is frequently encountered roaming the meadows and rock outcrops of the Logan Pass area (Hot Spot 3). For a blurred background that accentuates the sharpness of the subject, shoot from a low camera angle.

Garden Wall (far left). Skies filled with moving clouds create opportunities for dramatic landscapes throughout the day. Look for mountain peaks and other distinctive landforms that are theatrically illuminated by shafts of sunlight breaking through clouds. This scene was recorded from roadside below The Loop (Hot Spot 2).

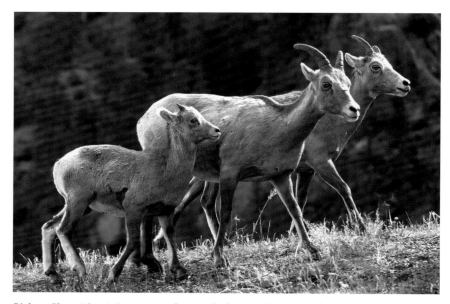

Bighorn Sheep (above). I waited to capture these sheep passing in front of a shaded background. As the animals sped up to get by my position, I took a dozen quick, motor-driven shots knowing that the chances of capturing an uncluttered arrangement of their trotting forms would increase the more photos I took. Bighorns can be readily photographed in the vicinity of Waterton Lakes Townsite (see Excursions).

Above The Loop (right). The Going-to-the-Sun Road presents many opportunities for landscape compositions (Hot Spot 2).

photogenic forests: the eastern lower slopes of the park are illuminated by the flashing tints of autumn aspens and cottonwoods, interior mid-mountain slopes are draped with lush patches of giant Douglas-fir and western red cedar reminiscent of the Pacific Coast, and above timberline the open, rock-strewn expanses are decorated with sculpted, twisted forms of subalpine fir known as *krummholz* (crooked wood).

One of the best aspects of Glacier is its nearby sister park, Waterton Lakes, just across the border in Canada. Although far smaller, this park is less crowded, has more pleasant weather, and harbors photography attractions of equal variety and abundance.

Summer is the ideal time for a photographic visit to Glacier. All park roads are open from about mid-June to mid-October. Glacier's climate is cool and wet with snow not unusual even in August at higher elevations. Be prepared for temperature extremes—from shirt-sleeves and sandals to parkas and toques in the same day, especially if you change elevations. July and August offer the best wildflower shooting. Although scenic work during summer may be dampened from time to time by flat light from overcast skies, this soft illumination is ideal for shooting waterfalls, cascades, and all manner of flora. In late September and October deciduous trees put on their yearly exhibit of gold and bronze and large mammals are at their most magnificent.

There are about 1,000 campsites in Glacier with reservations possible at Saint Mary on the east side and Fish Creek on the west side. Various dining and lodging options are available both within the park and outside entrances. Visitor centers are located at each end of Going-to-the-Sun Road as well as in Logan Pass in the mountain heartland. (For more information and reservations call 406-755-6303 or refer to the website.)

The great range of subjects at Glacier requires a full

complement of equipment and film for landscapes, macro still-life, and wildlife subjects. A compass will help you determine landscape lighting angles in advance of sunrise or sunset. It's essential to come prepared to deal with a variety of weather conditions—don't forget your rain gear! If you are visiting Glacier for more than a week, be sure to

make an excursion to Waterton Lakes, its sister park just across the border in Canada. If arriving from outside North America, check with Canadian immigration prior to your departure about entry requirements.

GENERAL STRATEGIES

If your trip is less than a week, spend all of your time in Glacier. For longer visits you should schedule about 1/3 of your time in Waterton Lakes National Park (see Excursions). Your activities in Glacier will center on Going-to-the-Sun Road. This awe-inspiring paved byway winds across the park, joining Saint Mary Lake and Lake McDonald via Logan Pass. You should spend a couple of days shooting attractions on each side of the pass and an equal length of time in the pass itself before moving north to the wildlife enclave at Many Glacier. If time permits, make your next stop Waterton Lakes.

You will need to adapt your shooting routines to the rapidly changing weather conditions. Unless clouds blanket the sky, you should be on site ready to capture one of Glacier's many landscape views under the ephemeral light and color of sundown and sunset. Midday periods may be devoted to shooting flora and fauna, especially if it is overcast; otherwise it's an ideal time for reconnoitering upcoming landscape sites.

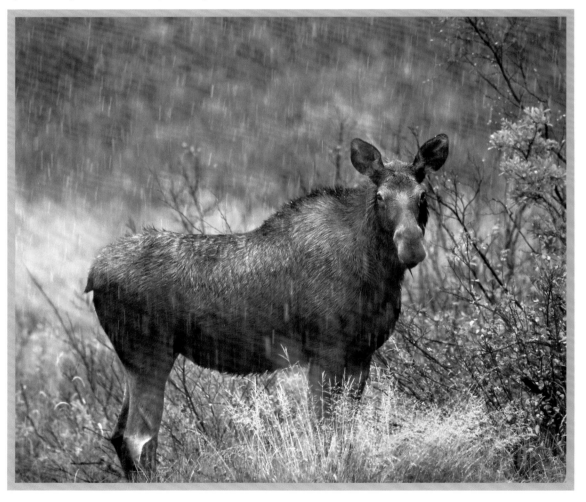

Moose (below). **A 500mm lens allowed close-up views of this wary subject recorded at one of the beaver ponds along Blakiston Creek on the south side of the Red Rock Parkway in Waterton Lakes National Park (see Excursions).**

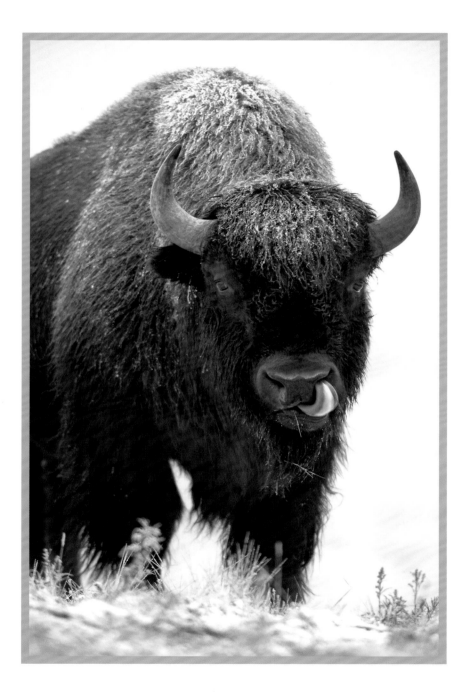

PHOTO HOT SPOTS

Unlike many other national parks, there are no classic photo locations in Glacier, except for Wild Goose Island, a scene that only works under colorful skies at sunrise or sunset. You will encounter a complexity of landscape options and changing lighting conditions that will tax your skill as a photographer.

❶ MCDONALD CREEK. During late summer and fall, slow-moving backwaters in the lower reaches of McDonald Creek offer opportunities to photograph reflections of nearby mountains, including Heavens Peak (see photo p. 83). The best time to shoot is late in the day when mountains to the east are front-lit or side-lit. Chest waders will allow you greater mobility to reach the perfect tripod site in these shallow, icy waters.

❷ THE LOOP. In but a few miles, this stretch of highway on the west side of Logan Pass offers a wide assortment of panoramic views as the road bends back upon itself in its assent of the pass. Massive granite pinnacles wrapped in spruce, aspen, and larch are especially dramatic in autumn. Make your shot selections from pullovers both before and after The Loop late in the day depending on cloud formations and lighting effects. Past The Loop, the road follows the Garden Wall on a steep incline with more great views and roadside wildflowers (see photo p. 82).

❸ LOGAN PASS. The most popular park destination and one that photographers shouldn't miss, Logan Pass offers magnificent views in all directions. Visitor activity focuses on the Hidden Lake Trail, a boardwalk which meanders westward and upward across alpine

tundra for 1.5 miles to an overlook which projects a classic view of a glacier-carved valley. This view is not photogenic due to the lack of light reaching the great recess below. The meadows along the trail are sprinkled with wildflowers in July—monkey flowers, glacier lilies, beargrass, and other species. Restricted to the boardwalk, you will find few opportunities to photograph the flora with full control over shooting angle and lighting. However, you will encounter numerous opportunities to photograph wildflowers throughout the pass area away from the main trail and along the roadside, as well as unconcerned mountain

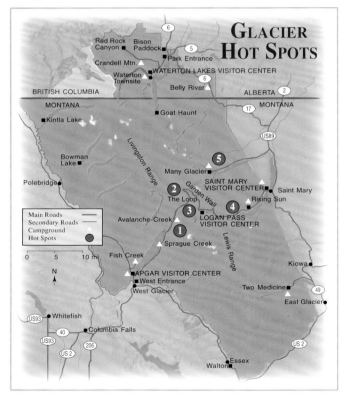

goats which wander the highlands (see photo p. 83).

❹ WILD GOOSE ISLAND. This is the park's most popular photo destination. The shooting site is situated roadside above Saint Mary Lake. Aside from framing and magnification, there are few options to approaching this subject. The success of your depiction of this small, romantic island huddled within a lofty barricade of granite peaks will depend on the fortuitous occurrence of two conditions—a still atmosphere for mirror-like reflections on the lake and a sky rumpled with broken cloud that will soak up warm pigments from a rising or setting sun (both can be good) and reflect them into the scene. The photo above is my fourth attempt.

❺ MANY GLACIER. This section of the park offers some of the best opportunities for photographing alpine wildlife, particularly mountain goats and bighorn sheep. Warm up to the area by exploring the wildflower-spattered, lichen-stained moraine just above the Many Glacier Hotel. The best hike is along the Grinnell Glacier Trail. You can jumpstart

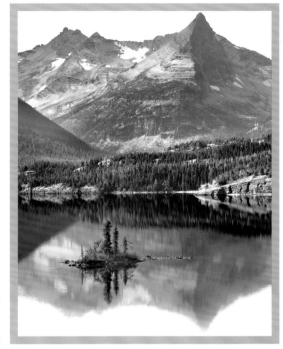

Wild Goose Island (above). **One of the most photographed vistas in the park, this view of Saint Mary Lake can be recorded from a well-signed pullout on Going-to-the-Sun Road east of Logan Pass (Hot Spot 4).**

Bison (far left). **The only way to record detail in both the highlight and shadow areas of dark animals is under soft, overcast light. This handsome brute was recorded in the bison paddock at Waterton Lakes (see Excursions).**

Clark's Nutcracker (below).
**Appearing magically at
campsites, especially when
food is being consumed,
this bold species is easily
photographed when
perched and waiting to
descend on an unguarded
picnic table. If time per-
mits, I prefer to focus
manually on avian subjects
to ensure that the eyes are
sharply rendered. Canon
EOS 3, Canon 500mm f/4
IS lens with 1.4X teleconverter, 1/250 second at
f/5.6, Fujichrome Provia.**

this trek by taking a boat shuttle across Swiftcurrent
Lake, walk the short distance to Lake Josephine, and
hop on another shuttle that will take you to the far end
of the lake. From here it's more than five miles uphill
to the glacier, not that you need to complete this jour-
ney. Along the trail you will encounter all kinds of
wildflowers, as well as scenic views and sometimes
mountain goats and bighorn sheep. For the best photo
results, work thoroughly with any interesting subjects
you encounter rather than squandering your energy on
covering a set distance.

EXCURSIONS

Waterton Lakes National Park in Alberta is the other
half of Waterton/Glacier Inter-
national Peace Park, a largely
nominal designation (the parks
are administered separately)
for this alpine ecosystem
straddling the U.S. and Cana-
dian borders. Several factors
distinguish the photographic
experience at Waterton. It is
generally uncrowded, wildlife
is easy to find and photograph,
and the open parkland setting
and numerous lakes and ponds
offer possibilities for capturing
landscape reflections, the most
dramatic of scenic motifs. The
park has drive-in camping

facilities at three sites (one with full RV hookups) and
a wide selection of lodgings and restaurants at quaint
Waterton Townsite.

The first major attraction you will encounter about
five miles north of the border crossing is a series of
pools and beaver ponds fed by Crooked Creek on the
south side of the highway. This is a fabulous sunrise
location for capturing the rhythmic contours of Sofa
Mountain cross-lit and reflected in still water. From
here it takes about 15 min-
utes to reach the entrance
station at the Waterton
Lakes basin, the most
developed part of the park.
The best shooting opportu-
nities are found here.

During summer, you
will find mule deer feeding
on the grassy hillsides above Lower Waterton lake,
often among glowing patches of sunflowers. In fall,
thickets in this same area attract rutting mule deer
bucks and herds of elk which congregate in Waterton's
warm valleys. Roaming widely over the aspen-patched
foothills, these elk are skitterish subjects, no doubt
mistaking photographers for the hunters they encounter
when outside the protection of the park. Thickets and
open prairies along lower Blakiston Creek are occupied
by rutting bulls in September and October. During au-
tumn, black bears also descend into the valley to feed
on berries and choke cherries growing along lake
shores and creeks.

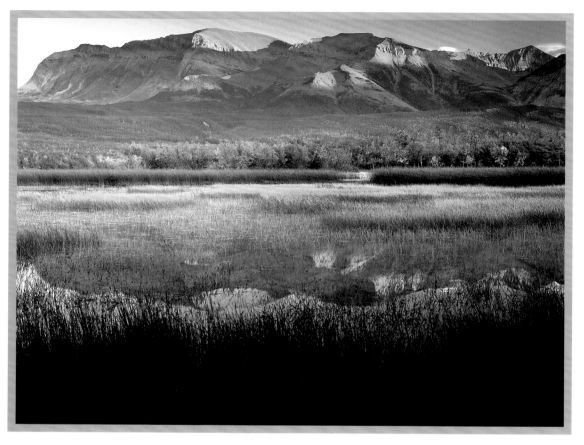

Sofa Mountain from Maskinonge Lake (left). This sunset view was taken from south of the picnic area at Maskinonge Lake. The open setting and numerous quiet pools at Waterton Lakes National Park offer many photo opportunities for landscape panoramas in reflection (see Excursions).

Buttercups (far left). This clump of buttercups, one of hundreds of varieties of wildflowers in Glacier, was photographed at wide-open aperture to achieve shallow depth of field. The out-of-focus blooms were used to frame the central picture area. Canon EOS 3, Canon 100–400mm IS lens, Canon 2D close-up supplementary filter, 1/125 second at f/5.6, Fujichrome Velvia.

Off Highway 6 on the northern boundary of the park is a large drive-through enclosure with a small herd of bison that you can photograph from inside your vehicle. The terrain is hilly and usually there is no problem with fencing appearing in the background. Bighorn sheep (and frequently black bears) wander at large in Waterton Townsite. With a bit of maneuvering you can easily photograph the sheep here in natural settings, but a more photogenic locale is to be found on the hillsides in the vicinity of the Prince of Wales hotel where small herds gather to sun themselves during colder weather.

It is not difficult to find great tripod sites for capturing landscape reflections both for sunset and sunrise. Quiet shallow pools along Maskinonge Lake and both Middle and Lower Waterton Lakes offer plenty of opportunities. Check out lighting and subject angles in advance and keep your fingers crossed for a parade of shapely clouds. Good luck and great shooting!

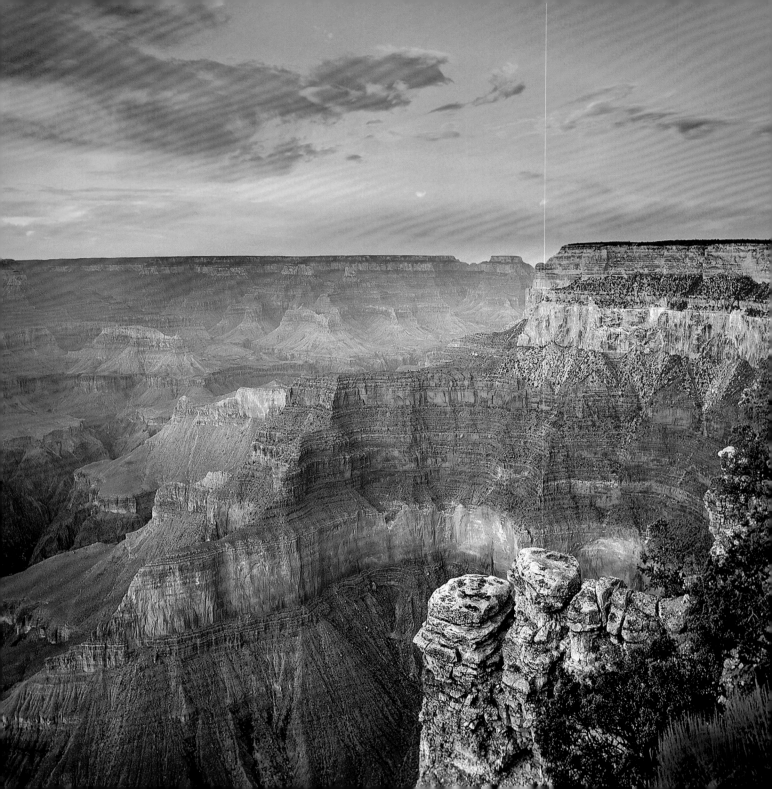

GRAND CANYON

Arizona • Spring/Summer/Fall/Winter • 520-638-7888 • www.nps.gov/grca/index.htm

ONE OF THE MOST STUPENDOUS geologic formations on earth, the Grand Canyon is visited by more than 5,000,000 picture-snapping tourists each year. Carved out of sheer rock over millions of years by the Colorado River, the canyon walls, stretching 277 miles, plunge thousands of feet in dizzying vertical drops. At the rim, landscape photographers are greeted with four key elements necessary for producing world-class scenic imagery: rich, varied colors (especially when dampened by rain) which radiate from the varied rock strata of the interior canyon walls, deep perspective defined by ranks of receding landforms and familiar near-field features, skies energized by robust cloud formations for much of the year, and dramatic side-lighting at sunrise and sunset due to the canyon's east/west orientation.

Protected within Grand Canyon National Park's 1,218,376 acres are life zones ranging from arid desert to moist coniferous forest which sustain 90 species of mammals and nearly 300 species of birds. Although this may seem encouraging

to wildlife photographers, most of these species are nocturnal or tend to inhabit shaded, cooler parts of the canyon where light conditions are poor. Mule deer and an occasional coyote, prowling the roadside for an illicit handout, are the only likely subjects that will send you scrambling for a big lens. There are plenty of exciting close-up opportunities, particularly during spring wildflower season which runs from April into June.

The park is bisected by the Colorado River into South Rim and North Rim sectors. Most of the park's

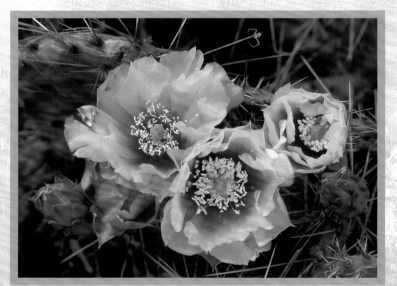

Bright Angel Point (above). This site on the North Rim was photographed after sundown when soft, warm light evenly illuminated the canyon interior and foreground features on the rim (Hot Spot 4).

Prickly Pear Cactus (left). There are plenty of cactus species to photograph in Grand Canyon. This bouquet was photographed in the shade of my own body. A white reflector bounced accent light into the scene for sparkling color.

Pima Point (far left). This South Rim location was photographed at sundown toward the east to capture three well-defined landscape planes (Hot Spot 3).

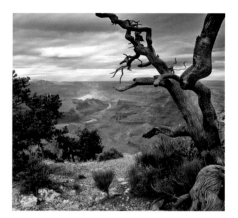

Desert View Overlook (above). **Interesting clouds, strong foreground features, and theatrical lighting effects on the chasm's interior forms are essential ingredients for Grand Canyon landscapes. Pentax 645 with 45–85mm zoom lens, one second at f/22, Fujichrome Velvia.**

Red Paintbrush and Pine Cones (right). **Paintbrushes and other species are common on the South Rim forest floor in May. This still life was photographed in the shade for soft, even lighting. The cool color cast that resulted was corrected with an 81A warming filter for a natural color balance.**

facilities and the best photo opportunities are along the South Rim, which is also the most popular and crowded area of the park, receiving about 90 percent of visitors. A paved road, sprinkled with numerous inspirational overlooks, skirts the rim of the canyon for about 30 miles. At 7,000 feet, the South Rim is flat, sloping gently away to the south. The scant 16 inches of yearly rainfall supports loose stands of pinyon pine, juniper, and ponderosa pine, all of abbreviated stature. The forest floor is littered with cacti, yuccas, sagebrush, rabbitbrush, and other shrubs. The North Rim receives twice as much rain and is 1,000 feet higher than the South Rim. Taller, thicker coniferous forests of spruce, fir, pine, and aspen interspersed with lush meadows dotted with wildflowers clothe the plateau. As you descend into the canyon, temperatures rise, moisture drops, and desert habitat takes over until you reach the floor where cottonwoods and willows sprout from the river banks.

Due to high elevation, Grand Canyon experiences cold temperatures and frequent snowfalls in winter. Summers are hot with cool nights; snow sometimes falls on the North Rim. Spring and fall bring changeable weather. Each season holds nearly equal attraction for the photographer. Winter offers its snowy accents, spring generates a burst of wildflowers, late summer heats up the skies above the canyon with dramatic thunderheads and lightning, fall offers fair skies and splashes of deciduous color.

Grand Canyon Village on the South Rim is the commercial center of the park with visitor centers, lodges, campgrounds (one with full RV hookups), restaurants and stores. Camping (800-365-2267) and lodging reser-

vations (303-297-2757) are essential spring through fall on both rims. There is a first-come/first-served campground at Desert View. Private campgrounds and lodgings are available in Tusayan, a few miles south of Grand Canyon Village. On the North Rim there is a lodge and campground at Bright Angel Point that is open from about mid-March to mid-October.

Grand Canyon is foremost a location for shooting landscapes. Bring zoom lenses from wide-angle to telephoto for precise magnification of terrain features. Split neutral density filters are needed to balance brightness between sunlit and shadow portions of the scene. A white reflector is essential for close-up subjects under sunny skies. You will find little use for super telephoto lenses.

GENERAL STRATEGIES

For a one-week visit, plan on spending all of your time working on the South Rim, principally in the vicinity of Grand Canyon Village. Here you have vehicle access to a wide range of sites. From March through November, access to overlooks along West Rim Drive from the first intersection west of Bright Angel Lodge to Hermits Rest is possible only by free shuttle bus. This transportation presents no drawbacks to photography. The buses run frequently all day long and will deliver you on site an hour before sunrise and pick you up an hour after sunset. For longer stays, you may wish to venture to the North Rim—only 10 miles as the crow flies but 215 miles/four hours by car. The shooting is fabulous from either rim, distinguished by variations in micro-features of the canyon rather than general impressions, which in Grand Canyon are

Utah Agave (above). **These succulents are common in dry South Rim habitats. This specimen was photographed at Mohave Point. A tripod, zoom lens, and overhead camera angle allowed me to attain tight, precise cropping of the leaf pattern.**

Yaki Point (far right). **Most landscape scenes benefit from having strong foreground elements, such as this tree (Hot Spot 1). Try to position the camera so that these features extend into the sky. This creates a strong link between land and atmosphere and strengthens design unity.**

Ponderosa Pines (below). **Powdery Grand Canyon snows make ideal accents to forest scenes. They melt quickly and you need to work fast to capture their ephemeral beauty. Here I used lacy foliage to frame a lineup of ponderosas, my center of interest.**

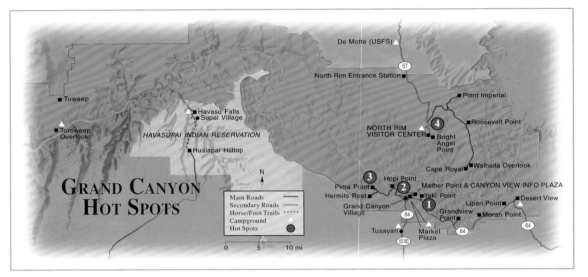

GRAND CANYON
HOT SPOTS

Main Roads	——
Secondary Roads	—
Horse/Foot Trails	•••••
Campground	▲
Hot Spots	●

0 5 10 mi

primarily a product of season, lighting and sky conditions, and time of day.

When devising landscape compositions, you should consider two interacting factors above all else: lighting (as a general rule restrict shooting to one-hour periods at sunrise and sunset) and skies (broken, dense cloud-cover usually provides the most drama). Beyond these basics, try to anchor Grand Canyon designs on three key landscape assets when they are available: the Colorado River, rock prominences within the canyon (mountains, domes, temples, thrones, and points), and distinctive foreground features that frame and give scale to the view (trees, rock outcrops). Although it is difficult to predict lighting effects in advance, especially at sunrise, schedule your shooting session for side-light or front-light on the main subject.

Shooting wildflowers, cacti, yuccas, butterflies, lizards, and squirrels at Grand Canyon requires routine close-up techniques. Shoot as early in the day as possible when the light is soft and the atmosphere is calm. With still-life subjects, use reflectors to brighten deep shadows or shoot them in the shade and warm up the resulting bluish color cast with a filter (81A).

PHOTO HOT SPOTS

All rim-top shooting sites have the potential for great pictures. Preferred viewpoints are those which open onto the Colorado River (Pima, Mohave, Hopi, Moran, Lipan, Desert View, and Toroweap), a

Painted Lady Butterfly on Apache Plume (right). **This desert shrub blooms in late May and early June, attracting butterflies. White petals act as natural reflectors, bouncing light into the underside of the insect for improved shadow detail and color.**

Havasu Falls (below). **A one-second shutter speed created this blurred-water effect (see Excursions).**

distinctive landscape feature that provides both scale and a center of interest for your compositions. Usually it's advantageous to search for tripod sites along Rim Trail away from crowds and guard-railed overlooks which limit design choices.

❶ YAKI POINT. Although this overlook does not give you a view of the Colorado River, it harbors one of the best-placed and best-formed foreground pinyon trees along the South Rim (see photo p. 95). The tree is 50 yards east of the main overlook just off the Rim Trail. The area around the tree is flat and open which permits a variety of shooting angles into the canyon. Just past the tree to the

east, a large Navajo sandstone pinnacle forms a small point and sets up an array of beautiful temples in the distance. Yaki Point is photogenic at sunrise and sunset. Access year-round is by shuttle bus only.

❷ HOPI POINT. From this overlook, numerous rock formations within the canyon project to catch shifting light patterns of the setting sun. It is the most popular sunset destination on West Rim Drive. Access is by shuttle bus only except during winter.

❸ PIMA POINT. Not as popular a sunset venue as Hopi Point, this less-crowded location offers 180-degree views and a glimpse of the river (see photo p. 90). Access is by shuttle bus only except during winter.

❹ BRIGHT ANGEL POINT. The short trail that leads south from Grand Canyon Lodge (on the North Rim) to the end of the point presents nice views to the west. A variety of foreground treatments is possible due to numerous trees and rocky terrain. Sunset and sunrise periods are both photogenic (see photo p. 91).

EXCURSIONS

Two of the most beautiful waterfalls in the world are located on the Havasupai Indian Reservation on Havasu Creek which enters the Colorado River in the western portion of Grand Canyon. Although this seems close at hand, reaching the falls is not easy but it is a unique adventure. This excursion requires a minimum of four days. First you must drive to the trail head at Hualapai Hilltop, which is about four hours from

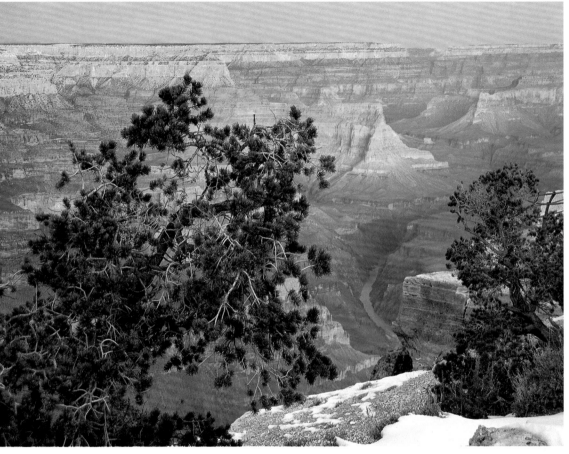

Grand Canyon Village via a circuitous route that takes you south to Interstate 40, then west to Route 18 near Peach Springs, Arizona, then back north again to the trail head. From here you must journey by horse (supplied with guides by the Havasupai Indians) or hike eight miles to the village of Supai where there is a lodge, store, and café and, two miles further, a campground. Call 520-448-2121 for more information.

The most beautiful of several waterfalls is Havasu, adjacent to the campground. There are excellent vantage points at the base of the falls, but you need to get your feet wet to reach them. It's best to shoot here early or late in the day when the falls and canyon walls are in shade (or any time on a cloudy day). Mooney Falls, about a mile downstream from the campground, is gorgeous but not quite so picturesque as Havasu. To reach the base of this waterfall requires a tricky, if not perilous, climb down a cliff, assisted by ropes and chains (not for the faint of heart). Both falls make excellent subjects from above but they must be photographed during twilight or on a cloudy day to overcome the scene's high contrast. Remember to take a tripod for long exposures that blur the flow of water.

This remote, sheltered canyon, its sheer, rusty walls trimmed with lush vegetation and doused by a series of blue-green waterfalls, seems locked in another time. You will be as enchanted by the fairy-tale setting and quiet life of the Havasupai as with the photos you take. Have a great trip!

Mohave Point (above). **The soft, hazy light of sunrise illuminated this scene. A split neutral density filter was used to reduce contrast. The dark area of the filter was placed over the sky and upper canyon walls to prevent overexposure in these areas.**

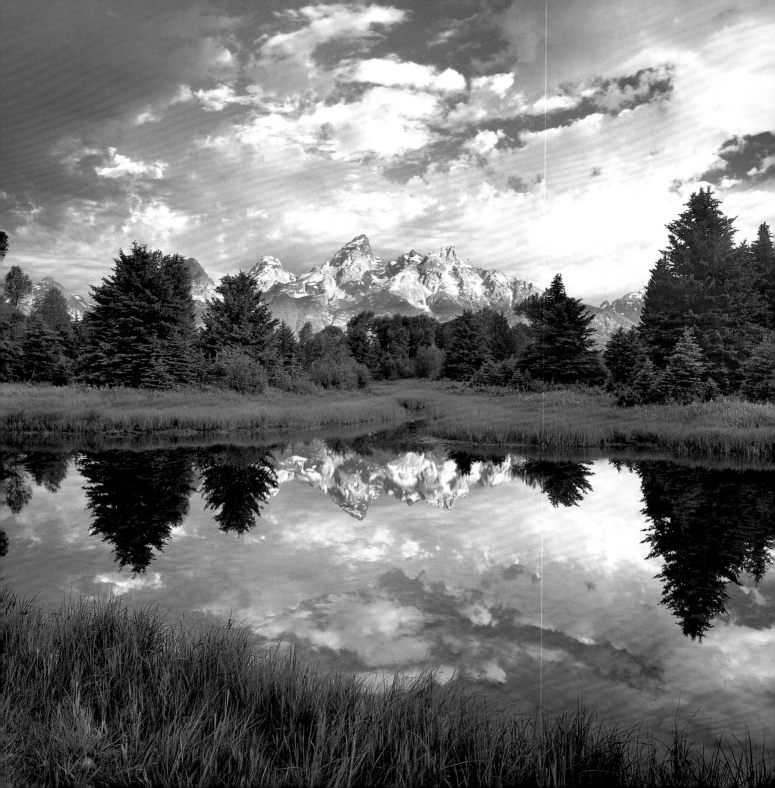

GRAND TETON

Wyoming • Summer/Fall/Winter • 307-739-3300 • www.nps.gov/grte/index.htm

Scarlet Buglers (above). **You will find these delicate trumpets throughout the park's dry, open habitat. A low camera angle yielded a view of the blossoms' distinctive profiles and captured pleasing out-of-focus background washes of prairie and sky.**

Pronghorn Antelope (left). **This wary species can be photographed occasionally from Antelope Flats Road (Hot Spot 1) using your vehicle as a blind. Canon EOS 3, 500mm f/4 IS lens and 1.4X teleconverter, 1/500 second at f/4, Fujichrome Provia 100F.**

Grand Tetons from Schwabacher Landing (far left). **This early-morning view shows the park's premier landscape photography attraction (Hot Spot 2).**

THE COMBINATION OF GRAND scenery and abundant, easily located wildlife at Grand Teton is unmatched by any other park in the lower 48 states. It should be at the top of every nature photographer's list of shooting destinations. The Teton Range, majestic and imposing, rises abruptly some 7,000 feet from the flat, tawny benchlands of the Snake River, a broad water course that winds gracefully through thick stands of cottonwood and willow. Nestled against the lower slopes of the Tetons is a series of pine-sheltered lakes that mirror the snow-capped, alpine backdrop on still mornings. Most of the park's 309,993 acres is on the east side of the Teton Range, a tiered mix of sagebrush flats, aspen parkland, evergreen forests, wildflower prairies, marshes, and river backwaters that lies open to the first warm rays of the rising sun, a dream come true for nature photographers. Over this open

terrain roam large ungulates readily spotted and easy to approach and photograph—bison, pronghorn antelope, elk, mule deer, and moose.

You will have an outstanding shooting experience at any time of the year in Grand Teton although the prime seasons are summer and fall. By late June the valley floor is brightened by the large, golden blooms of balsamroot sunflowers, blue lupines, and other species that beckon close-up enthusiasts. Large mammals have given birth and records can be made of these endearing youngsters cavorting over the prairie. Later in the summer, thunderstorms create skies rich in texture and color, especially at sunset. Bison bulls snort and churn up the sod with big front hooves. Wildflowers reach their peak of beauty at higher elevations. In fall aspens and cottonwoods ignite the landscape with glinting tints of bronze and gold (peak color

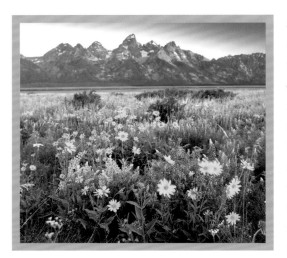

Teton Range from Antelope Flats (above). In late June the lupines and balsamroot sunflowers in this area (Hot Spot 1) make beautiful foreground content for shots of the Tetons. This photo was taken a few minutes before sunrise.

Bison (right). Patience, timing, and a low camera angle teamed up this grazing cow with out-of-focus sunflowers (Hot Spot 1).

Lupine (far right). You needn't always strive for a formal portrait when shooting wildflowers. Ultra close-up views provide intimate glimpses of delicate details and opportunities for abstraction.

arrives around the last week of September). Bull elk and moose, their antlers grown to enormous size, compete for mates. By the last week of November, tourist crowds have long dispersed and winter's arctic temperatures transform the appearance of the valley floor and looming peaks with soft blankets of snow, myriad sparkles of morning frost, and silver mists drifting out of the river basin.

There are four visitor centers and five drive-in campgrounds conveniently located along or near main park roads. Generally open spring through fall, all campgrounds are operated on a first-come/first-served basis. Except for Gros Ventre, they fill early in the day during July and August. Check the park newspaper (available at entry stations or visitor centers) for locations and opening dates. There are eight lodges with accommodation offered from spring to early winter. For more information contact park headquarters or the website. A variety of lodges, motels, restaurants, stores, and other services are available year-

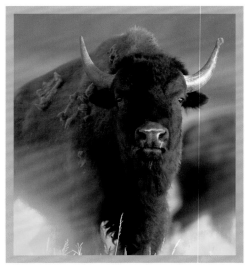

round in the thriving commercial center of Jackson, a few miles south of the park boundary.

Grand Teton experiences heavy snowfall by the beginning of November continuing through March. Summer temperatures reach to 90°F with nightly lows in the 40s. During September and October, days may be warm and pleasant or damp and chilly. Come prepared for both.

Grand Teton's mix of alpine terrain, abundant wildlife, and seasonally plentiful wildflowers calls for a full range of equipment from close-up accessories to super-telephoto lenses and heavy tripods. Bring fine-grained, slow-speed, saturated film for landscape work and medium speed film for shooting wildlife.

GENERAL STRATEGIES

Your shooting agenda will depend on numerous factors including your particular subject interest, weather conditions, wildlife activity, and time of year. A road circuit leading to most of the main photo attractions, both wildlife and scenic, can be driven in a couple of hours including brief stops. This circular route winds northward from Moose Junction (Teton Park Road) on the west side of the Snake River past a series of lakes at the base of the Tetons and then loops south (Highway 191) and comes back

down the east side of the river. You might wish to stay in a campground or lodging at the southern end of the park for shooting attractions in this vicinity and then relocate to the northern sector after a few days. Fortunately the park is compact enough so that commuting to any site, even for a sunrise shoot, is not a hardship. Classic tripod spots are scattered rather evenly throughout the park, as are the pockets of wildlife concentration. The daily shooting routine here is no different than in most other parks. Nearly all of the classic landscape images center, naturally enough, on the Teton Range. Plan to be on location about 30 minutes before sunrise to capture the fiery color on clouds gathered above the line up of peaks (should it materialize) or record the first flash of golden light on the highest granite pinnacles. Once you have captured the best of the sunrise display, you can check various locations known for wildlife activity while the light is yet warm and soft. In early summer, you may opt to pass the early morning period working with wildflowers. Middle parts of the day are best spent dealing with logistics, scouting new scenic sites, observing wildlife, or enjoying other park activities. Approaching sundown, repeat the morning routine in reverse.

PHOTO HOT SPOTS

For your first trip to Grand Teton, you would be wise to investigate and even photograph at each of the sites described below. This exercise will not only earn you a batch of great pictures but you also will become familiar with the layout of the park and the location of

of its special attractions. This selection of locations only includes those that can be reached by car or short hikes. There are numerous full-day hiking routes into canyons of the Teton Range worthy of photographic exploration, especially during late June and July when wildflowers peak. The easy/moderate trails conveniently reached via the Jenny Lake shuttle boat are usually the most photographically rewarding. They give access to inspiring viewpoints, waterfalls, creeks, and Cascade Canyon, a prime wildflower area.

① ANTELOPE FLATS ROAD. This large sagebrush plain alive with wildflowers in June (balsamroot sunflowers, blue lupines, scarlet buglers) spreads out on both sides of Antelope Flats Road about two miles north of Moose Junction. This

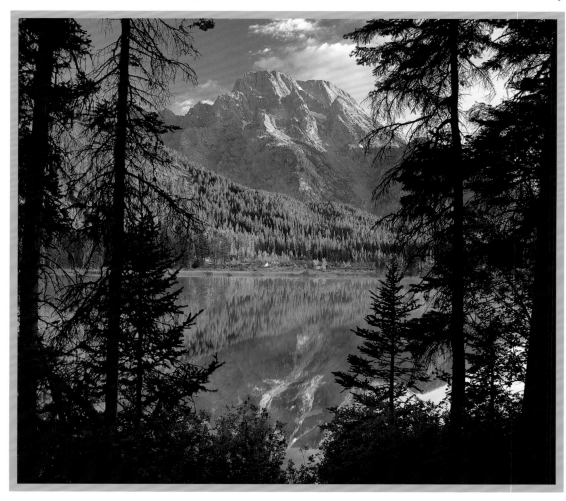

is a beautiful setting in which to photograph the bison (and occasionally pronghorn antelope) that commonly graze here. You can frame portraits of these shaggy beasts with a telephoto lens against a blossom-dappled background or foreground (see photo p. 100) or select a wide-angle or normal focal length lens and shoot bison against the Teton Range backdrop. You can ignore the wildlife altogether and shoot wildflower close-ups (see photo p. 101) or landscapes which marry the Tetons to an expanse of wildflower prairie.

② SCHWABACHER LANDING. This is arguably the most photogenic mountain scene in North America (see photos p. 98, 10). Summer offers the

likelihood of dawn clouds above Teton's soaring spires and autumn shows cottonwoods, willows, and aspens in warm pigments lining the river. To reach this sunrise site, take Schwabacher Road (a gravel road off Highway 191 about four miles north of Moose Junction) to the end. Once you are at the parking lot, walk north along the riverside trail 100 yards to just past the beaver dam and you will see the familiar reflection of the Tetons framed in a large, shallow, usually still pool. A normal to wide-angle lens provides appropriate

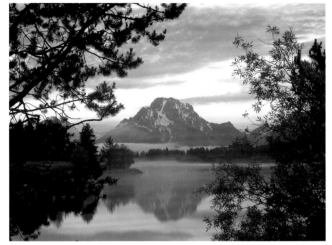

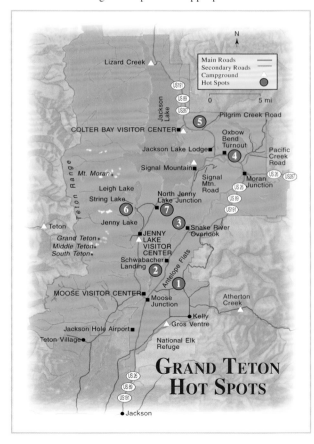

magnification of the scene and a one- or two-stop split neutral density filter will restrain the brightness of the mountains and sky and thereby emphasize the reflection.

③ SNAKE RIVER OVERLOOK. This

roadside viewpoint on Highway 191 about halfway between Moose Junction and Moran Junction presents the Snake River winding in a classic S-curve toward the Tetons. The photogenic properties decline each year as evergreens in the foreground grow higher and obscure the winding river. The shooting here is best at sunrise when the mountains are front-lit, but sunset views can be dramatic if broken clouds hang above and east of the mountains to reflect light into the scene (see photo p. 104).

④ OXBOW BEND. This large roadside pullout displays Mount Moran reflected in quiet backwaters of the Snake River. Unfortunately the pool is open to wind and slow currents and seldom projects a mirror-like image. I like to shoot from the shoreline east of the main parking area where overhanging limbs frame the scene (see photo above). In autumn, photography is enhanced by the burnished foliage of cottonwoods and aspens, mists rising

Mount Moran from Oxbow Bend (above). **I was on location (Hot Spot 4) 30 minutes before sunrise to catch the predawn play of color on the clouds over Mount Moran. This tripod site is at the water's edge about 300 yards east of the main roadside parking area. Pentax 645 with 45–85mm lens, two seconds at f/22, Fujichrome Velvia.**

Mount Moran from String Lake (far left). **High contrast between the sunlit mountain and foreground evergreens still in shade rendered the trees as dramatic black silhouettes. Exposure was based on an average reading of just the mountain prior to final framing (Hot Spot 6).**

Snake River Overlook (below). The S-curve of the Snake River leads the eye to distant Teton peaks catching the first light of sunrise in this classic park view (Hot Spot 3).

from the water, and moose browsing in the willows.

⑤ LUPINE REFLECTIONS. You are sure to notice this magical scene on numerous postcards and posters in the Grand Teton area. The view shows an expanse of lush lupines in the foreground, a pool reflecting the Tetons in the middle area, and the mountains them-selves on the horizon. Unmarked on the park map and generally unknown to park staff, this tripod location is found east of Colter Bay on the south side of the Pilgrim Creek Road (gravel) which runs along Pilgrim Creek East Fork. When in bloom the meadow is easily spotted near a small shed (visible from the main high-way). Luck and good timing are needed to capture all of the scene's distinctive elements. The pool only fills adequately in wet years and the lupines usually bloom in late June and July. Perfect calm is needed to record the flowers and the distant peaks in sharp detail due to the long exposure time needed. Dawn twilight and early morning are the best times.

⑥ STRING LAKE REFLECTIONS. The pools and quiet channels of String Lake provide opportunities for diverse compositions of the Teton Range and its reflection. Mount Moran is the main attraction here (see photo p. 102) but there are also open views of Grand Teton peak and the Cathedral group. A variety of effec-tive foreground subjects grows along the shore including huckleberry bushes (scarlet in autumn), reeds, and stately pines. Emerging from the quiet waters are beautiful moss- and lichen-encrusted rocks and deadfalls,

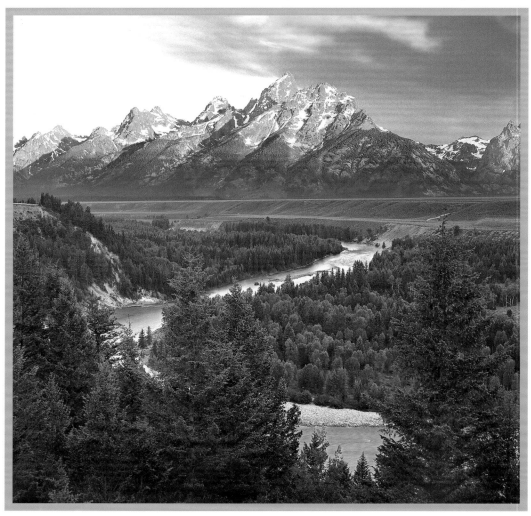

solid features which can be superimposed on the reflection to create visual irony (see photo p. 22). From the main parking area you can walk north on a trail leading through a pine/spruce woods a few hundred yards to reach a narrow channel which becomes wider as it extends for several hundred yards to the north. Sheltered by forests, this stretch of water spreads like a mirror at the foot of Mount Moran on calm mornings. The trail flanking String Lake to the south is also excellent. Sunrise is the best time to shoot here but sunset can be rewarding also if split a neutral density filter is used to reduce contrast (see photo p. 22, 102).

❼ **PATRIARCH PINE**. This is another classic image you will see on Teton postcards. It features a large wind-sculpted pine gracefully framing the main Teton formation. Unfortunately the road that used to pass by this tree is now closed and a 20-minute hike across a sagebrush plain is now necessary. To reach this sunrise site, park alongside the Teton Park Road 0.6 miles south of the North Jenny Lake Junction and head on foot directly east through a small grove of trees (there is no trail). When you reach a small ridge on the far side of the trees you will see a triangular peak on the horizon directly to the east. Continue toward the peak across the flats until you reach a small clump of trees on the next ridge. From here the majestic old pine should be easily visible. Proceed past the patriarch pine eastward so that you can shoot back toward the Tetons. Have a great shoot and watch out for the bison!

Yellow-bellied Marmots (above). **You will encounter these large, often fearless rodents commonly in Grand Teton, especially when hiking in subalpine areas. The easiest place to photograph them is behind the National Museum of Wildlife Art on Highway 191 about two miles north of Jackson. Here a colony has taken up residence in a pile of large boulders in the median of the parking lot.**

Moose (left). **Grand Teton is one of the best locations in North America to photograph moose. During the autumn rut (September/October) bulls and cows can be readily photographed in wetland willow habitats in the Oxbow Bend, Colter Bay, and Moran Junction areas.**

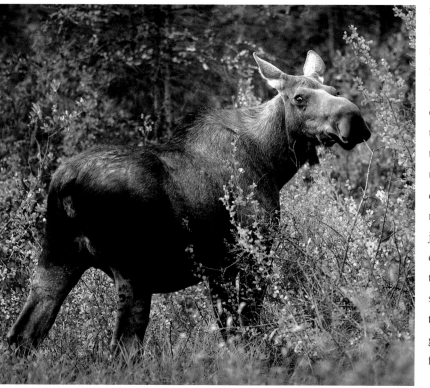

GREAT SMOKY MOUNTAINS

Tennessee/South Carolina • Spring/Summer/Fall • 865-436-1294 • www.nps.gov/grsm/index.htm

A NEARLY PRISTINE EXPANSE of Appalachian Mountain wilderness, Great Smoky Mountains' 521,621 acres straddle the border between Tennessee and North Carolina. These forested uplands attract twice as many visitors as any other national park, some 10,000,000 each year. On these ancient, mist-shrouded ridges and gentle mountains grow an astounding variety of plants (1,500 flowering species), mammals (60 species), and birds (200 species).

Five types of forests cover the mountainsides and river valleys including the finest examples of old-growth hardwood forests in the world in which numerous species grow to record size. For the photographer these woodlands provide infinite picture opportunities. In autumn there is a torrent of fall color, ranging from brown and purple through scarlet to bronze and lemon-yellow. Moun-

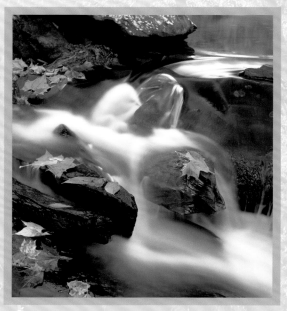

tain tops are cloaked in the evergreen pigments of spruce and fir, lower slopes and valleys are brushed with the warm hues of maple, oak, beech, birch, hickory, yellow-poplar, basswood, sweet gum, and magnolia to mention some of the prominent species. In spring these same woodlands are again ignited, not by the broad brush strokes of fall, but with dabs of yellow, pink, white, and violet. The blooms of hundreds of wildflower species decorate the forest floor in small patches and single blossoms of delicate shape and vibrant color—trout lily, lady's slipper, columbine, iris, trillium, aster, phacelia, and many others. The shaded shrubbery of the understory provides further illumination—the blooms of rhododendron, dogwood, laurel, and azalea. This wondrous palette can be displayed on the broad canvas of the landscape photographer or

Springtime Sycamore (above). **Soft light, even at midday, is common in Smoky Mountains National Park. This is ideal illumination for close-ups of forest details like this one taken in Greenbrier .**

Little River Leaves (left). **The Little River Road (Hot Spot 3) skirts the stream from which it derives its name. Along this route you will find many opportunities for blurred-water imagery. This close-up view was taken in mid-stream with a zoom lens. A polarizing filter used to reduce reflections from the leaves and water for better color.**

Smoky Mountains from Blue Ridge Parkway (far left). **This morning view into the park was shot from the Blue Ridge Parkway a few miles northeast of the Oconaluftee Visitor Center.**

Cades Cove (above). **This fertile valley, preserving forests, pioneer buildings, fields, and meadows is best photographed in early morning when mists swirl about landscape features. In this composition, the rock provides scale for the scene, creating an impression of three dimensions (Hot Spot 5).**

White-tailed Deer (right). **This is the most common large mammal in the park Males are known for their unusually large antlers. White-tailed deer are abundant in Cades Cove (Hot Spot 5) where this buck was recorded. For animal portraits, try to catch the subject looking into the picture space. Canon EOS 3, Canon 500mm f/4 IS lens with 1.4X teleconverter, 1/60 second at f/4, Fujichrome Provia 100F.**

presented with the intimate brush strokes of the close-up enthusiast. This lushly vegetated terrain receives plenty of rainfall, creating a topography laced with rivers, streams, and waterfalls, all of which constitute an added source of close-up subjects not to mention a new angle on landscape motifs.

Complimenting the subject matter is a climate that seems custom-designed for productive shooting. Skies are often overcast or hazy and the atmosphere calm, a wilderness studio where soft light generates saturated color and excellent shadow detail, where full depth of field and razor-sharp subjects are the rewards of long exposures and small apertures. Wildlife can be added to the list of still-life attractions, especially white-tailed deer which abound in certain areas of the park. Black bears are another Smoky Mountain specialty which lucky photographers sometimes manage to capture in their viewfinders.

Smoky Mountains is a large park with numerous roadways, both paved and gravel, which circle the perimeter, loop in and out, penetrate in dead-end forays to a trailhead or campsite, or transect mountain uplands. You could spend profitable weeks just exploring the roadside photography possibilities by car. The park's prime attractions however, lie along two routes. Newfound Gap Road nearly bisects the park on a northwest/southeast axis and provides as its highlight panoramic views of classic Smoky Mountain mist-shrouded terrain. The Little Pigeon/Laurel Creek Road meanders streamside for miles across the northwest sector of the park, looping at its terminus through Cades Cove, an idyllic valley of virgin deciduous timber spaced by open meadows cleared and cultivated in a bygone era.

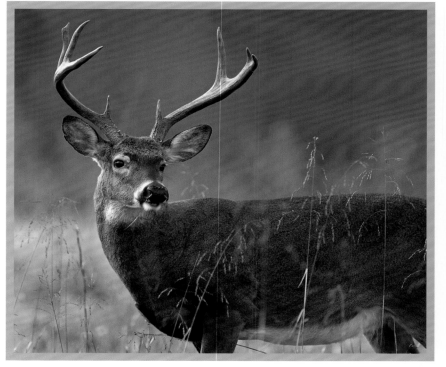

Visitor centers are strategically located inside the park near the main north and south entrances and at Cades Cove, as well as outside the park in Gatlinburg and Townsend, Tennessee. There are 10 campgrounds scattered about the park. Three of the larger ones (Elkmont, Smokemont, and Cades Cove) are conveniently situated in prime shooting locations. Except during winter, be sure to make reservations (accepted up to five months in advance at 800-365-2267). There is but one lodge inside the park (Leconte Lodge) which is accessible only by foot trail. Private commercial lodging, restaurants, and services are plentiful in

neighboring towns. Of these Gatlinburg has the best strategic location but it is also the most developed and crowded. Townsend and Pigeon Forge are good alternatives, less crowded but not as close to the action.

Local weather in the Smokies is affected by elevation which ranges from 800 to over 6,000 feet. The higher you travel in the mountains the colder and wetter it becomes. Spring weather is variable with cold and rainy days common. Summer is hot and humid, especially in the valleys. The most pleasant time is autumn when skies tend to be fair with warm days and cool nights. Frosts occur regularly in October. During winter, roads at higher elevations (including the road to Clingmans Dome) are closed due to snow and freezing temperatures. Chains are sometimes required to cross Newfound Gap Road after a snowfall. The valleys normally receive not much more that a snow dusting.

Spring and fall are far and away the best times for

View from Clingmans Dome (above). This location is great at both sunrise and sunset, especially when broken clouds hang above the vista to absorb and reflect the warm light of the sun. This shot was made from the west end of the parking lot minutes before sundown (Hot Spot 2).

View from Morton Overlook (above). **A telephoto zoom lens permitted precise framing of this pattern of hazy, overlapping ridges (Hot Spot 1).**

Jack-in-the-Pulpit and Wild Geraniums (far right). **I had to lay on the ground to record this delicate floral sculpture growing riverside in the Greenbrier area (Hot Spot 6). Light was bounced into the scene to brighten shadows and improve color saturation. Pentax 645, Rodagon 150mm f/5.6 lens with close-up bellows, polarizing filter, one second at f/16, Fujichrome Velvia.**

photography. Due to the park's varied elevation, the peak period for capturing either wildflowers or fall color can extend over several weeks. If you arrive during spring to find that flowers have already bloomed in the valleys, search for subjects on mountainsides and ridge trails. In autumn, fiery color first strikes mountain summits and then descends into the lowlands as the season passes. To time your shooting adventure, work with the following suggestions but be sure to check with park staff regarding actual conditions which vary from year to year: late April to mid-May for forest floor wildflowers, dogwood, and redbud; June and July for rhododendron, mountain laurel and flame azalea; last part of October for the best fall color which is found at middle to lower elevations.

You will need a full selection of lenses and close-up accessories for shooting the variety of subjects found in this park. Super telephoto lenses will be useful for photographing white-tailed deer, the most common large mammal. Quick-drying shorts and river sandals will allow you to get your feet wet in search of the perfect camera angle for a waterfall or rapids. In spring and summer, an umbrella and rain gear will keep you and your equipment dry during showers.

GENERAL STRATEGIES

Due to frequently overcast or hazy conditions, sunrise and sunset often do not present the dramatic display of sky color and landform-modeling that normally makes such times so magical for photography. Nevertheless, it is wise to set aside late- and early-day

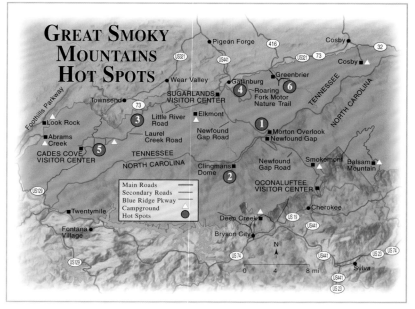

sessions for shooting at the park's premier viewpoints and then modify your activities to suit weather conditions. The presence of clouds and haze may adversely affect landscape photography but the Smokies' soft light and calm atmosphere are ideal for shooting mid-range forest scenes (no sky in the composition), waterfalls, babbling brooks, and wildflower and leaf close-ups. Mid-morning usually provides the best combination of strong, diffuse light and no wind.

The park is not so large that you cannot handle the main scenic attractions, even sunrise sites, from a base in Gatlinburg. If you wish to reduce the time you spend driving, stay at a campground or smaller town near your shooting location. For your first trip here, try spending a full day photographing and making short hikes from these four major driving routes, including a sunrise and/or sunset session: Cades Cove loop, Newfound Gap Road, Little River/Laurel Creek Road, Roaring Fork Motor Nature Trail. Once you have experienced these tours, return to the ones that you or conditions particularly favor for in-depth work, or explore new areas of the park such as Greenbrier or the east side and west side Foothills Parkways.

PHOTO HOT SPOTS

Visibility in the Smokies has declined (by 80 percent during summer) over the past 50 years primarily due to burning fossil fuels in generating stations. When shooting scenics, you will observe a white haze obscuring the landscape, especially during warm weather. Be persistent, some days are better than others.

Catawba Rhododendron (above). **The large blooms of this flowering evergreen shrub brighten Smoky Mountain forests in June and July. Throughout the spring and early summer, colorful blooms of numerous other understory bushes and small trees add colorful accents to the many shades of green of the forest habitat.**

❶ MORTON OVER-LOOK. This viewpoint is about 12 miles south of the Sugarlands Visitor Center beside the road as it winds upward to the pass. This premier sunset destination offers classic Smoky Mountain compositions of intersecting ridges sometimes accented with swirling mist (see p. 110).

❷ CLINGMANS DOME. On clear mornings this vista reveals blue mountain ridges stretching to the horizon. At sunrise the best vantage point is usually at the east end of the parking lot. At sunset try the rocky area at the west end. Both times are equally good. Let cloud and lighting conditions be the final arbiter of where you set up and what you include in the frame. Look for foreground trees to frame and give scale to the scene (see p. 109). During summer, wildflower shooting is good about the periphery of the parking area.

❸ LITTLE RIVER ROAD. There are many streamside pullouts along this narrow, winding, 18-mile paved route linking Sugarlands Visitor Center to the park entrance at Townsend. The attractions are at the water's edge—frothy rapids and tumbling cascades with trees hanging gracefully over the boulder-choked stream. Here you have possibilities for blurred-water compositions incorporating elements of the surrounding forest, lushly verdant in spring and summer, afire with warm color in autumn (see p. 107).

❹ ROARING FORK MOTOR NATURE TRAIL. This paved, one-way 5.5-mile route (closed in winter) a few miles south of Gatlinburg meanders through hills and beside racing streams. The road is reached by turning south at traffic light #8 on Gatlinburg's main drag (Route 441). In spring and summer you will encounter wildflowers all along the tour route and its foot trails. Autumn offers studies of the stream littered with colorful leaves. Roadside attractions are numbered and described in a booklet sold at a self-help station at the beginning of the tour. The overlook at Stop #3 presents beautiful vistas of iconic Smoky Mountain terrain at sunset (when polluting haze is absent). The trail to Grotto falls is at Stop #5. The trek to this graceful 20-foot plume is three miles round trip over easy terrain. You can shoot the falls dead-on or move behind it (into the grotto) for a novel angle (see opposite page). About 100 yards downstream from the falls is another cascade, not as high but just as photogenic as it tumbles rhythmically through a corridor of immense boulders. Near the end of the Roaring Fork Motor Trail, the road gives easy access to a variety of rapids and small waterfalls coursing through a photogenic maze of lichen- and moss-upholstered boulders (see opposite page).

❺ CADES COVE. This broad, flat valley was once

home to pioneer farmers. Their homes, barns, and churches are preserved as well as many of the fields and meadows which were used for cultivation or livestock grazing. For nature photography purists (like myself), it's a chore to dodge all of these human artifacts when trying to setup a composition. However, there are a lot of possibilities, especially in early morning, to record mist-shrouded pastoral scenes in soft, pastel light (see p. 108). The main attraction here are the white-tailed deer, especially in autumn when bucks carry large antlers and can be photographed against blurred backdrops of colorful foliage (see p. 108). The

deer are plentiful and fairly calm in the presence of people, but caution is necessary to stay within portrait range for more than a few minutes when shooting outside your vehicle even with telephotos of 500mm or longer. Arrive before sunrise to get a jump on the tourist hordes that show up after breakfast at this popular park destination. The 11-mile, one-way route circles the valley. Hyatt and Sparks Lanes provide interesting two-way shortcuts across the valley.

6 GREENBRIER. This quiet spot away from the main tourist route about 15 minutes by car east of Gatlinburg off Route 321 is a great place to photograph bubbling streams and small waterfalls. Foliage, fiery in autumn and freshly green in spring, hangs over the water. Roadside wildflowers are abundant here in April and May and the Porters Creek Trail at the end of the road is one of the park's premier wildflower locations. Have a great shoot!

Grotto Falls (above). **A 20-minute walk with moderate elevation gain will take you to this waterfall. The trailhead is accessed from the Roaring Fork Motor Nature Trail (Hot Spot 4). Make your hike when it's cloudy; otherwise direct sunlight will cause high contrast in the falls, eliminating details in highlights and shadows.**

Roaring Fork River (left). **The river sandals and shorts I was wearing made it convenient to grab this mid-stream camera angle (Hot Spot 4). For strong compositions, run the frothy liquid through the picture diagonally.**

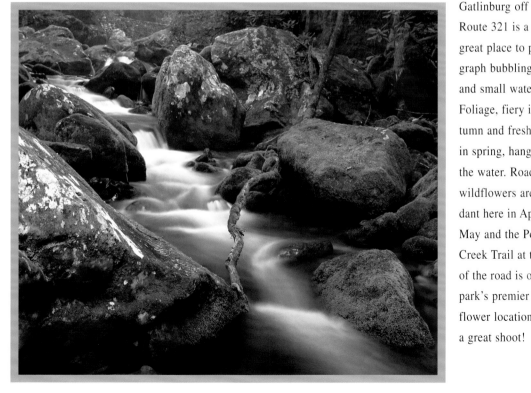

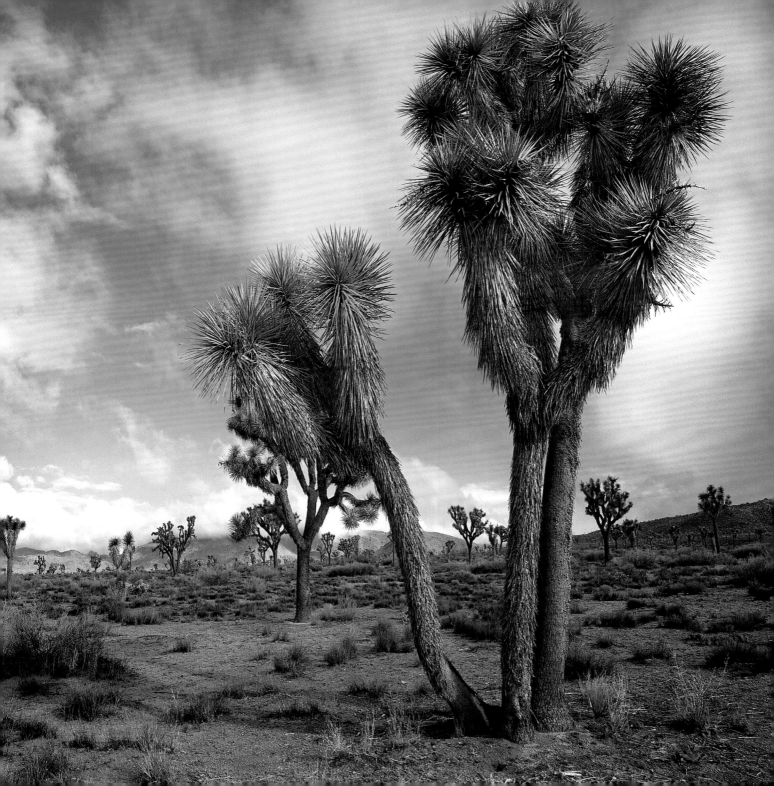

JOSHUA TREE

California • Fall/Winter/Spring/Summer • 760-367-5500 • www.nps.gov/jotr/index.htm

AS THE MEETING PLACE of two desert ecosystems, the Mohave and the Colorado, Joshua Tree National Park offers a variety of opportunities for photographing plants and wildlife of arid habitats within its 794,000 wilderness acres. The Colorado Desert occupies terrain below 3,000 feet in the eastern half of the park. Lower, warmer, and drier than western regions, these nearly monochromatic expanses stretch eastward from the park's midsection. The parched table lands are salted evenly with creosote bush (a grayish, nondescript shrub of modest size) and relieved periodically by photogenic patches of ocotillo, a red-flowering, spidery-limbed bush, and jumping cholla, a cactus bristling with sharp spines. In contrast, the higher terrain of the park's west side has cooler temperatures and greater precipitation which nurture the loose forests of Joshua trees that give the park its name. These shaggy, awkward-looking members of the lily family grow on sand and gravel plains amid wayward heaps and tall outcrops of rounded granite boulders frequently of enormous size and fantastic shape, an unworldly topography attractive to landscape shooters. In addition to these unique attractions, Joshua Tree is a great location for wildflowers when weather conditions are right. Beginning in February at lower elevations and lasting into June in upland regions, colorful blossoms adorn dry washes and flinty hillsides—poppies, clovers, lupines, mallows, sunflowers, and numerous species of cacti to mention but a few. The park is also home to the desert fan palm. Clumped in five oases, this is a large and distinctive species, somewhat begrudging of compelling photography due to the harsh lighting conditions of its open setting.

You will enjoy shooting at Joshua Tree at any time of year inasmuch as the park's most distinctive features (unique topography, Joshua trees, and cacti) present themselves

Barker Dam (above). This small pool reflects massive granite outcrops on its western edge, making it an ideal sunrise destination. Try to schedule your visit for a morning when clouds hang over the western horizon. Try to be on site ready to shoot at least 15 minutes before sunrise to the catch the light show reflected from the clouds (Hot Spot 2).

Beavertail Cactus (left). Cacti of many species bloom throughout the park from March at lower elevations into June at higher elevations . A white reflector was used to brighten the harsh shadows of this magenta bouquet.

Queen Valley (far left). This rhythmic stand of Joshua Trees grew alongside Park Boulevard in Queen Valley. A cloud-dappled sky provided delicate illumination for the scene.

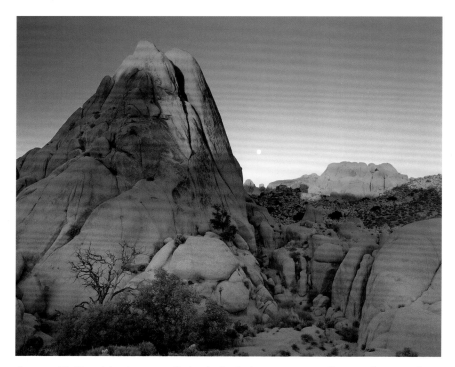

Outcrop with Moon (above). **The moon drew my attention to this massive rock outcrop near Jumbo Rocks campground, one of many in the park (Hot Spot 3).**

Monkey Flower Wash (far right). **During spring, you may encounter stretches of desert transformed by carpets of wildflowers. This March scene was discovered along the Old Dale Road. Canon T90, Canon 100–300mm f/5.6 L lens, polarizing filter, 1/2 second at f/22, Kodachrome 64.**

avoid disappointment, call park headquarters for an update in advance of your visit.

There are nine campgrounds scattered about this compact park allowing convenient commuting to shooting sites. Jumbo Rocks, Belle, and White Tank are closest to the main action and available on a first-come/first-served basis. No lodging is available inside the park, but ample accommodation and other services are conveniently located in the small towns lined up along the northwest border.

If you are camping, a super telephoto lens may come in handy for recording coyotes, jackrabbits, roadrunners, and lizards that frequent these areas. Otherwise, you will need equipment for close-up photography of still-life subjects (especially wildflowers) and for shooting landscapes. Bring stout hiking boots for clambering about rock formations in search of the perfect camera angle. Knee pads will make ground-level shooting of wildflowers more pleasant in

distinctively during any season. Summer is uncomfortably hot (well over 100°F) but relieved by thunderstorms and dramatic skies. Fall offers clear skies and pleasant temperatures. During winter, higher elevations experience freezing nights and are dusted periodically with snow. Spring is the preferred season, a time of pleasant weather and beautiful wildflower displays. Peak blooming times vary from year to year. To

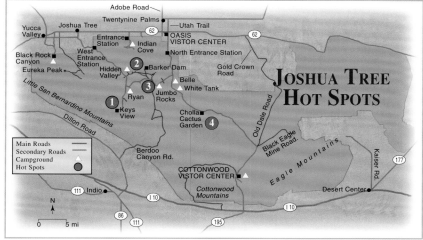

Keys View (above). **Photographed at sunset, this camera position is about 40 yards northwest of the viewing area near the parking lot (Hot Spot 1). In this composition the slope of the foreground contrasts with the rhythmic diagonal flow of ridges in the distance. A two-stop neutral density filter was used to reduce the brightness of the sky and record more detail in the shadow areas of the scene.**

the magnification of key features in preparation for the few minutes of shooting at sunset or sunrise. Once you are satisfied with your scouting, you can focus attention on wildflowers, wildlife, or other subjects which you may discover. You can access most of the top landscape locations easily from any of the campgrounds off Park Boulevard. More driving will be required if you are staying in one of the towns outside the park's boundaries.

PHOTO HOT SPOTS

As in so many parks, the best shooting locations in Joshua Tree at any given time are dependant on the weather and season. A colorful sky makes a difference to any landscape image, often exceeding the main subject in its effect on the photograph's impact.

this terrain strewn with sharp rocks, thorns, and cactus spines. A white reflector will brighten shadows and so reduce contrast and produce better color saturation in this starkly sunny environment.

GENERAL STRATEGIES

Although there are plenty of magnificent vistas to record in Joshua Tree, except for Keys View, they do not present themselves in the obvious fashion of an El Capitan or Grand Teton. You will need to spend time each day evaluating shooting locations by checking lighting angles, sorting out perspective cues, searching for interesting foreground elements, and establishing

❶ KEYS VIEW. This dramatic location is reached via Keys View Road which branches south off Park Boulevard 19 miles from the Oasis Visitor Center. The road climbs steadily for 4.5 miles to the crest of the Little San Bernardino Mountains, terminating in a small parking area. A 1/4-mile paved trail provides easy access to the rim and views to the south and west across a broad valley to the San Jacinto and San Gorgonio Mountains. This site is photogenic at either sunrise or sunset when the rhythmic lineup of ridges is defined by soft, warm light. Unfortunately, smog, which becomes more prevalent each year, may obscure the view. The best shooting

conditions occur in winter and during clearing storms. Try using a telephoto zoom lens to isolate the distinctive patterns of this landscape (see photo opposite).

②BARKER DAM. This location provides the opportunity to photograph Joshua Tree's distinctive granite outcrops reflected in a natural-looking pool held back by a concrete dam built by ranchers years ago. The easy one-mile loop trail is accessed from the dirt road two miles east of Hidden Valley Campground. The trail to the pool is a pleasant area to photograph wildflowers and cactus during spring. This site is most photogenic at sunrise with clouds on the western horizon. Granite outcrops on the west side of the pool receive the sun's first rays and cast unobstructed reflections (see photo p. 115).

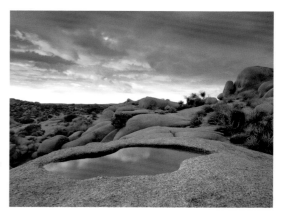

③JUMBO ROCKS. This location near the campground of the same name is an expansive maze of massive granite domes, steeples, benches, and towers. The rocks are fringed at their bases with Joshua trees, cacti, and desert shrubs. Your approach will be guided by ambient conditions of light and sky rather than the distinction of a particular rock formation. Jumbo Rocks (like other rocky areas) is especially exciting to photographers after a rain when shallow pools of water, ideal for capturing reflections, form in depressions (see photo this page).

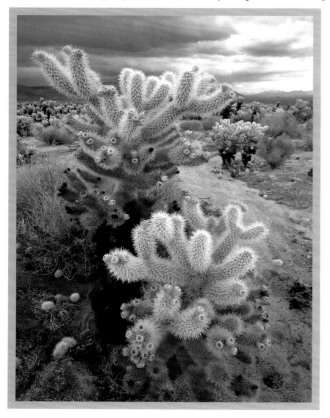

④CHOLLA CACTUS GARDEN. This dense growth of distinctive cactus with the demeanor of a teddy and the temper of a grizzly grows alongside Pinto Basin Road about 20 miles north of the Cottonwood Visitor Center. A good choice of background topographies and lighting angles are available at both sunset and sunrise. Due to the high contrast of the subject, you should shoot during twilight (when the sun is below the horizon) or on cloudy days (see photo this page). Good luck and don't back into a cactus!

Jumbo Rocks (above). **When shooting in this labyrinth of giant boulders (Hot Spot 3), I work my way along the crest of the formations, looking for interesting foreground features that I might combine with mountains or clouds on the horizon. This ephemeral pool reflected a colorful sunset due to a ground-level placement of the camera.**

Cholla Cactus Garden (left). **The subtle colors of these cacti are best recorded under cloudy skies or during periods of twilight before sunrise or after sunset (Hot Spot 4). Pentax 645, Pentax 35mm f/3.5 lens, polarizing filter, two seconds at f/22, Fujichrome Velvia.**

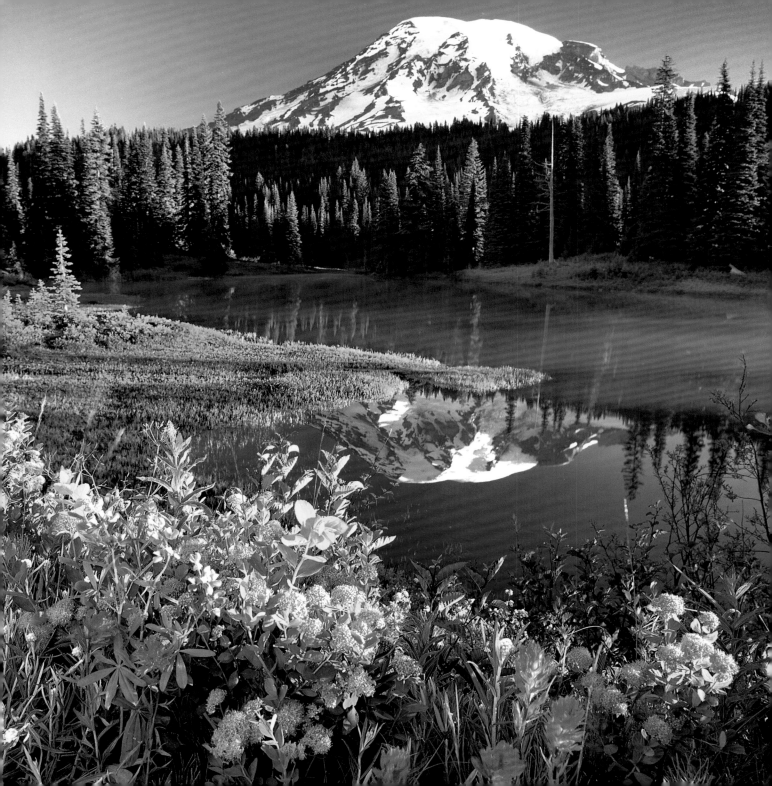

MOUNT RAINIER

Washington • Summer/Fall • 360-569-2211 • www.nps.gov/mora/index.htm

AN ENORMOUS ACTIVE VOLCANO, Mount Rainier soars to 14,411 feet, towering over nearby peaks in the Cascade Range by more than 8,000 feet. Often hidden by clouds, the mountain's isolated, ice-clad profile dominates the landscape for 100 miles in every direction on clear days. Its 25 major glaciers, spreading over 35 square miles, comprise the largest mass of permanent ice on any mountain in the lower 48 states. Below its shining photogenic crown, the slopes are carpeted by lush subalpine meadows renowned for their displays of wildflowers during summer. Various forest types sheath the middle slopes and foothills of the mountain, including temperate rainforests with giant specimens of Douglas-fir, western red cedar, Sitka spruce, and mountain hemlock soaring 25 stories. Adding to these attractions are white water streams and rivers, cascades, waterfalls, lakes, and tarns, and a confiding menagerie of alpine birds and mammals.

Mount Rainier is within easy driving distance of Seattle and Tacoma, Washington and Portland, Oregon. More than 2,000,000 visitors enjoy the park each year. During summer, its narrow, winding roadways and parking lots become jammed with vehicles, especially on weekends. Unfortunately July and August are also the best times for shooting due to the display of subalpine wildflowers, one of the most impressive in North America. If possible, schedule both your arrival and initial exploratory forays for midweek to avoid road delays and crowded trails. September is the next best month when the waning wildflower show is invigorated by colorful displays of autumn foliage and crowds have dissipated. The park offers all basic

Columbia Lily (above). **Mount Rainier is wildflower heaven during summer (Hot Spot 1). For dramatic portraits, stay low and get close.**

Mount Rainier from Reflection Lakes (far left). **This idylic location is one of the most photographed in the park (Hot Spot 2). A wideangle lens was placed close to the foreground flowers and set at its smallest aperture (f/22) for maximum depth of field.**

Black-tailed Deer (left). **This mule deer sub-species is common throughout the park. Eyes, the most important feature in portraits, should be well-lit and sharply focused.**

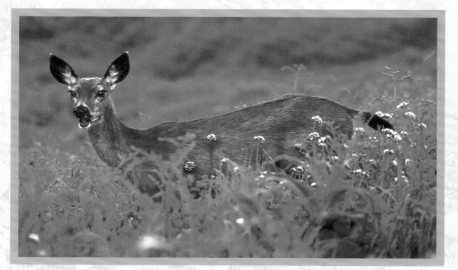

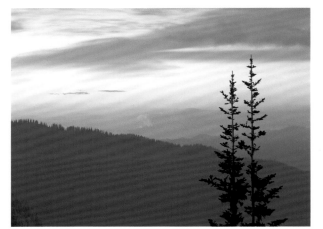

View from Sunrise Point (above). This roadside overlook (Hot Spot 4) provides sweeping views of the Cascade Range. It was taken with a medium telephoto lens (200mm) 10 minutes after sunset.

Red Columbine (right). This common park species was photographed near Reflections Lakes (Hot Spot 2)

Wind-blown Wildflowers (far right). This patch was photographed near the visitor center at Paradise (Hot Spot 1). A shutter speed of 1/8 second resulted in a blurring of the wind-tossed blossoms.

facilities except vehicle fuel. (You should fill up before entering the park and keep an eye on your gas gauge). If you are camping, it's a good idea to buy supplies in one of the towns outside the park where you will find better selections. Lodging is available both within the park (book months in advance for the summer season) and in settlements on the periphery. Two campsites, Cougar Rock and Ohanapecosh, are available only by reservation during summer (800-365-2267). At other campgrounds you should check in early in the day (most sites are taken by noon in summer on Fridays). Plan for rain and mist when you visit Mount Rainier. The mountain creates its own weather systems (mostly wet) and roads and trails at upper elevations are often swirling in fog in the morning. This soft light and misty atmosphere is ideal for shooting some of the park's main attractions—wildflowers, forests, streams, waterfalls, and wildlife.

You will want equipment for shooting everything from landscapes to lilies. Special helpful accessories

include rain gear, particularly rain pants for working low to the ground, and hip or chest-high waders for getting just the right angle on a waterfall, stream swirl, or reflection. An umbrella (and a helper to hold it) is handy for keeping your camera dry in the rain. Soft cotton cloths are recommended for wiping stray moisture from cameras and lenses. Vibrant color films (e.g., Fujichrome Velvia) are ideal for shooting in Rainier's soft light. Bring a medium speed film (ISO 100–200) for shooting wildlife in overcast conditions. A portable, fold-up reflector with a white surface will be beneficial for brightening shadow areas in wildflower portraits even when it is overcast.

GENERAL STRATEGIES

Primary photographic attractions are accessed from the park's major roads which skirt the south and east sides of the volcano. Photographing the main attractions can be divided into two or three geographic segments described here beginning with the most exciting.

In the south/central portion of the park you will find the park's most beautiful photo sites, the subalpine meadows, streams, and waterfalls of the Paradise area. There are also grand, high-elevation roadside viewpoints in this region. You could spend your entire visit here and not run out of stimulating subjects. The second major area is

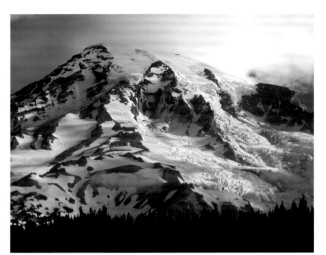

Mount Rainier (above).
This close-up view of Rainier's textured flanks was taken from Reflection Lakes with a telephoto lens in early morning. A polarizing filter was used to reduce haze and strengthen color (Hot Spot 2).

Paradise River Falls (far right). **This cascade is found alongside the Paradise Valley loop road. Soft light from overcast skies is essential for shooting waterfalls. To create blur, use a slow shutter speed (1/15 second or longer). Sharply etched, stationary features (rocks in this case) accentuate by contrast the silky flow of water.**

Sunrise, about an hour's drive east and north of Paradise on the highest paved route (6,400 feet) in the state. The road ends at Yakima Park, a huge open meadow with plenty of wildflowers. Grand vistas of Rainier and other peaks are accessed on trails radiating from the rustic Sunrise Visitor Center. Last on the list of the park's premier attractions are its temperate rain forests found in two sites. You'll drive right past one of them near the Stevens Canyon Entrance on your way from Paradise to Sunrise. To reach the second site, you must leave the park and re-enter at the Carbon River Entrance in the northwest corner, a long journey that is worthwhile if you have time to spare on an overcast day. Here, there are waterfalls and easy trails winding through big trees.

PHOTO HOT SPOTS

Mount Rainier is a huge wilderness with endless photo possibilities. These sites will help to get you started on your exploration.

❶ **PARADISE MEADOWS**. This sweep of subalpine terrain provides an extravagant show of wildflowers (more than 30 species in a rainbow of colors) through July and August. Several paved trails (some are under snow until August) beginning in the vicinity of the parking lot meander through the blooms allowing you to shoot trail-side specimens close-up (visitors are restricted to trails to protect the meadows from trampling) and to take wider pattern shots of concentrated patches. Descriptions of these hikes are provided by signs at trail heads.

❷ **REFLECTION LAKES**. These roadside pools provide one of the finest and most easily accessed landscape compositions in the park (see photo p. 120). From several vantage points the lakes provide both

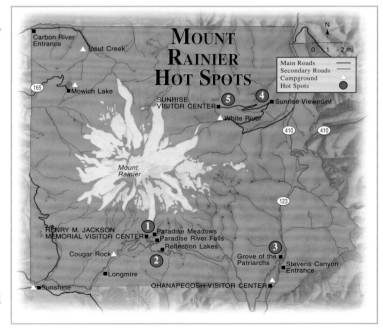

reflections of Mount Rainier and colorful bunches of wildflowers that can serve as interesting foreground features. The best light and time for mirrorlike reflections occur first thing in the morning. Be ready to shoot 45 minutes before sunrise to capture the first golden rays on the peak. Unfortunately, the mountain is apt to be shrouded in cloud at this time, even on sunny days, and it may require several attempts to capture this mountain in all its naked glory. There are plenty of wildflowers in the area for macro-shooting while you are waiting for the sky to clear (see photo p. 122).

3 GROVE OF THE PATRIARCHS. This old-growth forest is a choice photo destination during overcast periods only. Misty or light rainy conditions are even better for capturing the lush greens of these stands of enormous, moss-hung Douglas-firs, western hemlocks, and western red cedars. The trail head is about 1/4 mile west of Stevens Canyon Entrance on Stevens Canyon Road. The level path follows a 1.3-mile course along the Ohanapecosh River. The most impressive trees are across the suspension bridge on a small island which should be your prime destination (see photo this page).

4 SUNRISE VIEWPOINT. This overlook, about 2.5 miles east of the Sunrise Visitor Center on the main access road, offers panoramic views of a stack-up of mountain ranges and ridges to the north. At sunrise and sunset, this dramatic terrain surrenders to abstract telephoto views of compressed softly-tinted overlapping patterns (see photo p. 122).

5 SUNRISE TRAILS. The road to Sunrise is generally open from July through October, depending on

weather. The Sunrise area receives less rainfall than southern and western portions of the park. Its subalpine meadows, though not so lush as those at Paradise, offer many species and dense blossom patches. What makes this location special are the numerous trails radiating from the parking area that offer dramatic views of Rainier. The Sourdough Ridge Trail follows the ridge that looms above the road to the east. It is lined with wildflower meadows and provides some of the best sunrise angles on Mount Rainier. The half-mile Emmons Vista Trail (beginning at the south side of the parking lot) offers excellent sightings of Mount Rainier, Little Tahoma's rugged peak, and Emmons Glacier. This trail also offers possibilities for shooting marmots and ptarmigan. Remember to pack your umbrella and have a great shoot!

Grove of the Patriarchs (above). **This beautiful forest of old-growth trees (Hot Spot 3) is best photographed on wet, overcast days. Here a polarizing filter was used to eliminate foliage reflection and increase color saturation.**

Tatoosh Range from Ricksecker Point (far left). **This sunset scene was shot from the one-way loop road between Cougar Rock and Paradise. Pentax 645, Pentax 80–160 f/4.5 lens, split neutral density filter, one second at f/22, Fujichrome Velvia.**

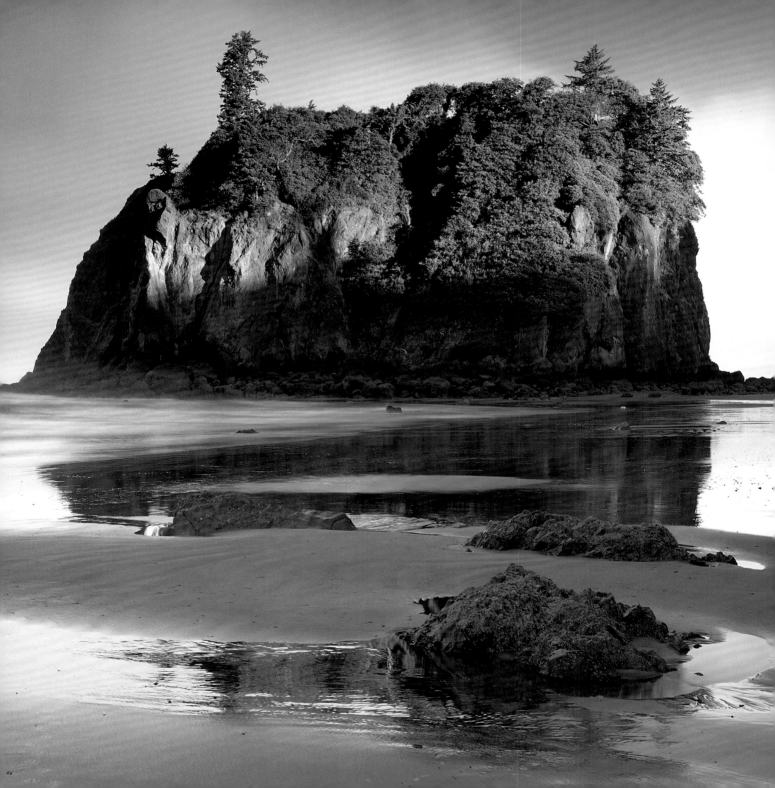

OLYMPIC

Washington • Spring/Summer/Fall • 360-452-4501 • www.nps.gov/olym/index.htm

OLYMPIC NATIONAL PARK'S 922,000 pristine acres is home to three easily reached wilderness eco-systems of distinctive character and compelling photographic interest. First is a disconnected 60-mile strip of stunning coastline stretching along its Pacific flank. These wave-groomed beaches are hemmed in by barricades of giant trees and furnished with a variety of photogenic landscape features: wide sweeps of rippled sand, fields of glistening boulders, tidal pools, and towering seastacks. On the western margins of the park's main inland sector grow virgin temperate rain forests of record size— soggy communities of monumental trees wrapped in moss and draped with ferns and lichens, a unique multi-textured world of greens offering myriad design possibilities. The third major photo attraction is an enormous, circular expanse of alpine terrain drained by 13 radiating river systems. This unspoiled habitat offers the photographer lush wildflower meadows during summer, confiding wildlife, and numerous breathtaking panoramic views of jagged ice-capped peaks and misty ridges.

Although close to Washington State's major urban centers, the park is buffered by the waters of Puget Sound which restrict the flow of tourists to circuitous highway routes and/or slower ferry passage. Nevertheless, peak summer periods experience crowded trails and heavy traffic. Campgrounds are available on a first-come/first-served basis (check in early in the day

Steller's Jay (above). **These large jays cruise about campgrounds hoping to pilfer food scraps. Intimate portraits can be captured with super telephoto lenses as the birds perch on nearby limbs watching the action below. Overcast light is best for recording their dark plumage**

Moss-wrapped Big-leaf Maples (left). **I noticed this tight group of trunks by the side of the road near the entrance to the Hoh Rain Forest (Hot Spot 3). Soft light from a cloudy sky was perfect for revealing the shades of green.**

Ruby Beach (far left). **Of the numerous spectacular beaches on the Pacific Coast, this is my favorite. This picture was taken on a misty summer morning at low tide (Hot Spot 4).**

Olympic Marmot (below).
**These oversized rodents
are found on Hurricane
Ridge (Hot Spot 1). They
can be approached within
10 feet if caution is used.
This flower-chomping
specimen was shot with a
500mm lens + 25mm exten-
sion tube for close focusing.
The eye-level camera angle
resulted in an intimate
portrait and a soft out-of-
focus background.**

during summer) and some are open year-round. There are several lodges offering accommodation by reservation. (See website or call park headquarters.) Port Angeles is the main commercial center for the entire park and, if camping, you should purchase your supplies here. All main access routes are off U.S. 101, a paved highway which plies the park's northern and western flanks.

Summer is the peak season for photography. You will be able to photograph wildflowers in alpine regions inland and coastal scenes during periods of low tide and sun-laced morning fogs. It's not unlikely that a summertime visit will also coincide with periods of overcast which are desirable for making the most of your rainforest photography. September and October are also good visiting times as alders, vine and big-leaf maples, and other deciduous tree species are wearing autumn colors and alpine areas are not yet obscured by snow.

In any season, you should come prepared for a variety of weather conditions. The park has a mild marine climate—normally summers are warm and sunny with the remainder of the year experiencing greater precipitation in the form of steady rain and drizzle at lower elevations with snow accumulating to 10 feet in upland areas.

Of special concern to photographers is the timing of daily tides. You will want to shoot on the beaches at the lowest tides in order to capture both the interesting animals and plants of the intertidal zone and the varied terrain of boulders, rocks, and still pools that are temporarily exposed by the receding waters. To help schedule your photo sessions, pick up a tide table at one of the visitor centers.

For photographic gear, a full range of close-up, wildlife, and landscape equipment will be needed to capture all of the park's distinctive attractions. Additional helpful accessories include a small white reflector for improved lighting when shooting close-ups of wildflowers, rain forest fungi, and intertidal life; surf sandals, sneakers, or waders and shorts for working along the shoreline; and rain protection for both you and your equipment, including cotton cloths or towels for mopping up cameras and lenses. Take along a good supply of fine-grained color film for landscapes and still-life studies and a smaller amount of medium-speed film for wildlife.

GENERAL STRATEGIES

The photo attractions at Olympic can be experienced best from four staging points: Port Angeles in the northeast corner, the Hoh Rain Forest area, Mora at the northern end of the Pacific Coast beaches, and Kalaloch at the southern end. These locations have convenient nearby camping and/or lodging.

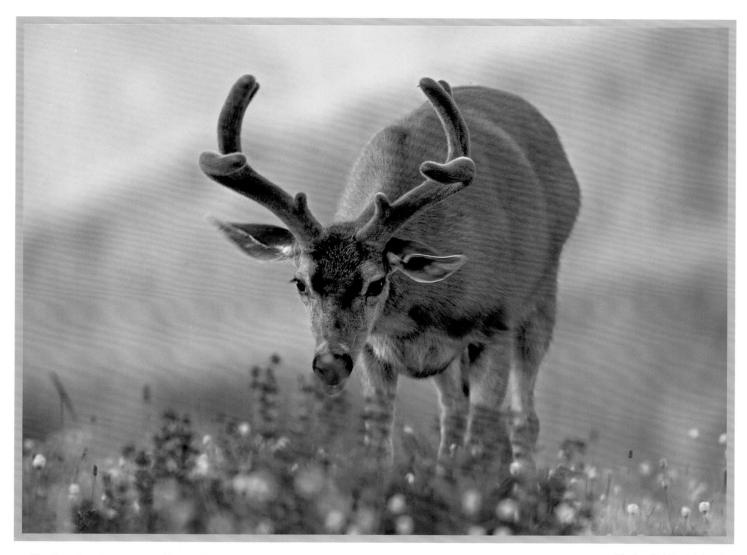

The Port Angeles area provides ready access to the park's premier alpine area, Hurricane Ridge. You can stay at one of the numerous hotels or motels in town about 17 miles (30 minutes) from the summit, or camp at Heart O' the Hills just inside the park boundary and save some commuting time. During summer, the paved access highway and the ridge area itself offer excellent shooting of wildlife, wildflowers, and landscapes.

When leaving Port Angeles for Mora on the coast, you should plan on spending a full day or more

Black-tailed Buck (above). **These people-habituated deer can be photographed feeding in subalpine meadows on Hurricane Ridge (Hot Spot 1).**

exploring the sights along US 101. On overcast days you will have good results shooting Marymere Falls near the Storm King Information Station and Sol Duc Falls about two miles past Sol Duc Hot Springs. Both sites are accessible by easy trails. On sunny days, you might want to forego midday photography for a relaxing soak in the hot pools at Sol Duc.

The attraction at Mora, the next overnight stop on US 101, is Rialto Beach, a long sweep of driftwood-cluttered, sand and pebble shoreline with interesting foreground features for setting up seascape views. From this coastal enclave head inland to the famed Hoh Rain Forest. Plan on another overnight stay which will allow photography in the soft light after sundown or before sunrise, should clear skies coincide with your visit. Your final destination, and for me the most excit-

ing attraction of Olympic National Park, is the southern coastal strip where a line up of seascape and tideline opportunities await you from Ruby Beach to South Beach.

PHOTO HOT SPOTS

① HURRICANE RIDGE.

Fearless black-tailed deer wander this area. One of the best deer spots is along the short Meadow Loop Trail above the main parking area. Olympic marmots can be photographed from numerous trailside locations usually during midday when they are feeding and basking in the sun. Wildflower patches, often dominated by lupines, are everywhere including along the main access road coming up from Heart O' the Hills. At the end of the road is the trailhead for Hurricane Hill. This route climbs through flower meadows and scattered marmot colonies to lookouts on the summit which give sweeping views in almost every direction. Both sunrise and sunset are ideal times for shooting here (see

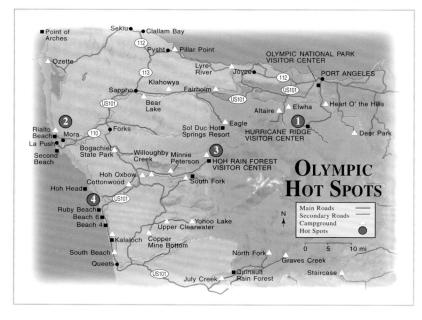

Kalaloch Beach (above). **I used a zoom lens to isolate the beautiful curves of this coastal stream winding toward the horizon. This scene was photographed near Kalaloch Lodge. Pentax 645, Pentax 80–160 f/4.5 lens, polarizing filter, 1/2 second at f/16, Fujichrome Velvia.**

Olympic Mountains from Hurricane Hill Trail (far left). **Numerous grand views in almost every direction are possible from the summit of this trail (Hot Spot 1). This picture was made with a 200mm telephoto lens. A two-stop split neutral density filter was used to prevent overexposure of the sky.**

Rialto Beach (above). **This glistening sunset composition was captured in between waves using a one-second shutter speed which transformed the rush of receding water into a textured flow of silvery silk. (Hot Spot 3.)**

Goosenecked Barnacles (right). **These colorful creatures usually can be photographed during minus (ultra-low) tides. On Olympic beaches, clusters can be found clinging to rocks near the water's edge. Overcast skies are needed to record the full range of texture and color.**

photo p. 132).

❷ RIALTO BEACH. Driftwood logs along this stone and pebble beach offer distinctive foreground ingredients for dramatic seascapes at both sunset and sunrise. James Island and Cake Rock offshore provide interesting components to target in the background. Nearby Second Beach on the south side of the Quillayute River is just as attractive. Golden light on seastacks offshore and low tides lend drama to morning shooting sessions during summer (see photo above).

❸ HOH RAIN FOREST. Try to schedule your photography here for an overcast day, a period of mixed cloud and sun, or twilight. You likely will not be happy with pictures made under sunlight from a clear sky due to excessive contrast. The Hall of Mosses Trail and Spruce Trail provide excellent photo possibilities with minimal hiking. You will benefit little by venturing elsewhere. The visual stimuli in a rainforest can be overwhelming. I often try to simplify scenes by isolating rhythmic patterns of trunks with longer lenses or by targeting interesting close-up details (see photo p. 129).

❹ RUBY BEACH. This is the most spectacular of a string of beautiful wilderness beaches in the park's southern coastal sector. During periods of minus-tides, expanses of rippled sand, tidal pools, enormous boulders, and tree-topped seastacks stretch as far as you can see up and down the coast. In the morning, the beach is draped with undulating fog and mist which cloak landscape features mysteriously and create stagey spotlight effects as the sun appears above the horizon. The exposed rocks are carpeted with colorful seastars, blue mussels, and other inter-tidal creatures. By sunset the fog has usually dissipated and you can capture the sky's flaming show reflected in still pools and glinting on breaking surf. Split neutral density filters are necessary to equalize the brightness of the sky and shoreline elements. The best place to shoot is usually near the water line. If you set up in the sand, be aware that incoming waves will undermine your tripod and cause it to topple. Long exposures create silky records of the water's winding journey around rocks and other obstacles as it surges up and down the beach. This is a huge, varied photo location. If possible, schedule at least one session at Ruby Beach for both

sunrise and sunset (see photo above). Other beaches, nearly as spectacular, are strung along the shore southward and should not be missed—Beach 6, Beach 4, and Kalaloch (see photo p. 133.) being my favorites. When shooting beaches, keep in mind that mood and atmosphere vary from day to day and minute to minute depending on wave action, tidal fluctuation, and sky conditions. Each shooting session is bound to produce different results. Stay out of the breakers and have a great shoot!

Ruby Beach (above). **This pristine wilderness shore (Hot Spot 4) merits several photography sessions, if time allows.**

REDWOOD

California • Spring/Summer/Fall • 707-464-6101 • www.nps.gov/redw/index.htm

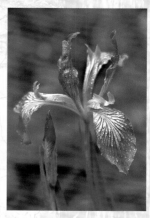

GROWING OVER 300 FEET tall and living up to 2000 years, the redwood tree, prized for its strong, rot-resistant wood, was threatened by logging near the turn of the last century. Fortunately remnant groves of the original forests were preserved in 26 California state parks including three that are today cooperatively managed in conjunction with Redwood National Park (108,400 acres). A sliver of fog-shrouded wilderness in the northwest corner of California, the protected area stretches along the coast for about 50 miles, encompassing not only towering redwoods but gigantic Douglas-fir, Sitka spruce, and western hemlock and understory berry bushes, ferns, and wildflowers. In addition, the park protects oak parklands, stream and river habitat, and miles of surf-swept beaches. In places the

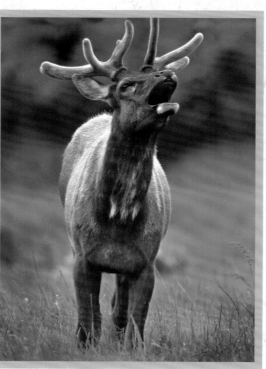

shoreline is smooth sand, in others it is a bulwark of boulders and rocky headlands harboring tide pools inhabited with sea stars, anemones, and urchins and patrolled by gulls, terns, and oystercatchers.

For the photographer, subject variety and weather conditions are often ideal for nonstop shooting from dawn to dusk. Light on the forests is usually soft, shielded from the sun's direct rays by a blanket of cloud or a breeze-wafted cloak of fog that choreographs a dance of sunlight and shadow on the textures and oversized dimensions of the forest. Should you become momentarily satiated by such grand views, you can direct your attention to smaller treasures of the understory—fungi, ferns, mosses, and lichens and blooms of flowering herbs

Douglas Iris (above). **This graceful bloom was recorded beside Howland Hill Road, a good area for wildflower species in spring. The frequently overcast skies in Redwood provide soft light ideal for wildflower portraits.**

Roosevelt Elk (left). **These giants of the deer family are common in the Prairie Creek Redwoods area (Hot Spot 2).**

Del Norte Coast Redwoods (far left). **When shooting forests, a calm atmosphere and soft light are essential for attaining detailed images with saturated color. Pentax 645, Pentax 45–85mm f/4.5 lens, polarizing filter, two seconds at f/22, Fujichrome Velvia.**

Cal-Barrel Redwoods (right). **There are endless possibilities for creating abstracted studies of texture, form, color, and pattern in the redwood forests (Hot Spot 3).**

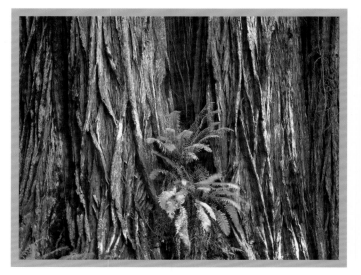

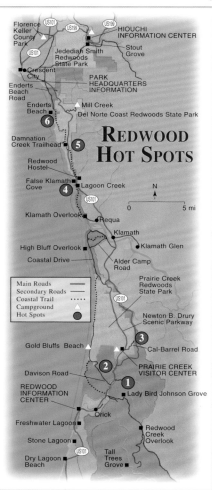

Florence Keller County Park

Jedediah Smith Redwoods State Park

Stout Grove

HIOUCHI INFORMATION CENTER

Crescent City

PARK HEADQUARTERS INFORMATION

Enderts Beach Road

Enderts Beach

Mill Creek

Del Norte Coast Redwoods State Park

⑥

Damnation Creek Trailhead ⑤

Redwood Hostel

False Klamath Cove ④ Lagoon Creek

N

0 5 mi

Klamath Overlook Requa

Klamath

High Bluff Overlook Klamath Glen

Coastal Drive Alder Camp Road

Main Roads
Secondary Roads
Coastal Trail
Campground
Hot Spots

Prairie Creek Redwoods State Park

Newton B. Drury Scenic Parkway

③

Gold Bluffs Beach Cal-Barrel Road

② PRAIRIE CREEK VISITOR CENTER

Davison Road ①

REDWOOD INFORMATION CENTER Lady Bird Johnson Grove

Orick

Freshwater Lagoon Redwood Creek Overlook

Stone Lagoon

Dry Lagoon Beach Tall Trees Grove

REDWOOD HOT SPOTS

and shrubs. No less a photographic attraction are miles of pristine shoreline offering beautiful seascape opportunities, especially at day's end. During low tide, you can aim your macro gear at colorful lifeforms exposed by the receding ocean. The coastal zone is also good for long-lens assaults on pelicans, herons, cormorants, and other seabirds. Additional telephoto targets include the Roosevelt elk, a 1,000-pound denizen of prairies and forest glades.

Redwoods's mild climate (40° to 60°F all year) welcomes photographers. Cool temperatures, rain, and overcast skies make winter the least desirable season for visiting. In early spring, forest openings and prairies are flushed with wildflower blooms. In late May and early June, redwood groves become especially beautiful as evergreen rhododendron shrubs illuminate the minty depths of the understory with pink blossoms. The lowest daytime tides occur during summer making beach photography attractive. The warmest season also experiences the most fog, an element that can be used to photographic advantage, especially when shooting in

the forests. In October, deciduous species (alder, big-leaf maple) add bronze and yellow pigments to the palette of forest greens and the antlers of bull elk reach their maximum size.

There are five visitor centers and six campgrounds scattered the length of the park. Camping reservations (800-444-7275) are advised during late spring and summer. Lodgings, restaurants, and supplies are available in Crescent City, Klamath, and Orick.

The wide variety of subjects—landscape, seascape, macro still-life, and wildlife—call for a full camera kit. Rain protection is necessary during any season. Bring quick-drying shorts and

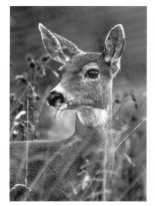

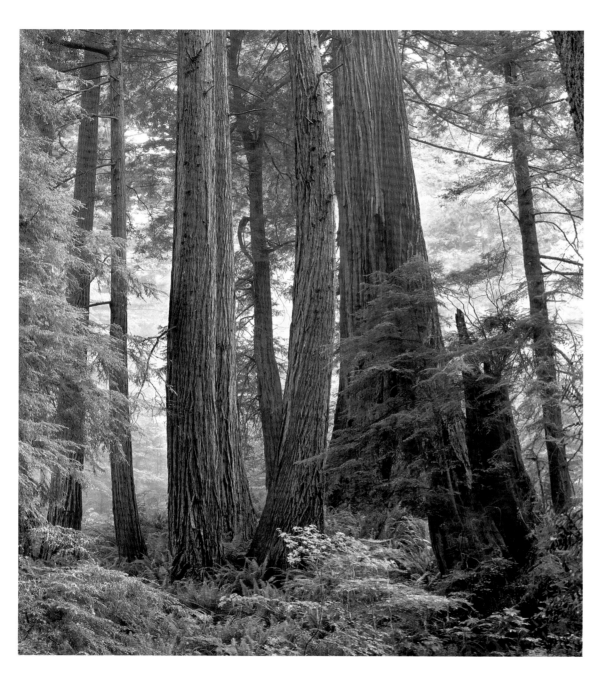

Coastal Trail Redwoods (left). This clump of redwoods was photographed along the Coastal trail, a photogenic footpath that runs parallel to Highway 101 for about five miles in the Del Norte Coast Redwoods sector of the park. By masking background features (such as these trees), fog imparts a feeling of depth to landscape images. In Redwood National Park, you will encounter fog almost every day during warm weather. For varied effects, work near the edge of fog banks.

Black-tailed deer (far left). When shooting animal portraits, try to capture the animal looking into the picture frame with its ears fanned toward the camera and its eyes glistening with highlights. You can often find herds of black-tailed deer near the Prairie Creek Visitor Center during the summer months.

Enderts Beach (above). **I waited until the sun neared the horizon to capture the warm tones and dramatic shadows cast by fist-sized rocks (Hot Spot 6).**

Black Oystercatcher (right). **During periods of low tide, these shorebirds forage commonly along boulder beaches (False Klamath Cove and Stone Lagoon areas). Although wary, black oystercatchers can be photographed with super telephoto lenses after careful stalking. Canon T90, Canon 500mm f/4.5 L lens, 1/250 second at f/5.6, Kodachrome 64.**

surf sandals for shooting along the beach. Cotton cloths are handy for wiping mist and sea spray from equipment.

GENERAL STRATEGIES

Fog will orchestrate most of your activities in this park, especially during warmer weather. It adds an element of mystery and exaggerated perspective to all forest photographs. Generally you will want to shoot the redwoods near the tattered, wispy periphery of a fog bank where penetrating shafts of sunlight can be used for theatrical effects. To access such locations, wait until early afternoon when clearing begins or drive to a higher elevation near the ceiling of the fog bank. Highway 101 through Del Norte Coast Redwoods State Park has classic redwood groves (with rhododendrons) and plenty of elevation change (stay at the Mill Creek Campground). Nearby are great beaches for sunset shooting. There's no harm in visiting the park's famous groves, but keep in mind these sites are famous for the size and abundance of

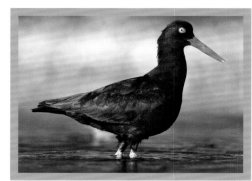

their trees rather than their photogenic attributes. I make light and atmospheric conditions my first consideration by working redwood stands growing on hillsides where I can adjust my shooting position both horizontally and vertically and more easily exclude distracting patches of white sky from the frame. Generally, I spend the first half of the day prospecting for fog-accented redwood groves and other forest compositions and pass the latter part of the day at the beach. Wildflowers, best photographed during calm, cloudy conditions, are found everywhere in spring and summer, especially along roadsides.

PHOTO HOT SPOTS

❶ LADY BIRD JOHNSON GROVE. The unique aspect of this grove, aside from the gigantic size of the redwoods, is an easy, winding trail that offers several magnificent views of entire, unobstructed trees in natural settings. Usually you only have opportunity to shoot the bulk, texture, and pattern of redwood trunks framed by intervening foliage or backed by a slash of white sky. Here you can demonstrate more readily the relative size and proportions of the forest habitat without compromising the design. The grove is located in the southern sector of the park off Bald Hills Road.

❷ PRAIRIE CREEK REDWOODS. You can readily see elk throughout the Prairie

Creek Redwoods sector, especially in open fields adjacent to the campground. The best place to photograph them is on both sides of Davison Road just off Highway 101 (see photo p. 137). There are small parking/viewing areas adjacent to where the elk congregate (usually in the evening). The elk are not alarmed by people walking along the road so you can move about to get the best camera positions.

❸ CAL-BARREL ROAD. This quiet gravel road in the Prairie Creek Redwoods sector winds through hilly terrain spiked with gigantic redwoods. Each bend in the road introduces a new arrangement of trees and light (see photo p. 138). The forest is fairly open and surrenders views that penetrate the forest interior rather than showing the usual wall of foliage.

❹ FALSE KLAMATH COVE BEACH. This stretch of wilderness coastline just south of the Del Norte Coast sector offers excellent sunset shooting whenever the sky is not completely overcast. There are numerous foreground boulders washed by waves and foamy surf and a few offshore seastacks to the north that can be used to anchor the distant view (see photo this page).

❺ DAMNATION CREEK TRAIL. There are beautiful arrangements of redwoods along the first half mile of this steep path. In late spring and early summer the misty understory is hung with pink blooms of rhododendron The well-marked trailhead is on the west side of Highway 101 at about the midpoint of the Del Norte Coast Redwoods sector.

❻ ENDERTS BEACH. A pleasant 20-minute hike down steep bluffs leads you to this sandy stretch. The trailhead is at the south end of the parking lot at the end of the Enderts Beach Road off Highway 101 south of Crescent City. Rock tables and rhythmic scatterings of smooth stones relieve the monotony of the sand at the north end of the beach (see photo p. 140). Have fun, keep dry, and take some great pictures!

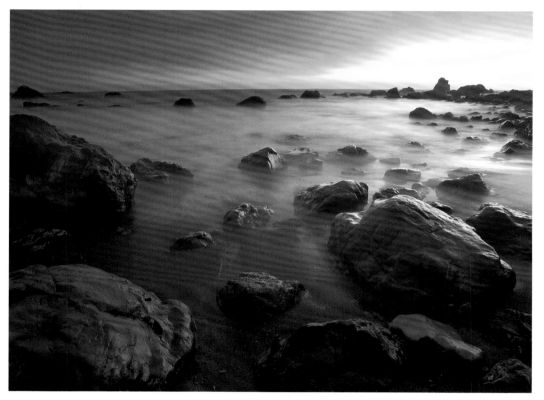

False Klamath Cove Beach (above). **An exposure of eight seconds created a dreamy effect as waves swirled around and washed over the boulders of this beach (Hot Spot 4). Rubber-soled river sandals permitted me to position the tripod among slippery rocks at the water's edge without fear of getting a soaking or taking a tumble.**

ROCKY MOUNTAIN

Colorado • Summer/Fall/Winter • 970-586-1206 • www.nps.gov/romo/index.htm

DISTINGUISHED BY ITS GREAT stretches of alpine tundra accessible by passenger car, Rocky Mountain National Park is a sterling destination for nature photographers. Here you will be able to photograph numerous species of mammals, diverse wildflowers, colorful autumn foliage, mountain vistas, glaciers, lakes, rivers, and waterfalls. At 265,751 acres, Rocky Mountain is but one eighth the size of Yellowstone National Park yet it receives an equal number of visitors—about 3,300,000 each year. Trail Ridge Road (paved) leads nature enthusiasts into the heart of this alpine wilderness, winding along a rocky ridge for nearly 11 miles at an elevation exceeding 11,000 feet. This route traverses open, gusty (winds occasionally exceed 100 mph) expanses of rolling, boulder-strewn grassland which sprouts diminutive wildflowers during summer. In every direction the view is punctuated by snow-topped peaks,

78 of which exceed 12,000 feet. Photographers will find equally enticing attractions in the park's lower elevations where the weather is less harsh, vegetation more lush, and wildlife more abundant.

Due to Rocky Mountain's high elevation, the warmer seasons are most favorable for photography. During spring, wildflower specialists will find plenty of species to photograph at low elevations beginning in early April. However, the drabness of the naked deciduous forests and stale appearance of lingering

Colorado Columbine (above). **Although not plentiful, these colorful blooms can be found in subalpine habitat throughout the park. For a simple portrait like this, make sure you establish sharp focus on the pistils and stamens.**

Yellow-bellied Marmot (left). **These big rodents are easy subjects—large, slow-moving, curious, and comical. They can be found sunning on boulders at and above timberline (Hot Spot 4). Canon EOS 3, Canon 500mm f/4 IS lens. 1/500 second at f/5.6, Fujichrome Provia 100F.**

Trail Ridge Pine (far left). **Wind-sculpted pines and lichen-etched boulders are found about one mile west of Rainbow Curve pullout (Hot Spot 4). They are best photographed at sunset against a colorful sky. Be prepared for high winds and cold temperatures.**

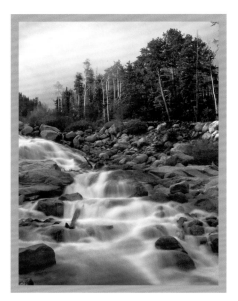

Roaring River Falls (above). **This waterfall, visible from the road in Horseshoe Park, can be photographed from various angles due to its open setting.**

Snowy Ponderosa Pine (right). **The snows of late fall and winter impart magic to common subjects.**

Bear Lake Road Aspens (far right). **The Bear Lake Road winds through some of the thickest, most easily reached aspen stands in the park. I used a zoom lens to isolate this pattern. Pentax 645, Pentax 85–160mm f/4.5 lens, 1/2 second at f/11, Fujichrome Velvia.**

snowpacks make this the least exciting season for scenic shooting, ordinarily a park highlight. During summer, the park's most crowded season, there are plenty of wildflowers at all elevations, the bloom above treeline peaking in mid July. Due to drier conditions, you will not find the sprawling carpets of color typical of subalpine meadows of Washington's Mount Rainier or Colorado's San Juan Mountains, but rather a good variety of individual specimens and small bouquets ideal for close-up work during the infrequent periods when the wind is not blowing. There are plenty of animals about at all elevations, particularly elk, bighorn sheep, mule deer, coyotes, marmots, and squirrels, most of them tolerant of the hordes of tourists and ready targets for telephoto shooters. Summer is also the season of afternoon thunderstorms that set afire evening skies to the delight of landscape enthusiasts.

For most photographers, autumn is the preferred season for a visit. The heavy crowds of summer have dispersed. The park's aspen groves put on a world-class exhibition of glowing gold

and glinting bronze, setting entire mountainsides aflame (see photo p. 145). The peak of color usually occurs in mid-September, but you should consult park headquarters to be sure of catching the show at its most spectacular. Rocky Mountain is one of the premier locations on the continent to photograph elk during the autumn rut. In numerous open meadows, trophy-sized bulls attract harems of cows, intimidating rivals with bugling and charging which sometimes results in combat. In autumn, a dusting of snow over grand landmarks and forest tapestries is not unusual, adding wintry magic to scenes still colorful with fall pigments. During winter, routes into high alpine areas are closed, but many roads are plowed at lower elevations. Here you will find camera angles on snow-draped terrain and icy peaks as well as opportunities to photograph large mammals in winter settings.

There are numerous campgrounds throughout lower elevations of the park, three being open year-round. The campgrounds on the east side of the continental divide fill early each day during summer and reservations are advised well in advance of your visit (800-365-2267). The town of Estes Park, situated adjacent to the best photo attractions, has numerous

lodges, restaurants, service stations, and supply stores. Visitor centers are conveniently located at both east and west entrances for picking up maps and getting information about local conditions.

Summer visitors should prepare for the varied weather typical of mountain environments. Alpine areas are subject to high winds and occasional rain, sleet, and even snow. Conditions are more extreme in spring and fall. From November through March, it is cold and windy with high temperatures in the 20° to 30°F range. A warm hat and windbreaker are indispensable in any season. Rocky Mountain's wide variety of subject matter calls for a full range of equipment, from close-up accessories to super telephoto lenses.

GENERAL STRATEGIES

The best scenic and wildlife attractions are found in the Estes Park area on the east side of the park. Here mountains with steep rock walls and ice-capped summits rise dramatically from surrounding foothills. The western flank, by comparison, is characterized by gradual evergreen slopes of less distinction.

You can enjoy the attractions on the east side in three stages, spending perhaps a day in each area and then returning to explore the photographic possibilities more thoroughly depending on your special interests and seasonal highlights. If you have not visited the park before, you will likely want to make your first foray up Trail Ridge Road into the alpine tundra for which the park is famous. Here you will pass through many square miles of rolling open terrain, featureless

for the most part, but salted with wildflowers during summer and enlivened here and there with small herds of elk, mule deer, and occasionally bighorn sheep. Because you are already at such a high elevation, distant peaks appear out of scale and unimpressive on film. Panoramic and wide-angle shots ordinarily will be more dramatic when taken from the valley floor. Trail Ridge is best for shooting elk and bighorn sheep in open settings, marmots and pikas sunning themselves on beautiful lichen-encrusted rock piles, wind-sculpted trees, and wildflower portraits.

Bear Lake Road, the most popular route in the park, is another area you will want to spend a day exploring.

The road winds upward through tall stands of aspen which display the park's most beautiful fall color in September. It terminates at Bear Lake, a great spot to capture reflections of Hallet Peak and other mountaintops. Popular trails circle the lake and lead up to Nymph Lake and Dream Lake, which are also good sites for scenic photography. The third area of exploration is the collection of parks (open meadows) clumped about the Fall River and Beaver Meadows entrance stations. All of these meadows are regularly used by elk and mule deer for grazing. Horseshoe Park and the salt lick near Sheep Lakes are especially attractive to bighorn sheep. These sites are within easy commuting distance of park campsites or lodging in Estes Park.

It's a good idea to start each shooting day well before sunrise, not only to capture the best light on the land and the peak of wildlife activity but also to avoid crowds and traffic that can delay and frustrate photography later in the day.

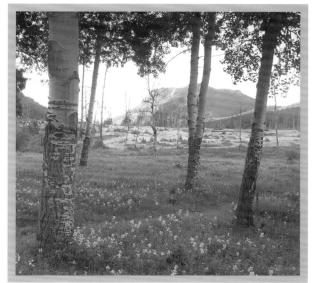

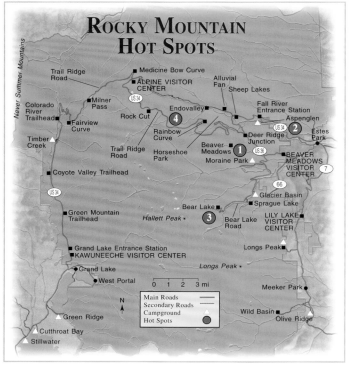

Horseshoe Park (above). **The open meadows of Horseshoe Park in the vicinity of the alluvial fan (see park map) provide opportunities for photographing rutting elk (see Hot Spot 1), wildflowers, rushing streams, and mountain reflections in still pools of the Fall River.**

Golden-mantled Ground Squirrel (far left). **These colorful rodents scamper about roadside pullouts where they are illegally fed by tourists. Rainbow Curve on the east side and Fairview Curve on the west side offer good light and plenty of subjects.**

Bighorn Ewe (above). **During summer and fall you can photograph bighorn sheep from the Sheep Lakes parking lot as they graze in the meadow and visit the salt lick. A telephoto lens in the 500mm range is needed.**

Elk Bull (right). **In September and October, many photographers spend days shooting nothing but rutting elk, a park specialty. It's not difficult to get a frame-filling photograph of a bugling bull but it's another story to capture the full majesty of its display in dramatic light. Work the early morning and late afternoon periods, be patient and persistent, and you should come away with some great pictures (Hot Spot 1).**

PHOTO HOT SPOTS

❶ ELK PARKS. Rocky Mountain is one of the best places in North America to photograph elk. During the autumn rutting season (September/October) you will have a chance to photograph large bulls and their harems of up to 50 cows. The classic shot shows a bull bugling in early morning with fogged breath issuing from his muzzle. Look for opportunities to capture this seldom-recorded view but do not approach closely; bulls will charge photographers suddenly and unpredictably. If you are in the open, you could be seriously injured and even killed. A 500mm lens with 1.4X teleconverter option is the ideal lens combination for this work. Most rutting behavior takes place after dark in open meadows (parks), but you will have plenty of opportunities for great pictures both early and late in the day before the elk retreat to the forest. As the rut continues, some harems remain in the open throughout the day, so if you have the option, plan your trip for early October rather than September. Photographers line up along park roads in considerable numbers whenever a big bull is in the open near the road. You can't miss such "elk jams" and you may wish to join these groups. It's fun socializing with other photographers and you may pick up tips on good shooting locations or photo technique, not to mention a batch of nice photos.

Horseshoe Park, Moraine Park, and Beaver Meadows are popular shooting areas. You may not enter meadows or photograph or observe elk from adjacent trails between 4 P.M. and 7 A.M. When shooting from trails during the day, keep your distance from rutting bulls and stay near an escape tree when they are close. A good area for shooting away from crowds is along the creeks on the south side of Old Fall River Road opposite the alluvial fan (see park map).

❷ BIGHORN SHEEP. Fall is the best time to photograph bighorn sheep. The animals are in prime condition (no shedding) and you may have a chance to photograph the head-butting behavior of the rams. During November, the best location for shooting rams lies outside the park boundary along the road between Estes Park and the Fall River entrance station. This is private property but usually the sheep can be recorded

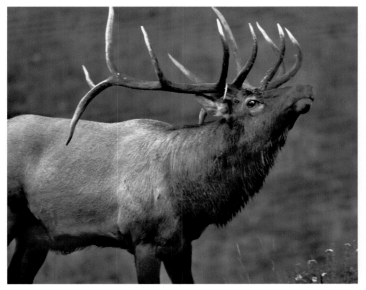

with long lenses from beside the road.

③ BEAR LAKE. Don't miss a dawn shooting session at Bear Lake. There is a nice group of boulders which shelters the water's surface from the wind, resulting in detailed reflections of Hallet Peak and other formations to the south (see photo this page). They are found on the north side of the lake about 200 yards from the parking area. There are also good reflection possibilities at Nymph Lake, an easy 15-minute hike along the trail to Dream Lake. You may wish to check out this site after you have photographed at Bear Lake.

④ TRAIL RIDGE ROAD. I have two favorite spots along this soaring byway. You will encounter the first one coming up from Estes Park at treeline about a mile west of Rainbow Curve where the uphill side of the road is lined with twisted, wind-tortured pines. These trees are excellent photo subjects at sundown when shooting toward the east (see photo p. 142). My other favorite area is in the alpine tundra in the vicinity of

Rock Cut where boulder outcrops near the road harbor yellow-bellied marmots. These big, lazy rodents can be photographed using your vehicle as a blind or after a patient approach in the open (see photo p. 143). For pikas, proceed past Rock Cut one mile to a pullout on the north side of the road. These softball-sized rodents inhabit the talus (rock fragment) slopes on the south side of the road. Happy hunting and great shooting!

Bear Lake Reflection (above). **To bring out shaded foreground details, I used a two-stop split neutral density filter to hold back the brightness of the sky and distant landforms which resulted in more even brightness of this scene (Hot Spot 3).**

SAGUARO

Arizona • Winter/Spring/Fall • 520-733-5153 • www.nps.gov/sagu/index.htm

THE UP LIFTED ARMS of the saguaro cactus have come to symbolize America's wild west almost as much as the cowboy. Forests of these enormous cacti, which can grow 50 feet high and weigh 10 tons, are preserved in Saguaro National Park, 91,443 acres of Sonoran desert habitat.

Saguaro is split into eastern and western units that straddle Tucson's urban sprawl, a condition that robs the park of much of its wilderness character. Nevertheless, there are many attractions here for nature photographers. Foremost are the unique desert plants which make both macro and landscape shooting a novel experience for many. The unique textures, shapes, and colors of cacti of many species— teddybear cholla, hedgehog, barrel, prickly pear, fishhook—make them compelling subjects year-round. In spring their blooms appear, spattering rock-cluttered slopes with brilliant spots of color. With ample rainfall, wildflowers of numerous species carpet hillsides in late winter and early spring. At the same time numerous bird species are readily approached for photography as they sing on territories and carry out nesting activities. Landscape devotees will find plenty to record both within the park and at nearby scenic attractions of equal beauty. There are rhythmic hills, rugged canyons, lone rock prominences, and flinty mountain ranges decorated by stately saguaros rising from soft tangles of palo verde, brittle bush, ocotillo, and cholla.

The only facilities available in the park are four backcountry campsites in Saguaro East. However, plenty of hotels,

Coyote (above). **This captive was shot in early morning at the Arizona-Sonora Desert Museum where animals are housed in natural habitats. (Hot Spot 1).**

Saguaro Flats (left). **This landscape view off Kinney Road in Saguaro West uses saguaro cacti to lead the eye into the picture. A split neutral density filter was used to balance the rosy pre-dawn illumination.**

Tucson Mountains (far left). **The Valley View Trail in Saguaro West leads to this boulder-crowned hill and a veiw of the Tucson Mountains (Hot Spot 3).**

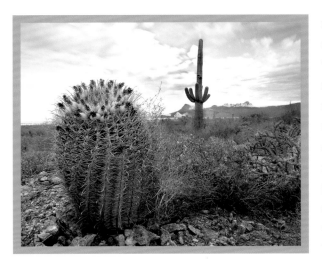

Panther and Safford Peaks, Saguaro West (above). **A 20mm wide-angle lens set at f/22 was placed about a foot away from the foreground barrel cactus to create a compelling sense of three dimensions in this careful arrangement of landscape features. (Hot Spot 3.)**

Cactus Wren (far right). **This portrait of a desert songster was composed to include the skeletal remains of this often-used saguaro perch at the Arizona-Sonora Desert Museum adjacent to the park (Hot Spot 1). Soft light from an overcast sky resulted in strong color saturation.**

motels, and restaurants are available in nearby Tucson. If you are camping, the best place to stay is at Gilbert Ray Campground (sites available on first-come/ first served basis only) in adjacent Tucson County Mountain Park which shares Saguaro West's southern boundary and protects an equally beautiful expanse of Sonoran desert habitat. The campground fills early, especially on weekends and holidays, and in late winter and spring. You can set up a bird feeder here and photograph subjects perched on typical desert vegetation as they come and go.

October through April is the most pleasant time to visit Saguaro with daytime temperatures reaching 60° or 70°F. Snow is possible through the winter months and adds beautiful, fleeting accents to the desert. The rest of the year sees average daily highs in the 100°F range and higher, limiting the pleasure of outdoor activities. Coinciding with the blooming period for annuals and cacti and the breeding season for birds, March and April are ideal months for photographic expeditions. Some years the peak wildflower bloom occurs in February. The large, creamy blossoms of the saguaro cactus appear in May and June. Call headquarters or check the park's website to check conditions and get help in scheduling your visit.

Saguaro offers a full nature photography experience and you will make use of lenses from ultra wide-angle to super telephoto as well as close-up accessories. Bring film for landscapes, wildlife, and plant close-ups in about equal proportion. Additions to your gadget bag should include a pair of tweezers for extracting cactus spines from skin and clothing and a small pair of pliers for pulling spines and thorns from your boots. If not removed these barbed needles work their way deeper into the flesh (beware especially of the teddybear

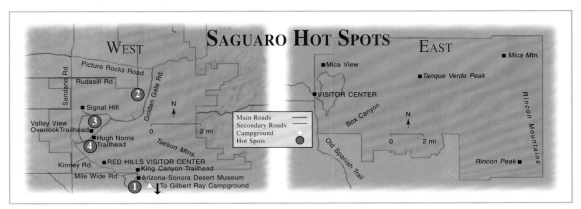

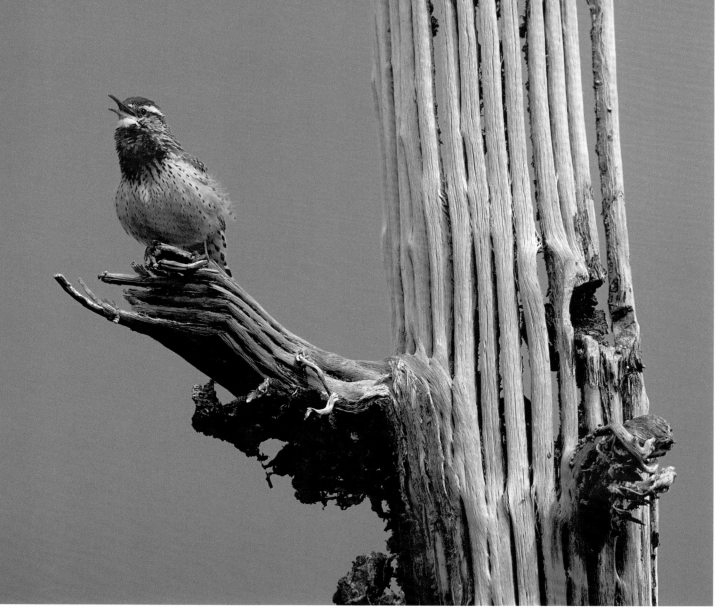

Singing Cardinal (right).
**This boistrous male was re-
corded from the coffee
shop patio at the Arizona-
Sonora Desert Museum
(Hot Spot 1). Canon EOS
3, Canon 500mm f/4 IS lens
and 1.4X teleconverter,
Fujichrome Provia 100F,
1/500 second at f/4 .**

Mexican Poppy (far right).
**In late winter and early
spring, this elegant species
spreads its radiant hues
over Sonoran desert hill-
sides. Abbreviated depth of
field created soft swatches
of color that frame the cen-
tral bloom.**

White-winged Dove (below).
**This curious subject was
photographed on its way to
a bird feeder at Gilbert
Ray campground.**

cholla). You should take a flashlight
as some sunset shooting sites are far
from the trailhead and a portion of
your return hike may have to be
completed in darkness.

GENERAL STRATEGIES

The best shooting in all subject
categories is found in Saguaro West.
If you are not able to stay at the
lovely campground in Tucson Moun-
tain County Park, which is located
in the midst of Saguaro forests and
only minutes from the park bound-
ary, try to find accommodations as
close as possible to this area. One of
the chief attractions at Saguaro West
is the Arizona-Sonora Desert
Museum, a zoo and herbarium of
native desert species situated on the park's southern
boundary. I seldom shoot in zoos but this one is beauti-

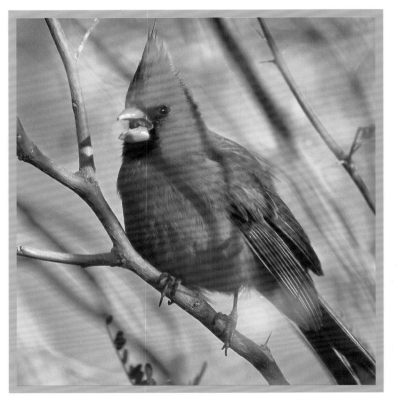

fully organized and naturally
landscaped with low-visibility
cages. I typically plan each day at
Saguaro West to commence with a
pre-scouted landscape shooting
session in the park, followed by a
couple of hours at the museum
where I spend most of my time
photographing free-roaming crea-
tures attracted to the lush and

natural desert landscaping. The middle part of the day
is taken up with hiking and scouting new scenic possi-
bilities, shooting wildflowers, and relaxing. By late
afternoon, I return to the museum for a short while
(buy a season pass if you plan to work this way) and
then proceed to a new sunset landscape location. This
routine is enjoyable and will yield a steady production
of satisfying photos for almost as long as you care to
follow it. Plan on spending about half of your visit at
Saguaro West and the other half divided more or less
equally among Saguaro East and a handful of wonder-
ful nearby excursions (see below).

PHOTO HOT SPOTS

There are many locations in Saguaro West and East and in Gates Pass of Tucson Mountain County Park with the potential for prize-winning landscape photos.

① DESERT MUSEUM. You will want to have a look at the photo possibilities of the captive specimens at this compact zoo. My favorite subjects are the coyotes in early morning when the light is golden and the animals are most active (see photo p. 151). The main attraction here, however, is free-flying bird species that nest on the grounds—cactus wren, cardinal, curve-billed thrasher, Gila woodpecker, phainopepla, and mourning dove. With patience and caution, these species (and others) can be photographed singing in spring atop saguaros, palo verde trees, and other typical desert plants (see photo p. 153). A 500–600mm lens with 1.4X teleconverter will provide frame-filling magnification. You should be ready to start shooting as soon as the museum opens at 8:30 A.M.

② PANTHER PEAK/SAFFORD PEAK VIEWS. These two distinctive peaks in Saguaro West's northern sector can be photographed from the gently rising foothills on the east side of Golden Gate Road with a variety of desert cacti, including saguaros, as foregound subjects. Early-morning side-light paints the mountains in bronze tints and softly models their angular forms (see photo p. 152).

③ VALLEY VIEW OVERLOOK TRAIL. Follow this trail westward from the parking lot for about 10 minutes until you spot a distinctive clump of naked rocks near the top of a steep hill a few hundred yards off the

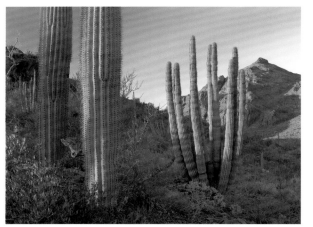

Ajo Mountains, Organ Pipe National Monument (above). **A polarizing filter was used to increase the color saturation of desert vegetation and darken the sky in this view of the Ajo Mountains. This sunset location, a couple of hundred yards off Ajo Mountain Drive, typifies the many picture opportunities available in this part of the national monument (see Excursions).**

trail to the northwest. From atop the hill there are nice views of a rumple of hills and ridges of the Tucson Mountains to the east which can be framed in a variety of ways by the collection of boulders. This site is good at both sunrise and sunset. There are wildflowers here in spring. Dense stands of saguaros at the foot of the hill make excellent subjects themselves as well as framing devices for distant mountains and hills (see photo p. 150).

4 HUGH NORRIS TRAIL. This trail offers some of the most dramatic panoramic views of the park's rugged topography and saguaro forests. The first shooting locations you will come to are on the steep switchbacks which begin about a half mile from the trailhead and climb to a ridge where more all-encompassing compositions are possible. Sunset periods offer the best shooting conditions here. Bring water and a flashlight for safe walking on the way back.

EXCURSIONS

All of these locations have pleasant campgrounds and nearby lodging and restaurants.

ORGAN PIPE NATIONAL MONUMENT

Organ Pipe's northern boundary is a little over two hours from Tucson. This isolated wilderness preserve is similar in habitat to Saguaro but has a greater variety of plants, including its large, multi-limbed namesake cacti, senita cacti, and elephant trees. The topography is a stark combination of mountains and plains and offers even better landscape shooting than at Saguaro. When conditions are right, the show of spring wildflowers is spectacular with spreading clumps of orange-yellow poppies, lavender owl's clover, and blue lupines coloring the desert slopes. Winding past beautiful overlooks, the Ajo Mountain Drive (a 21-mile loop) takes you into the heart of the Ajo and Diablo ranges and is the best scenic route in the park (see photo at left). For more information and to check on the wildflower bloom, consult park headquarters (520-387-5836) or the website at www.nps.gov/orpi/index.htm.

PICACHO PEAK STATE PARK

Visible for miles around, this immense rock prominence is just off Interstate 10, about 40 miles north of Tucson. The several peaks rise majestically from the desert floor. Unfortunately the rock prominences themselves are not overly photogenic; the only view offered photographers is from the north (the southern flanks of the peaks are on private property) which leaves the mountain walls in shadow at sunrise and sunset. Picacho's attraction is an extravagant display of wildlfowers (dominated by poppies) when conditions are right. Plan on shooting portraits and medium views of dense flower patches with cacti and ocotillo accents.

SUPERSTITION MOUNTAINS

This pocket range is composed of a rhythmic series of soaring stone ramparts whose west-facing profile is

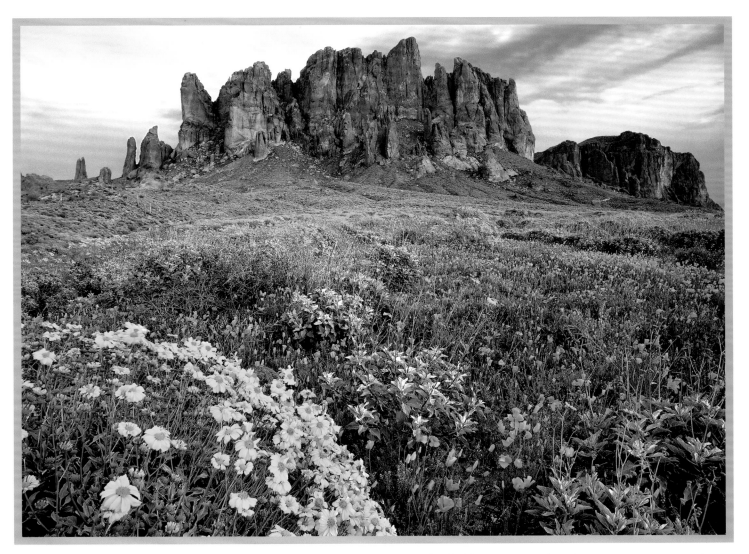

ignited dramatically by the setting sun. In years of ample rain, the display of wildflowers is second to none. A wide selection of tripod spots providing fabulous lineups of blooms, saguaros, and the famous peaks are accessed by numerous trails starting from Lost Dutchman State Park which has campgrounds and picnic areas. The park is less than three hours from Tucson on the eastern outskirts of the Phoenix suburbs. (See photo above.) Happy shooting and watch out for the cactus!

Superstition Mountains (above). **Several meandering trails, accessed from Lost Dutchman State Park, provide sunset angles on these distinctive peaks.**

SHENANDOAH

Virginia • Spring/Fall • 540-999-3500 • www.nps.gov/shen/index.htm

A RUGGED LAND OF BEAUTIFUL forests, Shenandoah National Park straddles the Blue Ridge Mountains, a rampart 3,500 feet high which guards the eastern edge of the Appalachian chain. This long narrow park varies in width from less than a mile to about 13 miles. Its 196,149 acres is bisected north to south by Skyline Drive, a 105-mile paved byway with 75 scenic overlooks engineered for the motorist's viewing pleasure. To help you navigate, concrete mile-markers have been placed along the east side of the road. For photographers (as well as the touring public), Skyline Drive is the main access to attractions—rugged peaks and gentle hillsides, streams and waterfalls, wildflowers, wildlife, and some of the most beautiful deciduous forests on the continent. These thriving woodlands comprise eight major forest types composed of diverse and distinctive species renowned for their fall color—the deep red of ash and blackgum, the burnished gold of birch, the orange of sassafras, the fiery spectrums of oak and maple. In spring, species equally photogenic illuminate the green depths with beautiful blossoms—tuliptree, serviceberry, dogwood, azalea, and mountain laurel.

This park is ideal for photographers who enjoy shooting close to their vehicles. Skyline Drive, the park's main thoroughfare, conveniently delivers you to the most beautiful vistas. You can shoot from designated overlooks or hike along the ridge for a more personal interpretation of the magnificent views spread at your feet. The easiest footpaths are part of the Appalachian Trail,

Pink Lady's Slipper Orchid (above). **These thumb-sized blooms are found in forest openings and roadsides in spring. This intimate angle was recorded from ground level with the camera stabilized on a beanbag.**

Crabtree Falls (left). **This silvery cascade was recorded with a two-second exposure in early morning shade. The site is reached by a 30-minute hike along a well-marked trail at Crabtree Meadows in the southern region of the Blue Ridge Parkway (mile 340).**

Fishers Gap Overlook (far left). **The rosy glow of twilight illuminates this scene in the Big Meadows area of Shenandoah National Park (Hot Spot 1). Pentax 645, Pentax 45–85 f/4.5 lens, one-stop split neutral density filter, four seconds at f/22, Fujichrome Velvia.**

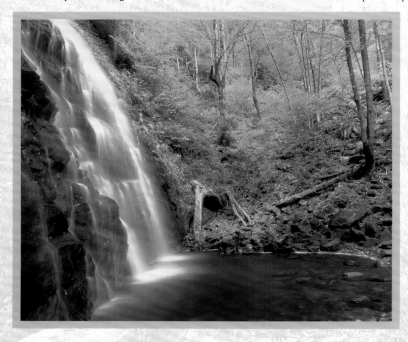

a 2,000-mile hiker's paradise stretching from Maine to Georgia. Marked with white patches painted on trees, the trail is well maintained, easy to follow, and not often steep. Trails marked with blue patches are for photographers who appreciate a physical challenge. They usually start at ridgetop and drop steeply down the escarpment, often running beside a swift-flowing stream and sometimes leading to waterfalls. It's not difficult going down but the return trip is gruelling when you are loaded down with a tripod and other photographic paraphernalia. There is only one waterfall (Dark Hollow) within reasonable hiking distance (1.4 miles round-trip with 440 feet of elevation change) of Skyline Drive. Other falls (about 15 altogether) require hikes exceeding two miles round-trip and 800 feet of elevation change. Fortunately many streams are broken periodically by small cataracts and frothy rapids that may be incorporated into compositions equally compelling as those of full-fledged waterfalls, obviating the necessity for extended hiking.

April and May are the best months for photographing the varied blossoms on the forest floor as well as those decorating the trees above. The weather is pleasantly cool and you needn't contend with the crowds, heat, and humidity of summer. Wildflowers continue

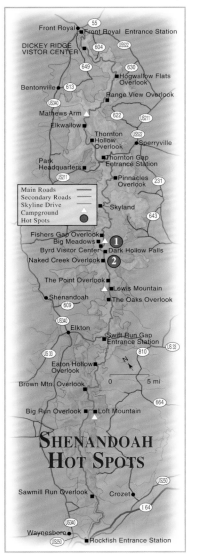

blooming throughout the warm months, dabbing roadsides and fields with the color of native and introduced species. Low water levels in summer make stream and waterfall shooting less attractive. Autumn color is gorgeous and normally most intense between October 10 and 25. This is the best time for a photographic visit, normally a delightful period of crisp temperatures and blue skies although you must contend with heavy tourist traffic, especially on weekends. Skyline Drive is kept open during winter (most facilities are closed), but bare and lifeless deciduous trees present less than thrilling photographic opportunities.

Shenandoah has four main campgrounds evenly spaced along Skyline Drive. Big Meadows is centrally located and nearest the best photo attractions. Reservations are advised in summer and fall (800-365-2267). There are three lodges, all well located in the park's midsection (800-999-4714 for reservations). Although

lodging is available at half a dozen small towns outside the park, it is more convenient and enjoyable to make your headquarters inside the park atop the ridge. Visitor centers are located at the north end of the park, in the center, and about 25 miles from the south entrance. If touring in spring, be sure to ask for a free wildflower blooming schedule when you pick up your park map.

You might also want to pick up maps to hiking trails.

Shenandoah offers a full nature photography experience and you should be able to put all of the equipment in your bag to good use. Most of your time will be spent capturing still-life views of the landscape and forests but you will be able also to make telephoto shots of white-tailed deer and perhaps wild turkeys

Brown Mountain Overlook (far left). **This viewpoint at mile 77 on Skyline Drive in Shenandoah has mature foreground trees for framing distant terrain and a northward orientation that gives uninterrupted views of wilderness along the length of the park. Such northern views (southern views also) capture scenes at sunrise and sunset when they are lit from the side, the best type of illumination to show the contour and texture of landscapes.**

Near Grandview Overlook (left). **These silhouetted roadside trees provide a striking contrast in size and color to the autumn forest in the distance. Photographed in mid-morning in late October, this tripod site is on the east side of the Blue Ridge Parkway at mile 283. A polarizing filter reduced haze and reflections from leaf surfaces for improved color saturation.**

Catawba Rhododendron (above). **This showy evergreen shrub is one of several related species which bloom along Skyline Drive and the Blue Ridge Parkway during May and June. Time your shooting for calm, overcast days.**

Mountains National Park. This forested terrain is equally beautiful to that found in Shenandoah and you will notice little, if any difference between the shooting opportunities on Skyline Drive and those on Blue Ridge Parkway. You can consider the strategies described here as equally applicable to both parks.

GENERAL STRATEGIES

Photography in Shenandoah and Blue Ridge Parkway falls mainly into two categories; taking landscape scenes from the overlooks and recording close-up and medium views from foot trails within the forest. When shooting from

around campgrounds and lodges where they are accustomed to people.

Skyline Drive runs the full length of Shenandoah and connects directly to the Blue Ridge Parkway, a similar paved byway that meanders southward for another 469 miles along the crest of the Blue Ridge Mountains until it finally connects with Great Smoky

ridge tops, nature purists will want to work where distant terrain is not marred by human settlements, logging scars, highways, and power lines. You will find that overlooks oriented to the north or south (those along sharp curves and east/west stretches of the road) often surrender spacious views of unspoiled wilderness. Due to Shenandoah's narrow confines, long-range

views to the east or west open abruptly onto unprotected territory that is frequently less than pristine. Such problems can sometimes be overcome by using telephoto zoom lenses to crop out unwanted landscape features. You also can hide small flaws with foreground branches, rocks, or other natural elements of your composition. The southern reaches of the Blue Ridge Parkway are flanked by large national forests, permitting expansive views of wilderness frequently in all directions.

Another problem you will encounter at designated overlooks is a lack of foreground features to frame and give perspective to the scene. This is the result of the park service dutifully trimming back vegetation on the edge of the ridge to provide unobstructed views. For full-featured scenics, you must get away from the groomed portion of the overlook, usually best

accomplished by hiking along the ridge or descending a short distance.

The central portion of Shenandoah near Big Meadows is the best place to camp or lodge. Here you will find the most facilities, lots of overlooks, wildlife, miles of trails, a variety of wildflowers, and waterfalls numerous but somewhat remote. Weather permitting, a productive schedule is to photograph from an overlook at sunrise, then spend the morning on foot shooting wildlife and still-life views of the forest and wildflowers. Test landscape camera angles during the afternoon and finish off the day by catching a sunset at one of your scouted locations.

Red Columbine (above). I used several small twigs gathered at the site to prop up the stem of this fragile bloom so that it would not shake in the wind during the one-second exposure.

Spiderwort (left). When making a portrait of two blossoms, position the camera so that the film plane (camera back) is equidistant from both sets of pistils and stamens. Choose a camera angle that places the flower against a distant background to create a soft backdrop.

PHOTO HOT SPOTS

Millions of years of erosion have softened the once sharp contours of the Appalachian Range, leaving a landscape more rumpled than craggy, uniformly gentle rather than precipitous with few of the eye-catching pinnacles and spires typical of ranges in western North America. You will find that the best photo opportunities are more dependent on local weather (fog, mist, snow, cloud formations) and seasonal displays of floral color rather than any particular topographic feature.

Foggy Forest (above).
Every patch of woodland in Shenandoah and the Blue Ridge Parkway has the potential for pleasing photographs. The picture's impact will be determined both by how you choose to compose the scene and ambient conditions of weather and seasonal color.

White-tailed Buck (right).
You will see many deer during your visit to Shenandoah. Deer in the Big Meadows area are both plentiful and accustomed to people. Try to capture active specimens in colorful settings.

❶ BIG MEADOWS. This five-square-mile plateau features the most varied and unusual habitats in the park. Two small wetlands, forest and brushland in various stages of succession from logging and farming of early settlers, maintained open meadows, and fringe areas along roadsides and around buildings together yield scores of tree and hundreds of wildflower species. This diverse flora supports a commensurate diversity of wildlife although the only species you are likely to photograph satisfactorily during a short visit are white-tailed deer and possibly turkey. One of the best wildflower areas in the park beginning in April and lasting

through the summer is around a small swamp near Big Meadows campground. Follow the paved trail across the road from the Dark Hollow Falls parking lot on Skyline Drive until you reach a horse trail. Then head north for about 50 yards until you reach a stream and small pond.

❷ DARK HOLLOW FALLS. The trail head to this, the most accessible waterfall in the park, is located at mile 50.7. This steep trail of 1.4 miles round-trip takes about 90 minutes to complete, not including photography. Water cascades through large boulders surrounded by lush forests. There are numerous sites for photographing frothy water along this energetic stream.

EXCURSIONS

Shenandoah and Skyline Drive are only the beginning of a photographic adventure that stretches for another 469 miles via the Blue Ridge Parkway (also administered by the National Park Service) to the Smoky Mountains of Tennessee and North Carolina. Considered to be one of the most scenic drives in America, this route snakes along the crest of the Appalachian Mountains for much of the way, offering endless views of parallel ranges, cross ranges, and scattered hills. A dozen visitor centers, nine campgrounds (open from early May through October), and numerous lodges are scattered along the route. Long and short hiking

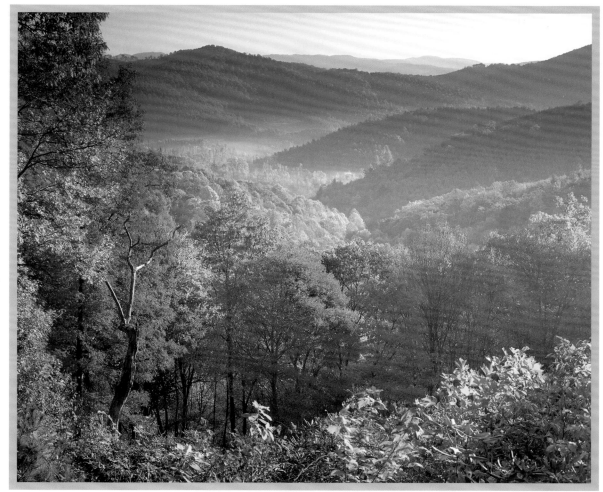

trails abound, many of them starting from roadside overlooks.

Like Shenandoah, this park is notable for its beautiful forests and rugged terrain. Due to the extensive elevation range (649–6,047 feet), periods for the spring wildflower bloom and fall color display vary considerably within the park. You should be able to find suitable subjects with easy drives to an appropriate elevation. Check with park staff for information on current conditions. Flowering shrubs (flame azalea, mountain laurel, rhododendron) put on a a singular springtime display that runs from mid-May through June depending on elevation. Flowering dogwood generally blooms in early May and forest floor wildflowers begin appearing in April. Fall color generally peaks during the last half of October. Twisting mountain roads and picture prospecting require cautious driving and you should figure travel time at around 25 mph not including photo stops. It will take about two weeks for you to cover the entire parkway without rushing or passing up good photo opportunities. If you can't spare this much time, select a small section for exploration (the southern third of the route is my favorite). Relax, enjoy the drive and your shooting!

Jumpinoff Rock Overlook (above). **Early-morning mist hanging in low-lying areas creates strong patterns and deep perspective. In this view from the Blue Ridge Parkway (mile 260), I used colorful foliage to frame the landscape.**

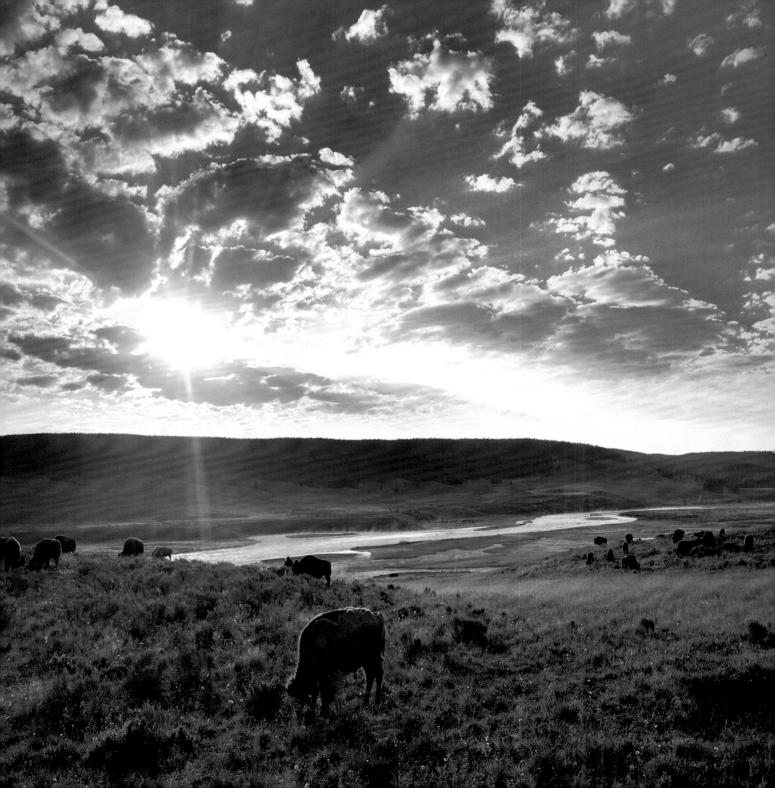

YELLOWSTONE

Idaho/Wyoming/Montana • Spring/Summer/Fall/Winter • 307-344-7381 • www.nps.gov/yell/index.htm

YELLOWSTONE WAS DECLARED the world's first national park in 1872. For nature photographers it remains to this day the gem of the national park system. Its 2,221,766 acres (larger than Delaware and Rhode Island combined) are home to a nearly complete assortment of Rocky Mountain megafauna. During a one-to two-week visit you should have a good chance of recording frame-filling photos of black bear, coyote, bison, elk, bighorn sheep, moose, mule deer, pronghorn antelope, and trumpeter swan. The park is known worldwide for its volatile geologic features. Its landscape is mysteriously alive with steaming hot springs, spouting geysers, bubbling mudpots, and smoking fumaroles—animated accents in this wilderness of plunging canyons, towering waterfalls, roaring rivers, pristine lakes,

rugged mountains, airy meadows, and tawny sagebrush steppes. On the intimate side, you will be confronted with lush displays of wildflowers during late spring and summer as well as an assortment of picnic area chipmunks, golden-mantled ground squirrels, gray jays, ravens, and Clark's nutcrackers to test your telephoto skills.

The park is centered on a high, undulating plateau (elevation 7,000 to 8,000 feet), the collapsed caldera of an enormous volcano. This crater, measuring nearly 30 by 50 miles, is covered primarily by forests of lodgepole pine and rimmed with rugged uplands and distant mountain ranges which provide expansive backdrops to wildlife and scenic photos. The great wildfires of 1988 left large portions of regenerating forests which support thriving

Sticky Geranium (above). **The best time for wildflower photography in Yellowstone is during summer (June/July) in the Dunraven Pass area, where this subject was photographed (Hot Spot 2).**

Trumpeter Swan (left). **These huge waterfowl (wingspan eight feet) are commonly seen in park rivers. This vocalizing specimen was recorded at Fishing Bridge. Seven Mile Bridge on the Madison River seven miles east of West Yellowstone is also a good location.**

Hayden Valley (far left). **This wide-open terrain is the top wildlife location in the park. In early summer herds of bison can be photographed grazing among lupines and other wildflowers (Hot Spot 4).**

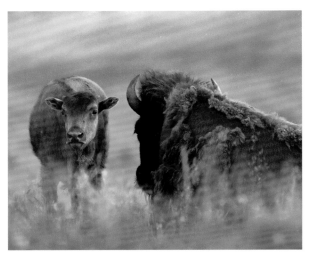

wildlife populations.

Major points of interest are linked by a 142-mile paved road which winds through Yellowstone's central region in a figure-eight loop. This route is linked to the park's five entrances by 100 miles of paved spur roads which also penetrate excellent wildlife and landscape photography territory.

Bison Cow and Calf (above). **June is a pleasant month to photograph bison calves. Intimate views such as this, normally are possible only with telephoto lenses longer than 400mm due to the cow's protective nature. Be cautious approaching on foot.**

Coyote (right). **This curious coyote was photographed near the road in the Hayden Valley on a frosty morning in September (Hot Spot 4).**

Absaroka Range from Dunraven Pass (far right). **A telephoto lens was used to compress the perspective of this lineup of misty peaks in early morning (Hot Spot 2).**

photography, Yellowstone provides fantastic shooting year-round. Springtime weather is often wet. Most roads are open by mid-May. Vistas look out over drab terrain not yet returned to life, but you will have an opportunity to photograph roadside wildlife including endearing newborns and their mothers. Summertime features pleasant weather, green foliage, wildflowers, titanic battles of rutting bison, but also

There are a dozen campgrounds scattered throughout the park. Most are open from late spring into fall with Mammoth Campground being open all year. More than half are operated on a first-come/first-served basis; for the rest you can make reservations by calling 307-344-7311. The park offers a variety of lodgings (cabins, hotels, inns) which are generally available from late spring through fall (for reservations call 307-344-7311). Private accommodation is available at Gardiner, West Yellowstone, and Cooke City just outside the park boundary. There are eight strategically located visitor centers providing current information on weather and shooting conditions. Park maps can be picked up at these locations or at the entrance stations.

Although autumn is the preferred time for

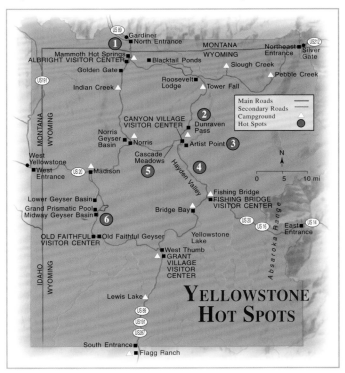

YELLOWSTONE HOT SPOTS

Grand Canyon of the Yellowstone (above). **This common view of Lower Yellowstone Falls was recorded from Artist Point on a hazy afternoon (Hot Spot 3). The scene is most photogenic in the morning after a dusting of snow. Pentax 645, Pentax 300mm f/4 lens, polarizing filter, 1/4 second at f/16, Fujichrome Velvia.**

Firehole River at Midway Geyser Basin (right). **It's best to photograph thermal features at sunrise when wildlife is up and about, skies and reflections are colorful, and tourists are absent. In this scene I used a two-stop split neutral density filter to reduce the brightness of the sky and improve color saturation (Hot Spot 6).**

traffic jams, overcrowded facilities, and full campgrounds. During September and October you will discover beautiful autumn color along water courses and lakesides, landscapes twinkling with occasional snow and frost, low-lying areas hung with mist, wildlife in peak condition in preparation for winter's approach, and the drama of the elk rut when massive bulls bugle challenges in forest clearings and open meadows. Winter brings the closure of park roads due to snow except for the plowed Gardiner-to-Cooke City route which leads motorists through rich wildlife territory. Snowmobile travel is permited within the park. At Mammoth and Old Faithful, wildlife gather in thermal areas to keep warm. Geysers and hot springs spew eerie mists. Access into the Old Faithful area is by snowcoach and personal snowmobile (available at West Yellowstone and Flagg Ranch). Mammoth Hotel and Snow Lodge at Old

Faithful Village offer winter accommodation. Temperatures are bitterly cold, necessitating special arctic apparel and other cold weather precautions. Be sure to consult park staff in preparing for an expedition. Also keep in mind that road openings and closures are not uniform; precise dates are available at headquarters.

Yellowstone National Park's great range of photo attractions requires a full assortment of equipment

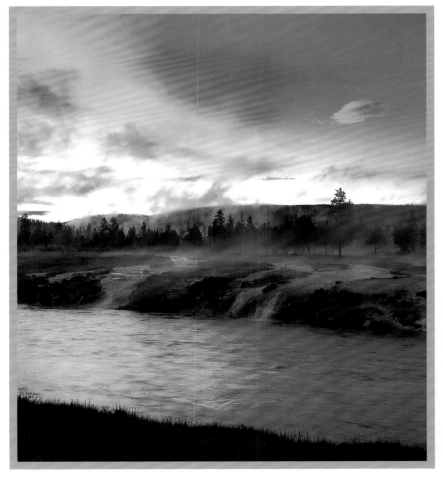

from super telephoto lenses to close-up accessories.

GENERAL STRATEGIES

In a one-to two-week visit, you will have time to sample Yellowstone's primary photo attractions. The daily routine suggested for most other parks also works well here. Try to shoot landscapes at dawn and wildlife immediately afterward. By mid-morning you should begin to make arrangements for the night's accommodation, especially during summer if you are camping on a first-come/first-served basis. Midday is the best time to rest, work on macro-studies such as wildflowers, and scout evening and next-morning landscape locations. Shoot wildlife again in late afternoon and end the day at a scenic sunset location. If possible, arrange for a few nights of accommodation in each of the following three locations. Mammoth Hot Springs area offers abundant wildlife (moose, elk, pronghorn) as well as colorful thermal terraces. Canyon Village is adjacent to waterfalls, the wildflowers of Dunraven Pass, and the abundant wildlife of Hayden Valley. Madison is the gateway to

geyser country and excellent wildlife habitat along the Madison and Firehole Rivers.

PHOTO HOT SPOTS

You may come across wildlife in practically any area of the park. It's a good idea to keep a camera with a telephoto lens attached handy for shooting from inside your car or for quick tripod mounting.

❶ MAMMOTH HOT SPRINGS. This is an excellent area for wildlife in fall and winter. Elk graze through the town and its outskirts. Colorful travertine terraces

Gibbon River (above). **Yellowstone's numerous streams and rivers provide opportunities for making blurred water compositions. This photo was made from the side of the road about 10 minutes after sunset under soft twilight. The exposure lasted about 15 seconds.**

pronghorn antelope on the continent. Shoot from your car or on foot.

❷ DUNRAVEN PASS. The road between Canyon Village and Tower Junction loops over Dunraven Pass (elevation 8,859 feet), the park's premier wildflower shooting destination. Lush arrays of subalpine species (arrowleaf balsamroot, lupines, paintbrushes) bloom during June and July. They can be photographed adjacent to the road or along the trail to Mount Washburn. Take precautions against bears.

❸ GRAND CANYON OF

Blacktail Ponds (above). **These quiet ponds are less than 10 miles west of Mammoth on the way to Tower-Roosevelt. Arriving before dawn, I was able to get into position to capture the reflection of this small cloud as it was momentarily tinted by the sun's warm light.**

make superb wildlife backdrops under overcast skies and are excellent subjects by themselves. Willow Park (about 10 miles south) is Yellowstone's top moose hangout. The twisting road north to Gardiner follows the Gardner River, an excellent area for bighorn sheep in late fall and winter as well as white-water river scenes. The gravel road heading northwest from Gardiner on the west side of the Gardner River (see park map) traverses rolling sagebrush country and herds of some of the most easily photographed

THE YELLOWSTONE. This most famous section of the park includes two enormous waterfalls and a frothy river racing between steep, multi-hued canyon walls. Both North Rim and South Rim drives provide access to beautiful overlooks. The short trail to Artist Point on the south rim leads to the classic view of the Lower Falls. Point Sublime is another excellent overlook accessed by a one-mile trail. The canyon walls are most colorful after a rain. This is a morning or cloudy day shooting location ideally recorded after a snowfall.

④ HAYDEN VALLEY. This is the best wildlife area in the park, an expansive basin of rolling meadows, ponds, streams, and rivers. You will be able to photograph elk, bison, and coyotes from your car at roadside. Moose feed along the river during twilight. During June and July you can shoot bison grazing among wildflowers, particularly blue lupine. If working on foot, be especially cautious and do not approach wildlife too closely. Grizzly frequent this area and you may come upon one unexpectedly in this undulating terrain—stay alert, make noise, and keep your bear spray handy at all times. Early morning and late afternoon are prime shooting periods.

⑤ CASCADE MEADOWS. This is a reliable place to photograph coyotes that have become accustomed to receiving (illegal) picnic handouts. The meadows are on both sides of the Canyon Village-to-Norris road about a mile west of Canyon Village. If there are no coyotes when you arrive, wait an hour or so.

⑥ MIDWAY GEYSER BASIN. The stretch of road between Madison and Old Faithful passes through the densest concentration of thermal features in the world. Grand Prismatic Spring at Midway Geyser is the highlight of many colorful pools. Elk and buffalo commonly wander about the boiling springs, pools, and streams. Catch them amid billows of steam and mist in early morning before the crowds of tourists arrive.

EXCURSIONS

The Beartooth Scenic Byway stretching from Cooke City to Red Lodge is a not-to-be-missed excursion through some of the most spectacular alpine scenery on the continent. July is the best time for wildflowers and cascading water. Have a great trip!

Grand Prismatic Spring (above). **Nice photos of this beautiful pool can be made right from the elevated boardwalk which skirts its northern shore. This aerial view was taken from steep, rock-cluttered hills to the south (Hot Spot 6).**

Bull Elk in Fog (left). **The elk rut runs through September and October. Bulls gather their harems and issue challenging bugles from open meadows. Productive areas are in and around Mammoth Hot Springs and along grassy river benches on the west side of the park. Bulls may charge photographers who approach too closely. Use a long lens and stay near your vehicle or a tree. Canon EOS 3, Canon 500mm f/4 IS lens, 1/250 second at f/5.6, Fujichrome Provia 100F.**

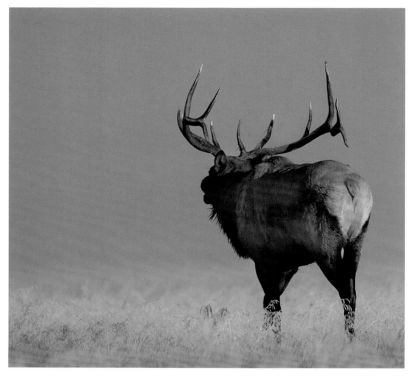

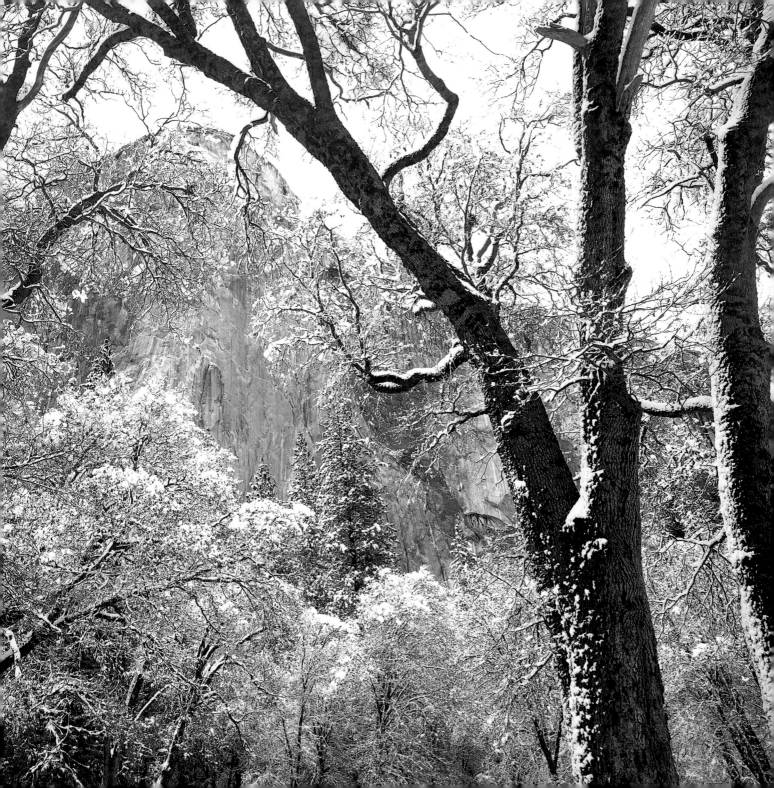

YOSEMITE

California • Spring/Summer/Fall/Winter • 209-372-0200 • www.nps.gov/yose/index.htm

NO NATIONAL PARK OFFERS such an inspiring collection of landscape photography attractions as Yosemite's 747,956 acres. The nucleus of this grand spectacle is Yosemite Valley, a gigantic, glacier-carved corridor walled in by naked peaks and smooth domes which reflect the light of sunrise and sunset as if forged in gold and bronze. This soaring tract of the Sierra Nevada range is laced by numerous waterfalls. They blast over the rim of the canyon and descend in an eerie, slow-motion roar to feed the crystal waters of the Merced River as it sweeps through the valley floor, inundating lush meadows and backwaters that reflect magnificent vistas from all directions.

The park harbors ancient groves of giant sequoias, the world's largest living organisms with individual specimens reaching 300 feet high and 40 feet in diameter. There are beautiful wildflower meadows in subalpine regions on the western slopes of the Sierra Nevadas and through the Merced River Canyon. Flowering trees and shrubs decorate the valley in spring while autumn foliage brushes the view with flaming pigments. Wildlife attractions pale in comparison, but big-lens buffs will find plentiful subjects in the park's abundant mule deer population, squirrels and coyotes.

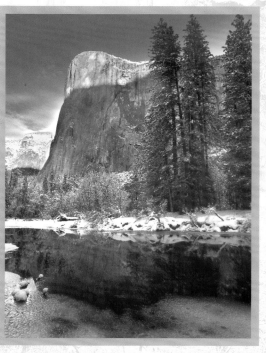

About 4,000,000 people visit Yosemite each year. Most of them come during summer (late June through September) and 90 percent visit only Yosemite Valley which represents a mere 5 percent of the park's total area. Fortunately for photographers, this is the least attractive time for shooting—facilities and roads are crowded, waterfalls have slowed to a trickle, and skies tend to be monotonously blue—pleasant for sight-seeing but lacking in pictorial merit. Outside the valley, the

Lupines and Poppies (above). In early spring, such wildflowers are abundant along the Merced River Canyon just outside the park's western boundary (Hot Spot 1).

El Capitan from Cathedral Beach (left). This site presents one of the best views of El Capitan at sunrise. A wide-angle lens is needed to include the reflection (Hot Spot 6).

El Capitan Meadows View (far left). An open, oak-studded plane at the base of the sheer 3,593-foot cliffs of El Capitan provides a variety of angles and foreground subjects for compositions of one of the park's most famous landmarks (Hot Spot 4). Pentax 645, Pentax 35mm f/3.5 lens, one second at f/22.

wildflower meadows in Tioga Pass normally put on their best displays from mid-July into August.

During spring, waterfalls are at their roaring best and wildflowers dot the valley floor. Dogwood, redbud, and azalea trees dab the forest with colorful blooms from late April through May. Meadows are temporarily flooded with reflecting pools.

In autumn, oaks, maples, dogwoods, alders, and cottonwoods add splashes of color to the evergreen

forests of the valley, usually in staggered presentations most concentrated from about mid-October into early November. The Merced River slows, leaving still channels that offer reflections of surrounding peaks.

Winters in Yosemite are mild with frequent drops of wet snow. It clings to alpine contours and the most slender of twigs, creating a sparkling fairyland that reveals the park at its most photogenic. As storms clear, shafts of sunlight penetrate the curtains of mist to theatrically illuminate the great stone monuments. Such shooting bonanzas are fleeting; the emergence of the sun can melt away this wonderland in under an hour.

There are 13 campgrounds in Yosemite, seven of which offer reservations up to five months in advance (800-436-7275). Wawona and Hodgdon, as well as Upper Pines campground in Yosemite Valley, are open all year. Reservations are required at the main campgrounds in Yosemite Valley, although drop-in space is usually available in late fall, winter, and early spring. Yosemite has lodgings from budget-priced tent-cabins to luxury hotel rooms (call 559-252-4848 for reservations or check the website). For inspiration, look at the display of photo books and prints at the Ansel Adams Gallery in Yosemite Village.

Like any alpine environment, Yosemite's

Harlequin Lupine (lower right). **This species can be found along the road in the Wawona area in the southeast corner of the park. Canon T90, Canon 70–200mm f/2.8 L lens, 50mm extension tube, 1/15 second at f/8, Fujichrome 50.**

weather can change quickly and is dependent on elevation (Tuolumne Meadows at 8,500 feet is 10° to 20°F cooler than valley areas at 4,000 feet). In Yosemite Valley, summer is usually warm and sunny; winter is mild with lots of precipitation (rain and snow); spring and autumn are typical transition seasons—cool and wet one day, sunny and warm the next. Bring clothing appropriate for a variety of conditions. The shooting here will be mostly of landscapes, so a supply of fine-grained color film and a set of contrast-control and polarizing filters are in order. Yosemite's waterfalls are one of the park's main attractions, so be sure to bring a reliable tripod for making blurred-water exposures. Plastic bags are needed to protect cameras and lenses against wet spray, as well as absorbent cloths to dry off equipment. Telephoto lenses are necessary if you want to shoot mule deer and an occasional coyote.

GENERAL STRATEGIES

During a one- to two-week visit, you will want to spend most of your time in Yosemite Valley working on its classic landscape features. In addition, the giant se-

quoias at Mariposa Grove (the most accessible and impressive stand in the park) near Wawona is a not-to-be-missed location. If driving, be aware that only expensive, emergency gas in small quantities is available in Yosemite Valley—it's a good idea to top-off your tank in El Portal, Wawona, Crane Flat, or Tuolumne Meadows before proceeding.

From July through September Yosemite Valley is

Giant Sequoias (above). **The park's largest and most accessible grove of giant sequoias is most beautiful after a fresh snowfall (Hot Spot 12). To reach this spot during midwinter, you must travel by snowshoes or skis .**

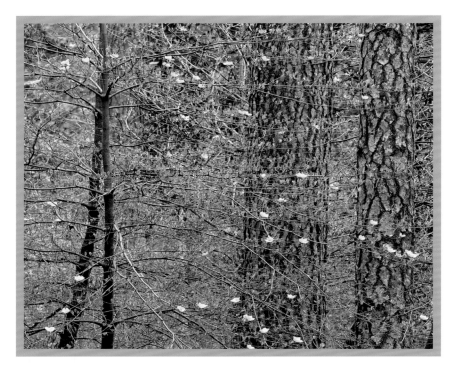

Flowering Dogwood (above). **I used a telephoto lens to compress the perspective of this patch of flowering dogwood trees along Tenaya Creek (Hot Spot 10). These understory trees bloom in May.**

Browsing Mule Deer (right). **Mule deer are common throughout the park (large herds graze Tuolumne Meadows). They are accustomed to pedestrians in Yosemite Valley and can be easily photographed with a telephoto lens.**

congested, especially on weekends. You will have little trouble finding a parking space for sunrise shooting, but at sunset you may need to take the free shuttle bus to destinations in the east end of the valley. At other times of the year, you should have little difficulty working from your own vehicle. For your first trip into Yosemite Valley, spend time becoming familiar with the road system. With the help of a park map, orient yourself to major features—El Capitan, Cathedral Rocks, Half Dome, Sentinel Rock, Yosemite Falls, Vernal Fall, Bridalveil Fall, and the meanderings of the Merced River. Once you have a feeling for the area, you can formulate a shooting schedule. Precisely how you proceed will depend on the time of year and the

weather. Cloudy days are ideal for shooting the park's numerous waterfalls, sequoia groves, deciduous forests, and wildflowers. During sunny periods, concentrate on landforms which are modeled and set aglow by the warm light of sunset or sunrise. At certain times of the year, a rising or setting sun may illuminate waterfalls theatrically. It's a good idea to work on one classic landscape view at a time—select a site, scout the location, determine what time of day will provide the best light, and then schedule the shooting session. During fair weather, the relatively small size of the valley will enable you to investigate several locations during the slack midday period. If it's calm and overcast, you will be confronted with exciting shooting opportunities through most the day. On your first visit, schedule a full day for shooting Mariposa Grove and a day or two for Tuolumne Meadows and Tioga Pass if your tour is during wildflower season.

Waterfalls are one of the park's main photo attractions. During spring, when they are most impressive, it is difficult to get close due to heavy spray which is broadcast by the wind for some distance. Plan to shoot these attractions on calm, cloudy days; alternatively schedule your shoot for when the falls are in shade and use a warming filter (81A) to balance the cool lighting conditions. Easy trails lead to and around the best falls—Upper and Lower Yosemite,

Bridalveil, and Vernal. Fortunately, your photos will show the elegant shape, size, and surroundings most effectively from the base of the flow, relieving you from making the strenuous uphill trek to the top. Explore trails for camera angles which include stationary elements that can be used to frame the flow of water. Trees and colorful vegetation are best for showing the scale of the scene; rocks and boulders, being unaffected by wind, exhibit sharp details which emphasize the soft blur of the falls. Shutter speeds of 1/2 second and slower will create sensuous blur, speeds of 1/125 second and faster will freeze the water's movement.

Yosemite is at its most beautiful as storms are clearing, a time when the sun peeks through clouds to spotlight cliffs and pinnacles, and mist swirls through the valley. Be prepared to shoot at these dramatic times rather than waiting for the storm to pass.

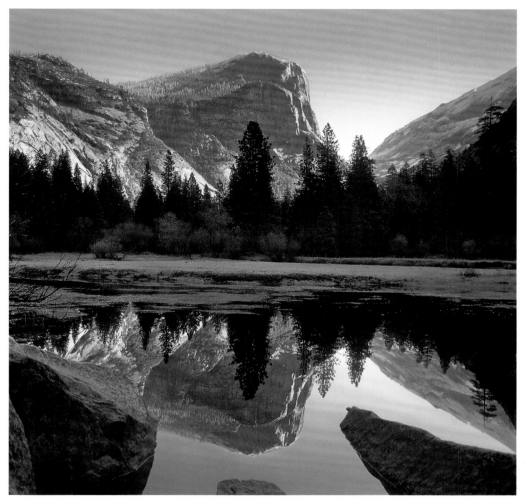

PHOTO HOT SPOTS

These top sites are some of the most accessible in the park. There are many others to be photographed along both Yosemite's roadsides and hiking trails.

❶ MERCED RIVER CANYON. Incline Road skirts the north side of the Merced River just outside the park's western boundary through the best springtime wildflower displays in the area. From mid-March to May (peak period is usually early April), the hillsides along the road are peppered with lupines, poppies, owl's clover, and other species (see photo p. 175). The river banks flash with the magenta blooms of redbud. To reach this area proceed west out of the park on Highway 140 just past the town of El Portal to Foresta

Mirror Lake (above). **I had to get my feet wet to take this carefully composed sunrise view of Mount Watkins. The best time to shoot at Mirror Lake is during late winter and spring when water levels are higher (Hot Spot 10).**

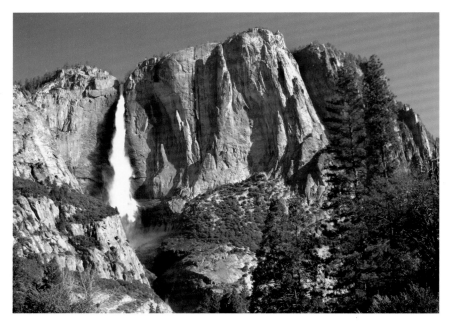

Upper Yosemite Fall from Cook's Meadow (above). **This area offers views of Upper Yosemite Falls in its alpine setting (Hot Spot 7).**

Half Dome from Sentinel Bridge (right). **You will record the best reflections of Half Dome from this spot during late fall and winter when the Merced River flows calmly through its channel (Hot Spot 8).**

Tuolumne Meadows Reflection (far right). **Such views are possible in early summer when the meadows are flooded with meltwater (Hot Spot 11).**

Road. Turn right, cross the river, turn left, and then turn immediately left again onto Incline Road which is paved for the first few miles, gradually becoming rougher until it ends. The wildflower patches are on steep terrain, so be prepared for some exercise.

② TUNNEL VIEW. This famous roadside location offers a panoramic view of Yosemite Valley, exhibiting many of the park's major geologic features to good advantage—El Capitan, Half Dome, Cathedral Rocks, Bridalveil Falls. The viewpoint is just before the tunnel leading out of Yosemite Valley on the road to Wawona (Route 41). A late afternoon/sunset site, this is a straight-on shot with little opportunity for personal variation. Luck and timing are required to make an outstanding image—look for a dramatic spotlighting of landmarks beneath a sky hung with fiery clouds. A

telephoto zoom will be your most useful optic.

③ VALLEY VIEW. This inconspicuous pullout along the Merced River offers panoramic views into Yosemite Valley. The scene features El Capitan, Cathedral Rocks, and Bridalveil Falls with the Merced River flowing through the lower portion of the scene. The best time to shoot here is at sunset in autumn when water levels are low and calm pools of water among the rocks trap reflections of the distant terrain. Don chestwaders or shorts and river sandals so that you can move freely about the river channel to pinpoint your tripod location for the best arrangement of rocks, reflection, and landscape features. To reach this site take Northside Drive to the west end of Yosemite Valley; the pullout is on the left side of the road just after the sign for Route 41 Wawona/Fresno at road marker V11.

④ EL CAPITAN MEADOW. This large, flat meadow is dotted with beautiful oak groves and ponderosa pines (see photo p. 174). It lies along the Merced River below the towering monolith of El Capitan. Across the river to the south, Cathedral Rocks dominates the view. The meadow is on the south side of the park road 2.5 miles west of Yosemite Lodge. El Capitan catches warm side-light at both

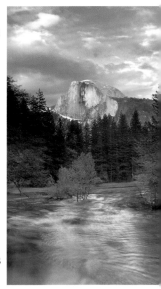

sunrise and sunset throughout the year with lighting angles during winter being preferred. There are lots of foreground choices (mostly trees) at this spot and plenty of room to move around the meadow for different points of view. This is a great place to be during stormy, unsettled weather.

5 CATHEDRAL ROCKS REFLECTION. This quiet spot offers mirror-like reflections of these majestic granite formations in springtime when temporary pools dot the valley floor (see photo p. 182). Proceed two miles west from Yosemite Lodge until you see a small gravel pullout on the left side of the road as the road curves to the left. The pools are on the left side of the road. Photography is good at either sunrise or sunset.

6 CATHEDRAL BEACH. This shooting location is on the south bank of the Merced River adjacent to Cathedral Beach picnic area off Southside Drive 1/10 mile east of El Capitan Bridge (crossover). There are good tripod locations along the edge of the river where quiet pools reflect El Capitan under early-morning light (see photo p. 175). You will need an ultra-wide-angle lens to capture both the monolith and its reflection in the same composition.

7 YOSEMITE FALLS. This great cascade plummets 2,645 feet in three stages. The upper fall is best photographed from afar (Sentinel Bridge parking lot and Cook's Meadow provide a variety of superlative views) as part of the grand landscape setting (see photo p. 180). Lower Yosemite Fall offers opportunities for closer studies incorporating details of the immediate surroundings (see photos p. 182, 183). A short trail

Lower Yosemite Fall (above). **It's usually not a good idea to allow the flow of a waterfall to rush clear to the edge of your picture. Here I used foreground trees to trap the cataract and keep the viewer's eyes from following the stream out of the composition (Hot Spot 7).**

Cathedral Rocks Vista (right). **These underrated rock formations are among the most photogenic in Yosemite Valley. The best time to shoot them is spring at either sunset or sunrise when they reflect in snowmelt pools on the valley floor (Hot Spot 5).**

leads from the parking area on Northside Drive opposite Yosemite Lodge to a viewing-bridge spanning Yosemite Creek. Check your lens often for mist which drifts on gusty winds from the fall.

⑧ SENTINEL BRIDGE. This location provides a revealing angle on Half Dome's distinctive profile. The view is best recorded at sunset when the sheer rock face is tinted with shades of gold, peach, and orange. You can shoot from the solid stone bridge or drop down to the path along the Merced. In late fall and winter, the slackened course of the river provides well-defined reflections of Half Dome. A two-stop, split neutral density filter is needed to reduce contrast between the sunlit dome and shaded river basin (see photo p. 180).

⑨ GLACIER POINT. This inspiring overlook, more than 3,000 feet above Yosemite Valley, offers commanding aerial views to the northeast of Half Dome, Vernal Fall, Nevada Fall, and the canyons and rumpled crest of the Sierra Nevada. Late-afternoon sunlight accentuates this rugged topography. At sunset Half Dome glows with day's last warm rays. The overlook is 32 miles from Yosemite Valley via Route 41 (south toward Fresno) to the Glacier Point Road.

⑩ MIRROR LAKE. The idyllic waters of this small lake reflect the humped prominence of Mount Watkins (see photo p. 179). The scene is best photographed at either sunset or sunrise during winter or spring when water levels are high. An easy three-quarter-mile, uphill hike along a paved road (which is for bicycle or handicapped use only) will get you to the site. The route starts at shuttle bus stop #17 and parallels tumbling Tenaya Creek, a good spot to shoot flowering dogwood trees in May (see photo p. 178).

⑪ TIOGA ROAD. This high-country byway traverses the center of the park, skirting evergreen forests,

sparkling lakes, lush subalpine meadows, and the icy peaks of the Sierra Nevadas. Normally open from late May to late October, the road offers its most popular vista at Olmstead Point, a commanding site amid rounded boulders (great foreground features) that serves up an inspiring backside view of Half Dome and other rugged terrain at sunset. Although there is much to shoot all along this route, the photo highlight is Tuolumne Meadows (55 miles from Yosemite Valley), a grassy subalpine plane dappled with snowmelt pools in June which reflect surrounding landforms (see photo p. 181). The meadows sprout colorful wildflowers beginning in late June and peaking in late July.

⑫ **MARIPOSA GROVE**. The largest of the park's sequoia groves is located about 30 miles from Yosemite Valley near the south entrance. Plan your trip here for a cloudy day and hope for a little rain to soak the forest and produce saturated hues (use a polarizing filter for maximum color). A good dusting of snow is even better, but it does not come without a price. The steep, two-mile entrance road is usually closed by a light flurry (the steep pavement becomes slippery) and you will be faced with an uphill hike of about 45 minutes.

In midwinter, snows are deep and you will need to ski or snowshoe the distance. Explore the numerous paths that transect the grove. Look for rhythmic arrangements of trunks and textures and juxtapositions of smaller trees and giant sequoia trunks. Bring a tripod to handle the low light, long exposures, and small apertures (see photo p. 177). Have a great trip and wonderful shooting!

Yosemite Creek (above). **This stretch of frothy stream right below Lower Yosemite Fall is an excellent place to compose blurred stream photographs. Pentax 645, Pentax 45–85mm lens, polarizing filter, two seconds at f/22, Fujichrome Velvia.**

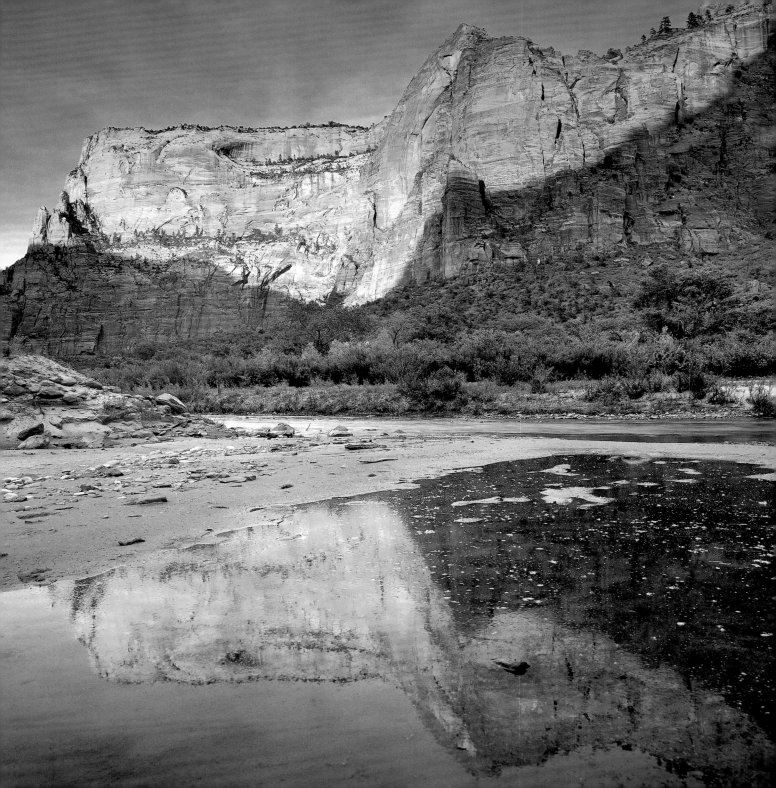

ZION

Utah • Spring/Summer/Fall/Winter • 435-772-3256 • www.nps.gov/zion/index.htm

THIS GENTLE WILDERNESS, nestled amid the semi-arid plateau country of southwest Utah, confronts the visitor with a glowing amalgam of daring color and sculpted rock lovingly arranged and gigantic in scale. The heart of this 147,551-acre park is a narrow canyon carved by the Virgin River over a period of a million years, a gorge lined by sheer, rainbow-hued walls soaring 3,000 feet above the valley floor. This collection of domes, hanging valleys, slot canyons, and blunt peaks tinted in shades of cream, amarillo, rust, and rose loom over a valley floor planted with juniper, willow, cottonwood, oak, and maple. Nooks and crannies are decorated with varied shrubs, cacti, and wildflowers. Vegetation patterns change quickly over this steep terrain—a mile above the Virgin River, mesatops are sprinkled with forests of Douglas-fir, ponderosa pine, and trembling aspen.

The main photographic attractions are clumped in the southeast corner of the park along Highway 9 (Zion-Mount Carmel Highway) and Zion Canyon Drive which thread through a glorious lineup of stone monuments, most named by the original Mormon explorers and settlers—Great White Throne, Temple of Sinawava, Alter of Sacrifice, Towers of the Virgin. The park offers many opportunities for landscape photographers; however, its photogenic properties extend beyond glamourous contours. Within the canyons, reflected light glows warmly from the reddish walls generating intriguing still-life compositions of textured sandstone and vegetation tinted with fresh mint in spring and hammered bronze in autumn. Plentiful wildflowers and a routine smattering of wildlife round out the photographic attractions.

You will have a rewarding shooting experience in Zion during any season. In winter, frosty temperatures dust the park's sandstone architecture with snow and skies are periodically filled with great banks of cloud—

Claret Cup Cactus (above). **Zion harbors a variety of wildflower and cactus species. The display of blooms peaks during May.**

Mule Deer (left). **You will encounter many opportunities to photograph mule deer in this park. Usually unafraid of people, they are common along roadsides, near campgrounds, and in brushy habitat along creeks and rivers. This trophy buck was recorded at Zion Lodge, one of the most reliable mule deer sites in the park.**

Emerald Pools Creek Reflection (far left). **There are several well-positioned reflecting pools where this creek meets the North Fork Virgin River (Hot Spot 5).**

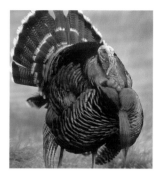

Wild Turkey (above). **These birds can be photographed about the grounds of Zion Lodge. The big toms display year-round but are most earnest during late February and early March.**

Towers of the Virgin (right). **This scene was shot behind the museum at sunrise in early November. A two-stop split neutral density filter was used to balance light intensity between the sunlit and shaded areas of the scene (Hot Spot 3).**

Deer Tracks along Pine Creek (far right). **Reflecting pools of Mount Spry and the East Temple are found in the lower reaches of Pine Creek near its juncture with the Virgin River (Hot Spot 2). Park near the huge roadside boulder on the Zion-Mount Carmel Highway just west of the Zion Canyon turn-off.**

ideal canvases for the fiery sunset colors. Winter temperatures are not extreme (daytime highs may reach 60°F) and summer crowds have disappeared. Except for northern sections of the park, roads and campgrounds are kept open. The best time to visit is during or right after a snowfall.

Spring brings a re-emergence of foliage on trees and shrubs, greenish tints to the waters of the Virgin River, and a display of wild blooms (including yucca and several cactus species) which lasts from April through June, peaking in May. Weather is variable, especially in April when conditions may be wet and cold.

During summer the park becomes crowded and temperatures rise to over 100°F. These irritations may seem minor compared to the special picture opportunities that this season offers. From mid-July into September thunderstorms brood over the park, generating dark, textured skies and theatrical lighting effects across colorful rock faces. After a downpour, waterfalls and springs gush from cliffs and rivers rush over ter-

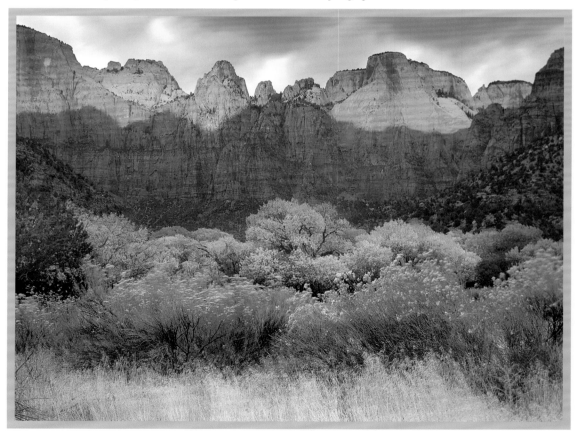

rain and past verdent foliage saturated with color.

Autumn offers mild temperatures and few clouds. The color change is delayed in southern Zion—most trees turn from late October into early November. River courses become draped in warm tints and famous landmarks are framed by colorful boughs. Kolob Canyon in the north serves up its best leaf display (including the gold of aspens) in mid-September.

There are two campgrounds near the south entrance. One of these accepts reservations (800-365-2267). The other is operated on a first-come/first-served basis and usually fills by noon during summer. Zion Lodge is a beautiful place to stay in the heart of Zion Canyon (reservations 303-297-2757). Campgrounds, lodgings, restaurants, and grocery stores are found in the town of Springdale just outside the south entrance.

Be prepared for changing weather at any time of the year. Day/night temperatures routinely vary by as much as 30°F. Pack river sandals and quick-drying shorts for reaching ideal tripod positions in rivers, streams, and pools. Split neutral density and polarizing filters, as well as reflectors, will be valuable for modifying the frequent high-contrast lighting conditions of the park. Landscape imagery and close-ups of wildflowers and desert plants will put the greatest demands on your equipment. In autumn a telephoto lens in the 500mm range is ideal for recording people-habituated mule deer with trophy racks that inhabit Zion Canyon.

GENERAL STRATEGIES

For your first visit to Zion, you will want to spend

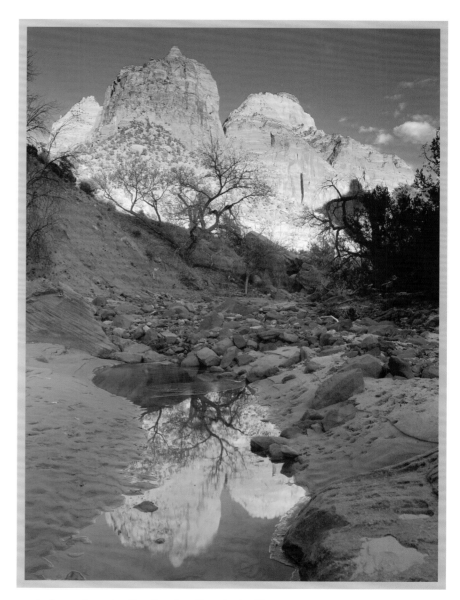

most of your time shooting the attractions in the Zion Canyon area, saving two or three days to explore and photograph along the Zion-Mount Carmel Highway to

Autumn Cottonwoods (right). **The Temple of Sinawava area is an excellent place to photograph beautiful trees against red sandstone backdrops in soft light (Hot Spot 6).**

The Watchman (below). **This dominating prominence was shot from the hillside behind the museum. At sundown this position offers interesting foreground features for the colossal rock formations guarding the east side of the river (Hot Spot 3).**

the east. During a two-week stay you could schedule a couple of days for Kolob Canyons; otherwise save this sector for a return visit.

Although the park is filled with spectacular landforms, it's not as easy as you might think to take home pictures suitable for framing. The most accessible locations are on the canyon floor where dim, shaded rock faces are often surmounted by overly bright skies. Split neutral density filters can help balance the scene's contrast by reducing the brightness of skies and sunlit cliffs. Unfortunately the straight-line division between clear and dark areas of such filters doesn't fit the irregular borders between highlights and shadows that reality usually draws. These circumstances make it

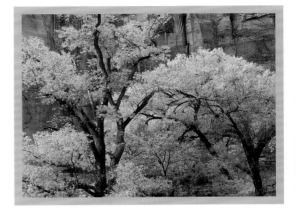

doubly important to shoot in the soft light of sunrise and sunset. High-contrast situations can be mitigated by filling the shaded lower portion of the composition with bright reflections from sunny terrain found in streams, pools, and river backwaters (see photos p. 184, 187). Or you can avoid sunlit features altogether and record arrangements of trees and canyon walls illuminated indirectly by light reflected from rock faces.

During fair weather, plan to shoot a distinctive landscape view at both sunrise and sunset. Spend the middle part of the day working on still-life compositions within the shaded confines of Zion Canyon and/or testing light and camera angles of new locations.

Zion Canyon is accessible only by shuttle bus from about April 1 to October 31. You can leave your car at Zion Canyon Visitor Center or in special parking areas in Springdale. The first bus departs at 5:45 A.M. in time to reach sunrise shooting sites. There are many designated stops and buses run all day at frequent intervals. Just remember to bring adequate film, all necessary equipment, and some munchies.

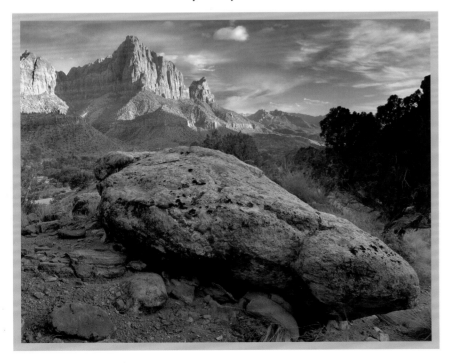

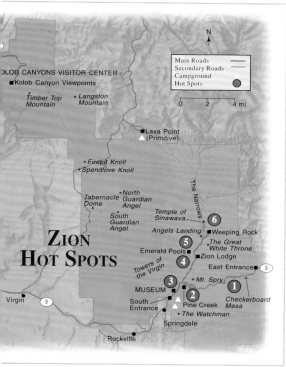

ZION
HOT SPOTS

Map labels:
KOLOB CANYONS VISITOR CENTER
- Kolob Canyon Viewpoints
- Timber Top Mountain
- Langston Mountain
- Lava Point (Primitive)
- Firepit Knoll
- Spendlove Knoll
- Tabernacle Dome
- North Guardian Angel
- South Guardian Angel
- Temple of Sinawava
- The Narrows
- Angels Landing
- Weeping Rock
- Emerald Pools
- The Great White Throne
- Towers of the Virgin
- Zion Lodge
- East Entrance 9
- Mt. Spry
- MUSEUM
- South Entrance
- Pine Creek
- Checkerboard Mesa
- The Watchman
- Springdale
- Rockville
- Virgin 9

Legend:
Main Roads
Secondary Roads
Campground
Hot Spots
0 2 4 mi

PHOTO HOT SPOTS

Keep in mind that these sites, like all hot spots described in the book, can be reached by hikes of less than an hour, most in only a few minutes. There are additional great locations in Zion that require more effort, most popular among these are The Narrows and Bright Angel Point.

❶ CHECKERBOARD MESA AREA. The high country east of Zion Canyon along the Zion-Mount Carmel Highway offers relief from the difficult lighting conditions of the canyon. Here you will find panoramic views of mountains and valleys and plenty of wildflowers and cactus growing near the road. The main attraction is the unworldly collection of pine-studded sandstone rocks that are eroded into swirling, fantasy shapes and etched with linear patterns. Unfortunately it's not easy to get either an original or dramatic shot of Checkerboard Mesa, the most distinctive rock formation in the park. Intriguing personal scenes are reached by hiking into the formations where you can cast about for artistic interpretations. Sunset, sunrise, and cloudy days are the best times for shooting.

❷ PINE CREEK. This stream offers terrific photo attractions. Along the trail north of the bridge across the Zion-Mount Carmel Highway you will find a sandstone wall stained pink and blue as well as several reflecting pools featuring the West Temple. Below the bridge is a nice stretch of marsh vegetation and just before Pine Creek joins the Virgin River are more small, still pools reflecting Mount Spry (see photo p. 187).

❸ MUSEUM. Behind this facility is one of the best sunrise locations in the park where warm light plays over magnificent sandstone palisades known as Towers of the Virgin. Foreground features include tawny grasses, rabbit brush, and cottonwood trees (see photo p. 186). Zoom lenses will enable you to frame the best combination of colorful clouds (should you be so lucky) and prominent peaks. At sunset, climb the rugged hills behind the museum for good

Slickrock and Moon (below). **The plateau country east of Zion Canyon is filled with pine-studded slick-rock architecture stained in shades of orange, rose, and ocher (Hot Spot 1). Numerous mounds and terraces are etched with swirling patterns and crosshatches. This image, taken during predawn twilight, is the result of a double exposure. The moon was shot with a telephoto lens at the standard exposure of 1/film speed second at f/16 (at night or during twilight these settings will not record features of the landscape). I then framed the slick-rock landscape scene with a 20mm lens reserving a clear patch of sky for the moon.**

Claret Cup Cactus (above). **Soft light is hard to come by in arid environments like Zion. Here I created my own by shading the subject with an umbrella. This technique works best for flowers photographed from above which crops out sunlit spots in the background. You may want to warm up the color balance with an 81A filter. Canon EOS 3, Canon 100–400mm f/5.6 IS lens, Canon close-up lens 500D, 1/4 second at f/11, Fujichrome Velvia.**

Near Middle Emerald Pool (right). **The trails to these pools pass under sandstone walls draped with vegetation. I was careful not to include sky in this photo in order that all parts of the scene remain within the exposure latitude of the film (Hot Spot 5).**

foreground features and clear views of numerous pinnacles and mountains to the northeast and southeast (see photo p. 188).

④ VIRGIN RIVER BACKWATERS. Zion Canyon Road parallels the river for its entire length. In places you can scramble down the steep bank to the water's edge where reflections in pools, as well as varied vegetation, can be used as foregrounds for canyon landmarks. The best area is where Emerald Pools Creek meets up with the North Fork Virgin River (see photo p. 184). Space is tight here and you will need an ultra-wide-angle lens to include both the towering landforms and their reflections.

⑤ EMERALD POOLS. This site offers colorful canyon walls decorated with lush foliage and accented with small cascades (see photo at right). Photography is best attempted during overcast conditions in spring or after a summer rain when the waterfalls are swollen by runoff. The first (lower) pool is reached by a wildflower-flocked, half-mile trail from Zion Lodge.

⑥ TEMPLE OF SINAWAVA. This mystical amphitheater at the end of Zion Canyon offers impressive views of looming rock towers through curtains of gorgeous cottonwoods and other trees. Although the main attraction is a midstream rock named The Pulpit, more exciting images normally result from working on abstract renderings of beautiful colors and shapes, especially in autumn when Fremont cottonwoods shimmer in tints of gold and ochre (see photo p. 188).

EXCURSIONS

There are plenty of fabulous natural attractions aside from Zion in this part of Utah. The most outstanding is Bryce Canyon National Park about 80 miles to the east. Few knowledgeable photographers visit one park without scheduling time at the other.

BRYCE CANYON

This small park (35,835 acres) offers the usual national park facilities—campgrounds, a visitor center, and well-marked trails as well as private accommodations and services nearby. More than a 1,500,000 visitors each year are drawn to this crenulated, intricately carved amphitheater, a supernatural landscape of

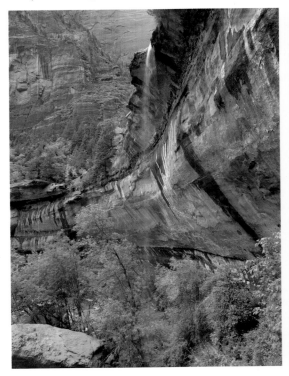